THE MASTER PRINTER'S *Workbook*

a professional guide to b+w darkroom techniques

steve macleod

RotoVision

This delicate image
was flashed post

for claire

A RotoVision book

Published and distributed by RotoVision S.A.
Route Suisse 9
CH-1295 Mies
Switzerland

RotoVision SA, Sales, Editorial & Production Office
Sheridan House, 112/116a Western Road
Hove, East Sussex BN3 1DD, UK

TEL: +44 (0)1273 72 72 68
FAX: +44 (0)1273 72 72 69
EMAIL: sales@rotovision.com
WEBSITE: www.rotovision.com

Copyright © RotoVision SA 2003

10 9 8 7 6 5 4 3 2 1

ISBN 2-88046-733-0

Edited by **Clara Théau-Laurent and Leonie Taylor**
Designed by **Bailey Design Associates**
Production and separations by **ProVision Pte. Ltd.** in Singapore
Tel: +65 6334 7720
Fax: +65 6334 7721

Although every effort has been made to contact owners of copyright material
produced in this book, we have not always been successful. In the event of a
copyright query, please contact the publisher.

THE MASTER PRINTER'S *Workbook*

a professional guide to b+w darkroom techniques

steve macleod

contents

foreword

Some of the world's leading photographers put their faith in Steve Macleod on a daily basis. These are photographers who cross the broadest fairways in terms of individual style and approach, from the driving and edgy fashion portraits of self-made icons such as Mario Testino and Rankin, through to the often harrowing and eye-opening storytelling pictures of Gary Knight and Zed Nelson.

The reasons why they choose Steve are numerous, however, it is mostly his unique approach to each photographer's work that professionals seek out – he provides an edge to every individual print. It may be clichéd to say that printers are extensions of the photographer's eye, but the qualities and skill that Steve exhibits throughout the contents of this book show not only a great degree of sensitivity towards the subject matter, but also a deep understanding of the photographer's multi-tasking mind – Steve brings focus to the final print. This is essential when you consider that the demands placed on modern-day photographers mean that they have moved on to the next job – probably in another country – while Steve is left to manipulate another quick-fire negative in his darkroom.

We can probably learn more about the print and producing the optimum negative from Steve's book than we can from any other photographic source.

Learning how to get the information we require into each negative, rating and processing the film so that the content can be effortlessly drawn into the print, is an art that is captured comprehensively in this book. By using the techniques described in these pages to create our own prints, we will become more accomplished photographers as a result, educating ourselves to think on the most lateral plane. In a world led by a colour-obsessed media, Steve makes black and white stand out.

Hamish Brown,
London September 2002

preface

This is primarily a book about photographic technique and about the creative input that both photographer and printer apply to the image in a way that does not aim to duplicate reality, but rather to translate the visual expression that we identify as photography.

The original aim of this collection was to describe how so many of the images that we see in magazines, books and exhibitions come about, by providing a breakdown of how photographic film works and by looking at how exposure and developement affect it. Moving through the printed image section, I wanted to show how varying papers and chemicals can influence the final interpretation of the print. I felt that the key to satisfactory creative printing was about making informed decisions based on disciplined experience. Yet, whilst compiling this journal, I myself have come to realise that

photography and printing is simultaneously all and none of these things: experience and expression, and the translation of memories into a two-dimensional medium, are just as key to this process. This is not printing by numbers, it is more about communication, imagination and sensitivity with a creative means of application.

As for the technical aspects of this book, everything that I have learned, whether practical or theoretical, I have learned from others, and as I often lecture in the craft of printing, one thing always remains – I can only impart my own experiences and ways of working, and I do not want to encourage imitators. My belief is that people should make mistakes, learn from them and find their own paths. There are no shortcuts or quick fixes here but, ultimately, this book may help some develop their knowledge and apply it with confidence and imagination.

Steve Macleod

gallery

SOLAMENTE PARA
LAVARSE LA
MANO

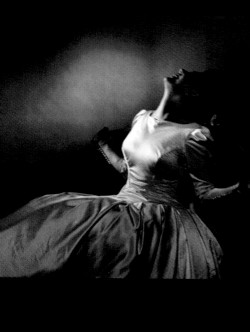

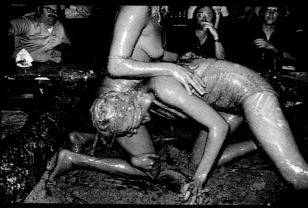

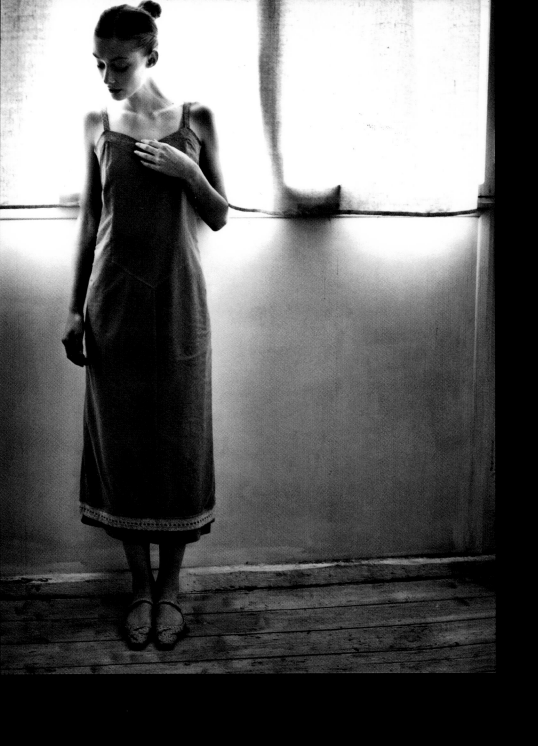

rate for toning.

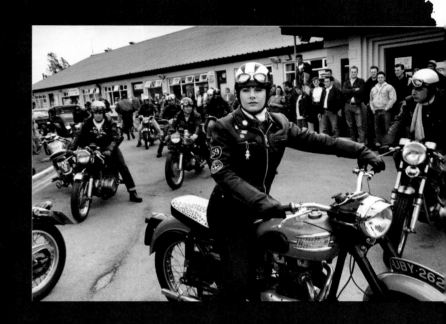

darkroom planning
and construction

Whether it is for occasional home use or the professional environment, there are a few basic requirements that are standard to every darkroom. Firstly, a custom-built space is not a prerequisite: a kitchen, bathroom, even the cupboard under the stairs, can be used, as long as it can be made light-safe. Edward Weston used only a sheet of contacting glass and a simple ceiling lamp to produce some of the most amazing prints I have ever seen.

Before you do anything, plan. This small word is fundamental and makes the printing experience much more enjoyable. Make yourself a checklist; establishing the space that is available to you is a priority. It can be difficult trying to build a darkroom that also doubles as a busy family bathroom; it may take a good hour to set everything up, only for you to be disturbed by someone else's call of nature! You may have to be flexible, printing after peak periods, which can be the middle of the night. Nothing is impossible, so take the time to think about how your darkroom life can be made easier.

It is paramount to work in a light-tight space, particularly when loading film. If this is not practical, use a changing bag. Removable window covers or blackout cloth attached by Velcro™ to the window and door frames works well. Fold-down or temporary worktops make the space more adaptable and, by following a routine, you can get into the darkroom quicker to process and print.

It is a bonus to have running water, but if none is available, then prints can be stored in a tray of water and washed at the end of the session. Keep the water as grit- and dust-free as possible by using an inexpensive tap-fitting filter unit. If you are using a dedicated darkroom space, then invest in a water temperature/filter control unit, which not only monitors the water temperature but also removes dust, grit and any undesired chemicals from the supply.

Making the adaptations that you need, make sure you keep the dry and wet areas as far apart as is practical within your space. If you do have to work on a single bench, put a partition between wet and dry areas. Opposite is an illustration of a common darkroom layout, which works by dividing the wet and dry areas down the middle. The dry side of the room is used for loading film and paper, for the enlarger and possible storage space for lenses, tools and accessories. The wet side is for trays, tanks and wet processes. Make two lists: one for the 'must have' and one for the 'don't really need' darkroom items. Anything that is not a necessity can be stored elsewhere.

Ask yourself: is the room temporary or permanent? How easy is it to transform? Is it for both processing and printing? Do you prefer to work from left to right or the other way round? The object is to try and cut down on the frustrating activities that hamper your creative enjoyment.

in focus

Make a scale model of your darkroom space and all the equipment that you definitely need in there, that way you can move the pieces around until they fit in an organised manner. A list of typical darkroom requirements are as follows:

1 a light-safe environment
2 a dust-free environment
3 a source of running water
4 power supply
5 proper ventilation
6 designated wet and dry areas

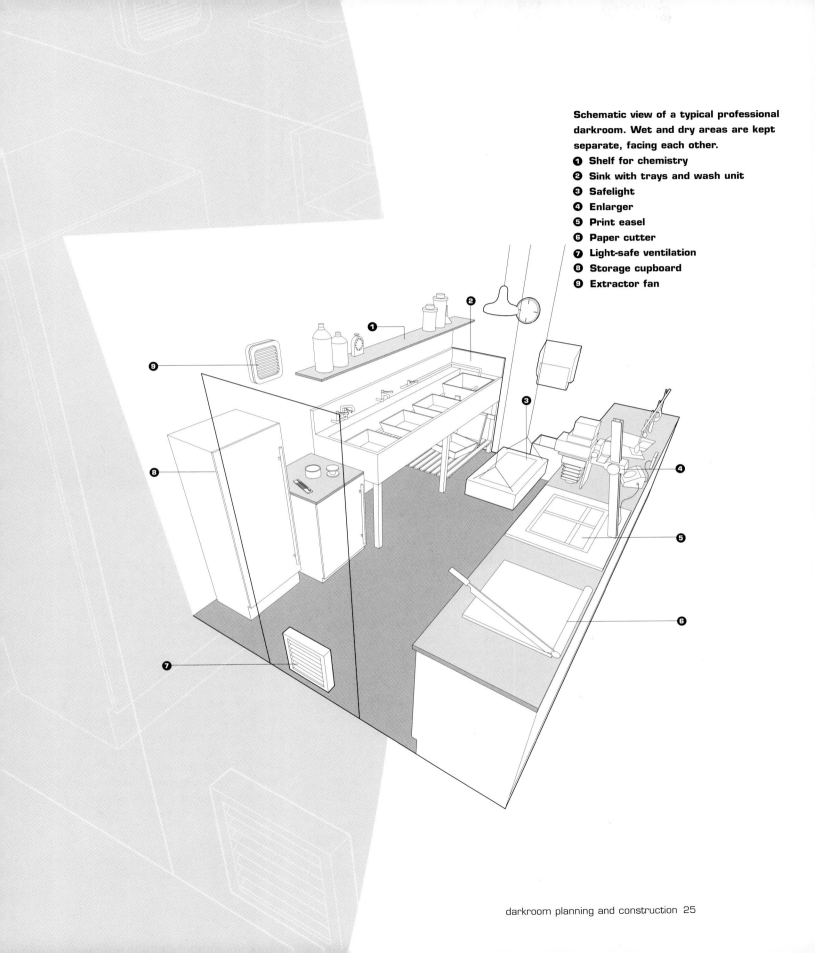

Schematic view of a typical professional
darkroom. Wet and dry areas are kept
separate, facing each other.
❶ Shelf for chemistry
❷ Sink with trays and wash unit
❸ Safelight
❹ Enlarger
❺ Print easel
❻ Paper cutter
❼ Light-safe ventilation
❽ Storage cupboard
❾ Extractor fan

size matters

The size of the negatives that you shoot determines the camera you use and, in turn, the enlarger. The size of prints that you want also determines the size of easels and trays. When you plan the darkroom, you'll be able to see where the enlarger and the wet-tray area can fit. Do not despair if you cannot fit all the trays in a line: the developer tray is the most important, the stop-bath and the fixer are secondary and can reside below the wet-bench area.

It is a luxury if you can afford custom-built sinks, wash units and drainage facilities, but for most, keeping it simple is key: keep wash water in a tray temporarily and then thoroughly wash prints at the end of your session. One of the most effective print washers I have used is the Nova print washer; it takes up minimum space, uses water economically and provides a guaranteed fresh flow of water across the print surface. Nova have also manufactured a similar version for containing developer, stop-bath, fix and wash-tanks. With no cross-contamination, it is ideal for those with limited space, though it does restrict your visual control in the developer tank.

Exhausted chemistry can be stored in jars and transported for suitable dumping later (see local directories for specialist contrators). Use a bin for unwanted and spoiled paper to cut down on clutter. The less hassle involved, the more rewarding your work will be.

ventilation

Ventilation is a must in any confined space, not least the darkroom. Toxic fumes can build up, causing drowsiness and headaches, so a passive air inlet and forced or active extraction are ideal, mounted on opposite sides of the room. If this is not possible, at least have an extraction fan with a fitted light-tight vent. This way, any harmful chemicals can be drawn from the workspace.

WARNING! Darkrooms are potential death traps, with electricity and hazardous chemicals in close proximity. Be aware of the dangers and get into a routine where you can locate everything you need in a safe manner. Manufacturers provide chemistry labels and instructions for our benefit. There are many hazards involved with processing and printing, so be aware of them and always take preventative action.

safelighting

As fixed-grade papers are sensitive to blue light, and variable-grade papers to both blue and green

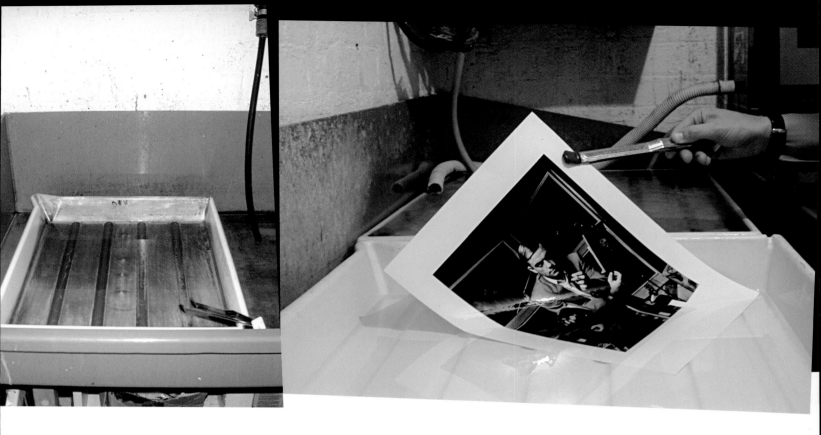

light, most darkroom safelights are either red or amber. Most papers can be used under amber light with a few exceptions, such as Sterling Premium F and some of the Kentmere range. I tend to use both types depending on the process and, though amber does provide better visibility, if you are in any doubt, use the red variety. Once again, plan your requirements and check manufacturers' recommendations.

The position of safelight should be another planning consideration. Never mount a safelight in a position that will hinder your working area; if practical, put it up to the side of your workspace, bearing in mind that by positioning your lights too close to the baseboard, you risk fogging the printing paper. A simple safelight test is to place a piece of printing paper in the easel, leave it there for five minutes and then progressively cover up the sheet with a piece of thick card at five-minute intervals, in effect creating a test sheet. Process the paper as usual, and any

safelight fog or flare will show up as grey on the paper. If any fogging does occur, then move your safelights and check for stray light from enlargers and other sources. This may take time, but it is an effective manner in which to test for fogging. Keep lamps at least three feet (92cm) from the work surface.

Another important piece of lighting is the Maglite torch. These are not only handy for locating misplaced equipment in the dark, but also for more creative printing techniques such as flashing or making false keylines. They also come with a red filter attachment and, with caution, can be used to judge print development.

People are often unhappy with the quality of the prints that they produce, and this can be down to the type of enlarger and the quality of the lens that they use.

enlarger types

People choose a particular enlarger because it helps them to achieve the images they want. Whether you prefer dial- or fixed-sheet contrast filtration, there are several types of enlarger available. Consider the format in which you shoot, as this will determine the make of enlarger you need: if you only ever intend to print 35mm, there is no point shelling out for a 10 x 8in (25.4 x 20.3cm) floor-standing Devere enlarger with matching lenses.

The enlarger you choose does not have to be state-of-the-art. What is more important, is the quality of the lenses that you print through. If you can, invest in quality lenses rather than the enlarger body. Also, consider whether you intend to print only black and white, colour, or both; enlargers have filter attachments below or above the lens, or have dial-in filtration units. Colour heads can be used for black and white but the filter accuracy may be affected.

There are three main light-source types of enlarger: the condenser (which includes point-source), the cold cathode and the diffuser. Point-source and condenser enlargers provide light through a series of lenses. The light is quite 'cold' and prints have a separated grain, called 'salt-and-pepper'. The drawback is that every dust mark becomes visible, providing excellent opportunities for print-spotting practice! Cold-cathode enlargers use light tubes to provide their illumination, and they can be slow in operation, requiring longer exposure times; they also have a very soft light quality, which can mask negative defects. Unfortunately, as variable-contrast filters are designed to work with a different incandescent light source from that available through cold-cathode heads, they cannot be depended upon for accuracy using such filters. Diffuser enlargers are fast and reliable: they use a piece of white material to diffuse the light illuminating through the negative, giving a wide tonal resolution but also a slight loss of grain sharpness. The advantage is that they also hide stray dust spots.

Personally, for day-to-day operation, I use a Devere 504 bench enlarger fitted with an Ilford 500 Multigrade diffuser head. This allows me speed and accuracy, mounted on a sturdy and reliable base. I also use a Bezelar enlarger that has interchangeable condenser and cold-cathode heads. This is excellent for sharp 'salt-and-pepper' prints.

The construction of the enlarger chassis must also be considered. The height of the column will determine the maximum size you can print, though some come with a swivel head so that you can print onto the wall for larger-sized prints. The baseboard should also be large enough to accommodate the print easel. The negative carrier is designed to keep the film as flat as possible. Carriers come in sizes to fit all formats and oversized carriers allow black keylines to be printed in.

The enlarger timer is not in itself part of the enlarger so check whether one is supplied in the purchase cost. Timers are a wise investment as they allow accuracy especially when multiple printing. A wall timer is also an invaluable tool when processing film and developing prints.

If you are in any doubt as to which type of enlarger you should choose, consider how you would like the image to appear, the type of subject matter you'll be working on and the negative stock you'll be printing. Look around and don't be afraid to ask manufacturers and distributors for examples of the grain and resolution that can be achieved using their models. People are often unhappy with the quality of the prints that they produce, and this can be down to the type of enlarger and the quality of the lens that they use. Many hire and college darkrooms have several types of enlarger under one roof, so you can try before you buy.

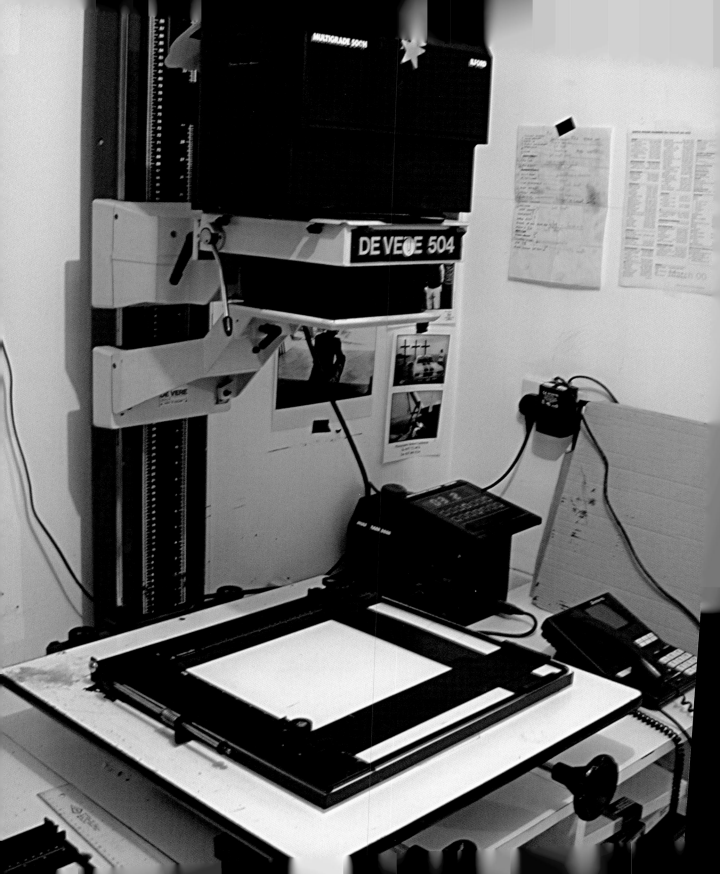

film

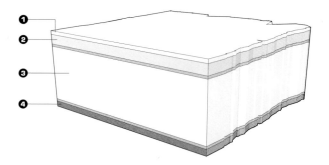

film composition

❶ Anti-scratch layer, which dissolves during development.

❷ The emulsion – the light-sensitive silver halides that normally contain compounds of bromine, chlorine or iodine, suspended in gelatin and applied in thin layers.

❸ Film base, usually in the form of clear acetate or polyester.

❹ Anti-halation layer, which absorbs excess light that passes through the film base and can reflect back into the emulsion, causing flare and a 'halo' effect around highlights. In some cases, this also dissolves on processing.

There are so many different types of black-and-white film around today that it would be impossible to try and list them all here. However, I do think it is important to show how film works in relation to light, and what control can be achieved by varying film speed.

The basic components of film have changed little since the beginning of the 20th century. On exposure to light, the grains of silver halide are 'triggered', producing a latent invisible image on the film emulsion that is variable depending on the amount of light each area has had. We control the amount of light hitting the film plane through the use of exposure and lens aperture. Once the film is processed, the latent image appears as reduced metallic silver. Areas of the film that have been exposed to less light are of lower density and yield less metallic silver, whereas greater amounts of light yield more silver and thus higher density, so we end up with a continuous tone-negative image. The silver halides are suspended in a gelatin that is applied in many 'thin-emulsion' layers, and is attached to a base material of non-flammable cellulose triacetate or polyester.

film speed

Each type of film manufactured has a particular sensitivity to light, meaning that that film requires a specific amount of light to enable it to produce a working density. This is known as the 'trigger point', and greater amounts of light yield greater densities on the negative.

By controlling the amount of light reaching the film through the use of exposure time and lens aperture, we can ensure that the film receives only useful working light in a range that is dictated by the film's manufactured sensitivity range or film speed. There have been several speed systems used for modern films, in particular the American Standards Association (ASA) and Deutsche Industrie Norm (DIN), which have been combined to form the International Standards Organisation (ISO). The speed of a film is worked out on an arithmetic scale where most fall within a range between ISO25 and ISO3200. A film that has double the ISO rating needs one stop less exposure and a film with half the ISO rating needs one stop more exposure. Film ratings are normally subdivided into one-third stop settings – 50, 64, 80, 100, 125, etc – therefore, every third index number represents one full stop.

We can normally find a film to suit our needs, whether it is for studio-lit portrait photography or low-light documentary photography. But what happens when we have only one type of film and we need a fast shutter speed or smoother skin tones? Most modern films allow for down- or uprating, known as 'pulling' or 'pushing'. These techniques are useful when it comes to adjusting speed, as it is also helpful to know that uprating and extending development will increase contrast, whereas downrating and curtailed development can decrease contrast.

We normally set the dial on the camera to the manufacturer's guidelines, but these are

I was discussing the merits of using either Ilford Delta 400 or HP5+ 400 film with Gary Knight. Gary is a documentary photographer who finds himself in a wide variety of environments and needs a film that can be adaptable but also consistent. We agreed that at ISO400, the Delta worked better than the HP5+ giving finer grain and resolution. At a higher EI of 800, there was little difference, but it was at the even higher settings of EI1600 and 3200 that the HP5+ came into its own – there was less loss of contrast than with the Delta and the shadow details held up particularly well. If Gary were to go any higher than this then I would recommend using Delta 3200 and down-rating it to 1600 and processing normally, as this would give better results than the HP5+.

'Every Silver lining has a cloud', and like so many aspects of photography, there is often a sacrifice to be made in the pursuit of some other detail. Slower-speed films have fine grain and expanded resolution but with relatively higher contrast, whereas faster-speed films have larger grain and lower contrast and compressed resolution. So be careful when selecting film: not only should it give you the speed you require, but also the grain and resolution that is needed.

recommendations based on average settings. With practice, we can ignore the manufacturer's guides by creating our own exposure index. Kodak Tri-X is normally rated ISO400 but is very useful when it comes to pushing to higher speeds, particularly EI800 or EI1600. Obviously, these techniques are experimental and I would recommend testing film and developer combinations before going 'live'. Be aware also that manufacturers periodically change the characteristics of their films with little or no warning, so I check the small print.

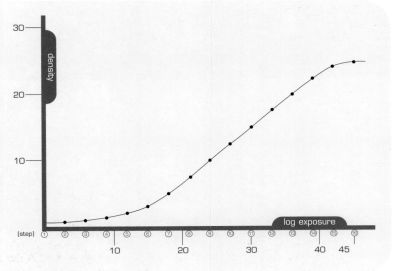

film density curve > **The characteristic curve of a photographic emulsion. Every film has a different curve, and the higher the contrast of the emulsion, the steeper the curve will be. Development affects the curve too. Increased development time moves the 'toe' of the curve (the point at which the line curves upwards) to the left, indicating that less exposure is required to reach the base fog level.**

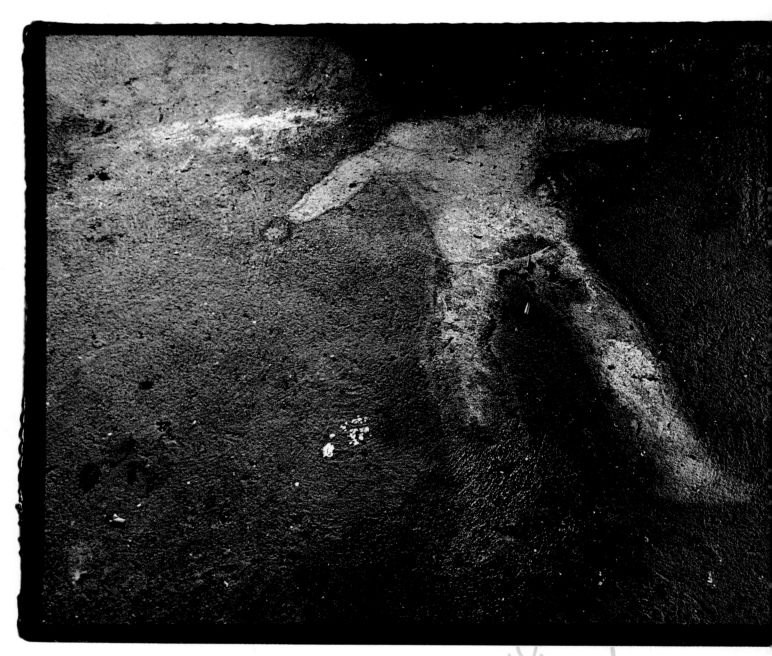

blood.

(6) burn in
for further
add 5 s

1-4 18°C

C

b

a

TO SKETCHBOOK. 8

difficult because I've got to hold the detail

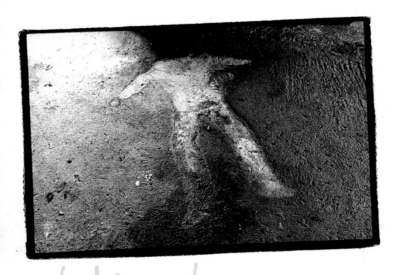

photographer > Gary Knight | **title >** Body Remains, Meja | **paper >** Forte Polywarmtone Gloss Grade 3 | **exposure >** detailed below
developer > Agfa Neutol WA 1-4 | **time >** 2 minutes

process > This print was difficult as I had to hold the detail in the body outline away from background and also try to burn in density to the top-left floor area. At f/8, I made 40 seconds exposure, holding back everything right of A for 10 seconds. For the remainder of the exposure, I followed the body shape with a dodging tool to lighten the area, and made sure the spent rounds stood out with the blood stains. At B, I burnt in the middle/top-left corner for 20 seconds, then top left C, for a further 10 seconds. I vignetted each corner for five seconds and then, with a hole in card, burnt in 10 seconds around the outline of body to emphasise the shape.

card burn

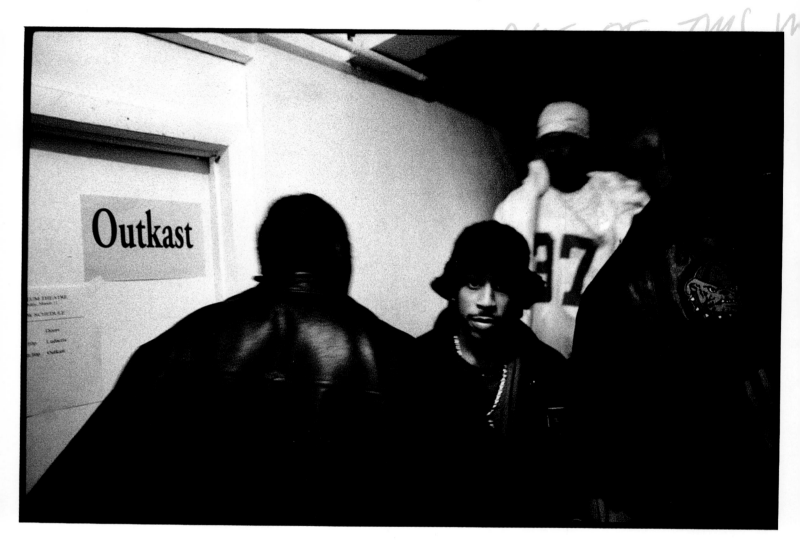

photographer > Hamish Brown | **title >** Ludacris backstage | **paper >** Ilford Multigrade Gloss 2 ½ | **exposure >** detailed below
developer > Ilford PQ 1-10 **time >** one minute

process > Hamish shot this while on tour with Ludacris and Outkast, the atmosphere was continually dark and menacing and Hamish wanted to emphasise this by using Kodak TMZ 3200 rated at 6400. Once processed, the film has increased graininess and contributes a dark edge to the story. At f/16, I made 30 seconds exposure, dodging the right-hand side and shadows for 10n seconds. I added 10 seconds to the upper-left side and exaggerated the face looming from the darkness.

Remember that the manufacturer determines grain size, whereas choice of developer reduces or increases graininess.

film grain

When looking at negative film, we can detect small grains of reduced metallic silver – the faster the speed, or ISO, of the film, the larger the grain crystals. The size of the grain is determined at manufacture and cannot be altered, but how that grain develops is determined by the choice of developer, which can clump together individual grain crystals, creating a coarser-looking negative. Another factor in negative grain and sharpness is the use of the 'resolution' and 'acutance'. Resolution or 'resolving power' is the ability of the film to render fine graduated detail, which is normally better in slower-speed films. Acutance is the separation or edge sharpness between two defined objects, and describes the sharpness of the line between them. Overexposure or extended development can cause a reduction in acutance.

film types

The various film types produce different results...

ilford pan F A very fine-grain, medium-contrast panchromatic film with low ISO50 rating.

ilford FP4 A fine-grain medium-contrast film with high exposure latitude and refined acutance.

ilford delta 100 A medium-speed film with exceptional fine grain emulsion.

kodak plus x 125 A fine-grain, medium-speed film equivalent to Ilford FP4 but with more contrast.

ilford SFX 200 Specialist black-and-white film, with extended red sensitivity, that can achieve an infrared look when used with deep-red filters.

ilford delta 400 Fast fine-grain film that can be pushed up to EI1600 with good exposure latitude.

ilford HP5+ A high-speed, fine-grain panchromatic film with a medium contrast emulsion that push processes exceptionally well.

kodak tri x A fine-grain industry standard, comparable with HP5+; can be push processed.

agfa pan 400 A high-speed, low-contrast film with medium grain.

fuji neopan 400 This new generation film has a modified grain structure, which appears fine-grained.

kodak t-max 400 This is a high-speed film with very fine grain that makes it useful for pushing, but images can appear to look thin on the negative.

ilford delta 3200 A genuine high-speed film that works well at its normal rating or EI6400; also works effectively at EI1600 processed normal.

kodak t-max 3200 High-speed/low-light film, excellent at EI6400

fuji neopan 1600 Characteristics similar to the Neopan 400; can be used at high speeds of up to EI3200.

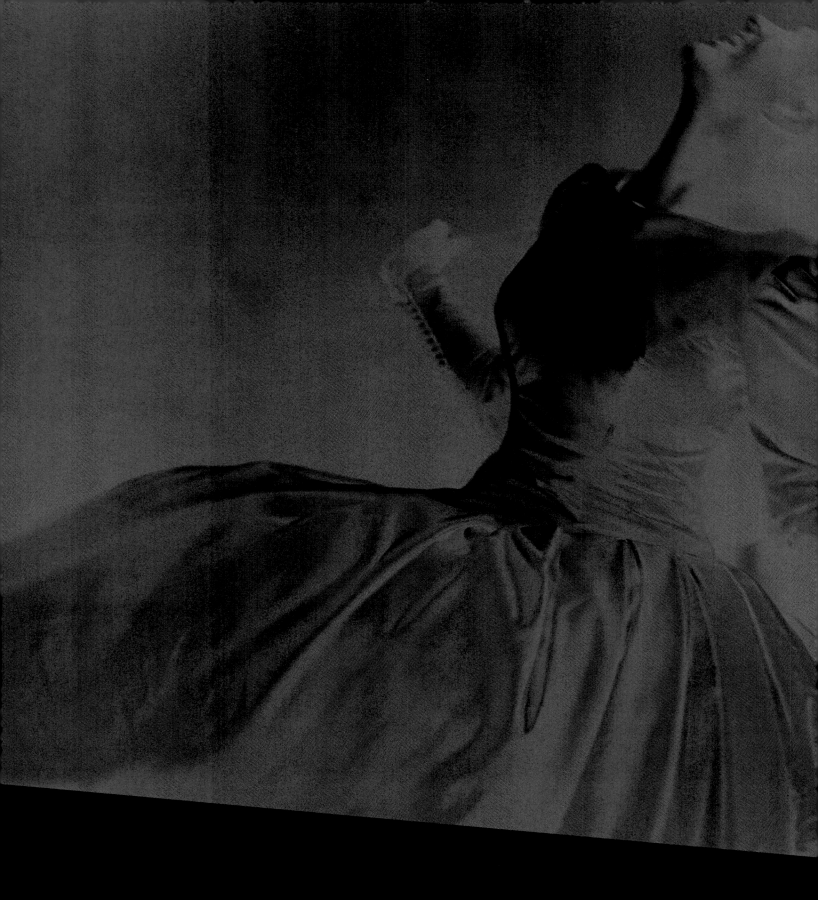

chapter 3

exposure and development

How do we achieve the perfect negative? Well, how long is a piece of string? After choosing the suitable film, we have to decide how to control the amount of light falling on the film to create a useful, working negative.

The likelihood of error before creating perfection is high, but I am a great believer in perseverance and the continual learning curve.

The objective of this passage is to give us an understanding of visualisation and effective average film exposure of a given subject. So, before we get into exposure calculation, let us take a few moments to discuss visualisation.

Taking photographs does not improve our ability to see things or give us an added advantage over our peers. What it does is train us to think differently about what and how we see. We are ultimately transferring a three-dimensional subject onto a two-dimensional plane and creating an illusion of time and space. What is common to all of us, is that we all set in motion various photographic decisions as to how our subject will be captured; this

includes film type, exposure, processing and, eventually printing. Yet no two photographers view the world in the same way, and the completed imagery will be down to each individual's interpretation and emotional response. Our eyes scan a scene, jumping in and out of focus and returning to certain areas of attraction. When we fail to observe important light subtleties that the eye and brain do not register, then problems are created when translating exposure details to the camera. Therefore we have to depend on certain tools to aid us in correct exposure metering.

photographer > Jamie Beeden | **title >** Ian Brown | **paper >** Agfa Multicontrast Gloss Grade 3 | **exposure >** detailed below
developer > Agfa Neutol WA 1-10 | **time >** two minutes

process > Jamie had only a few minutes to set up and take this shot. It has become something of a classic and is now part of the National Portrait Gallery permanent collection. At f/8, I exposed for 30 seconds, dodging the eyes for five seconds and the right side of the hood for five seconds. I burnt in the left side to black for fiv seconds.

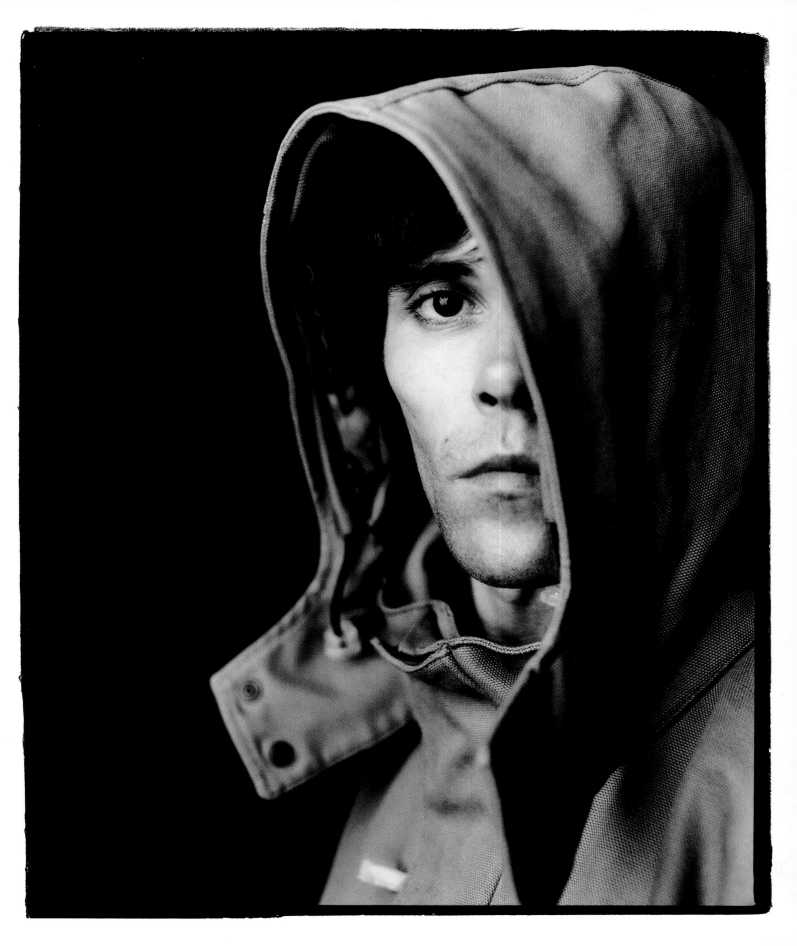

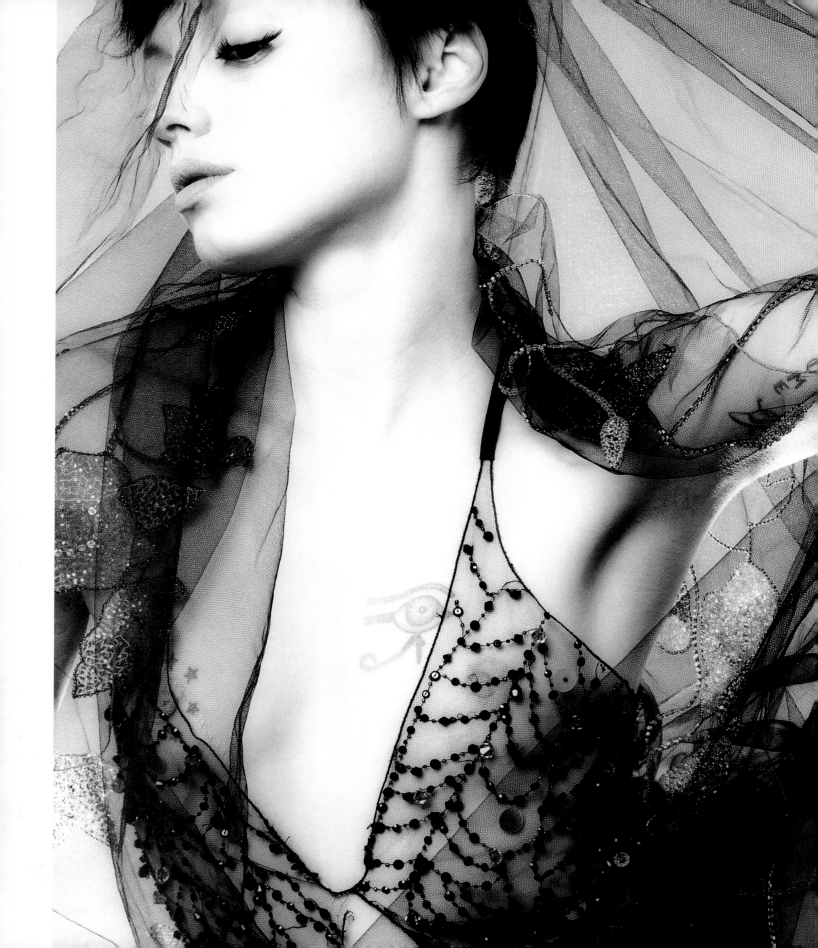

photographer > Jamie Kingham | **title >** Untitled | **paper >** Ilford Multigrade Gloss Grade 3 | **exposure >** detailed below
developer > Ilford PQ 1-9 | **time >** two minutes

process > This was quite a complex print in that 40 per cent of the exposure was diffused (see page 102) and therefore an increase of contrast of one grade was made to compensate for the flattening effect of the diffusion. I worked out a contrast without diffusion of grade 2, so I increased to grade 3 for the working of the print. At f/11, I gave 25 seconds exposure, but dodged back shadow details in the silk and chiffon. Also, with my left hand, I use an anti-newton glass suspended below the lens for 10 seconds to diffuse light onto the print. I added 10 seconds at A, five seconds at B, 10 seconds at C and five seconds at D, being careful not to lose the shadow details.

Whenever you view a subject, always look for the darkest and lightest areas; if possible take meter readings from both, compare and set the meter to translate the average exposure setting midway.

exposure and metering

Photographic exposure is the darkening effect of light on a film's silver halides, and is controlled by the amount of light and the time for which it is allowed to fall on the film, often defined as a simple formula: Exposure = Intensity x Time. Therefore, exposure will remain the same if we increase the intensity of light reaching the film while reducing our exposure time, and vice versa, if we close down the lens aperture and increase the shutter speed, our exposure will remain the same. Exceptions to this occur during exposures affected by the 'failure of reciprocity law' (see oposite).

You may have heard of the terms 'incident' and 'reflected light' in photography, but what do they mean? Simplified, the objects that we view are illuminated by light falling on them, and an incident light meter measures the average light on the subject directed towards the camera. What I find more useful is the use of a reflected-light meter, which, aimed from the lens axis, helps us evaluate more accurately what the range of light and dark areas of our image are, as this is a truer representation of what we actually see. As most reflected light meters read only about a 30 degrees area of the subject, they would always make an assumption about a scene and, therefore, give an average meter reading. The meter has no way of knowing how predominantly dark or light a subject is, and this averaging often leads to incorrectly exposed film. This is where we must train our eyes. Whenever you view a subject, always look for the darkest and lightest areas; if possible take meter readings from both, compare and set the meter to translate the average exposure setting midway. By making educated decisions about our high and low value exposures and camera settings, we are bound to accumulate a higher proportion of successes. It is important to remember that our equipment tries to render a literal understanding of the subject, and we have to choose to apply this or to deviate to a more expressive and emotional interpretation.

Add 10 seconds on right m...
on wooden floor.

overexposure and underexposure

If asked, most photographers would admit to bracketing their shots. Whatever their reasons, most photographers will agree, that if in doubt, it is better to overexpose rather than underexpose. If underexposure occurs, then there will be a loss of shadow detail, and if it isn't recorded on film it is never going to translate onto the printing paper. Overexposure has its problems too: loss of resolution and, if extreme, increased graininess that can be detrimental to the final image. However, if you are in any doubt, err on the side of marginal overexposure.

reciprocity law

The exposure formula $E = I \times T$ does not work during very long or short exposures, and the reciprocity law acts as a corrective measure. The effects are due to varying intensities of light and not from exposure time, as films are designed to respond to light intensity, and if the exposure light is more or less than the recommended range, then the light is less effective, therefore requiring more or less exposure time.

exposure time	RF exposure adjustment
1/1000 seconds	none
1/100 seconds	none
1/10 seconds	none
1 seconds	1/2 stop more exposure
10 seconds	1 stop more exposure
100 seconds	1.5 stop more exposure

in focus

Try viewing a particular scene, firstly as you would normally with an overall view, then look at individual parts of the scene through a rolled up piece of card. What happens is that we can become more selective and in tune with particular areas of the subject. This is how a reflected spot meter operates – it can measure specific points of light and dark areas without scanning an overall view, resulting in more accurate readings.

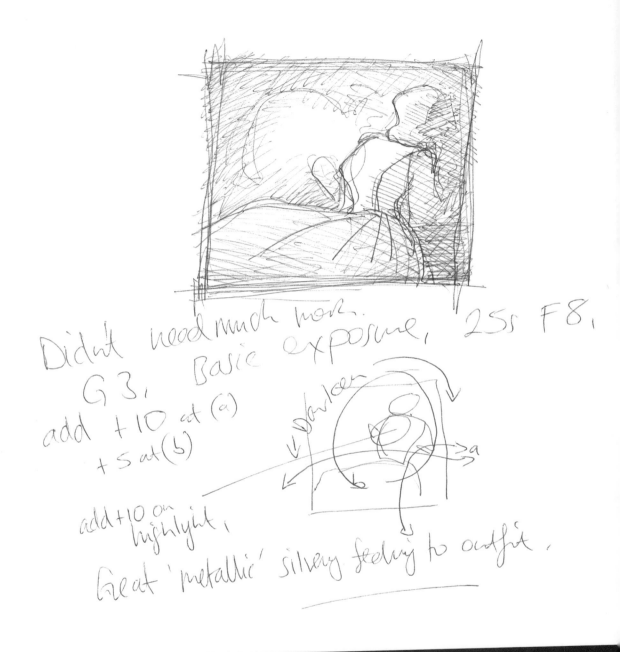

Didn't need much more.
G3, Basic exposure, 25s F8,
add +10 at (a)
 + 5 at (b)

add +10 on
highlight,
Great 'metallic' silvery feeling to outfit.

photographer > Unknown | **title >** Untitled | **paper >** Ilford Multigrade Gloss Grade 3 | **exposure >** detailed below
developer > Ilford PQ 1-5 | **time >** three minutes

process > I wanted to create a dark, classic look here and to concentrate on the 'metallic' feeling of the gown. Luckily, this didn't need much work. At grade 3, the basic exposure was 25 seconds at f/8, adding 10 seconds at A and five seconds at B, and, finally, an additional 10 seconds on the highlight area of the chest.

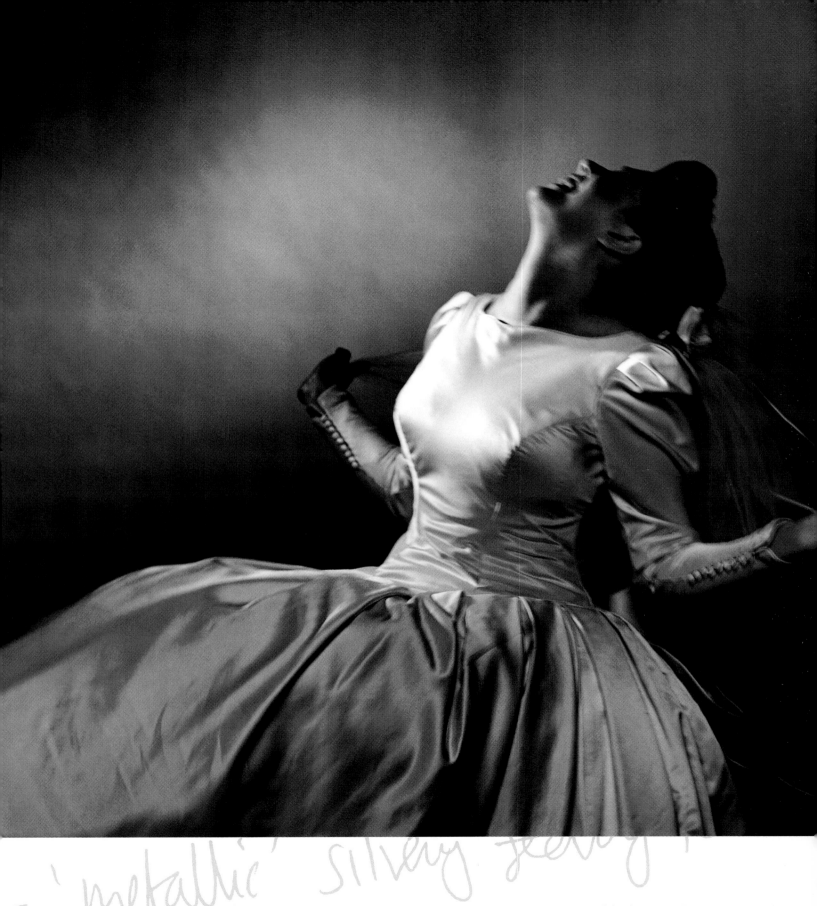

'metallic' silvery feeling

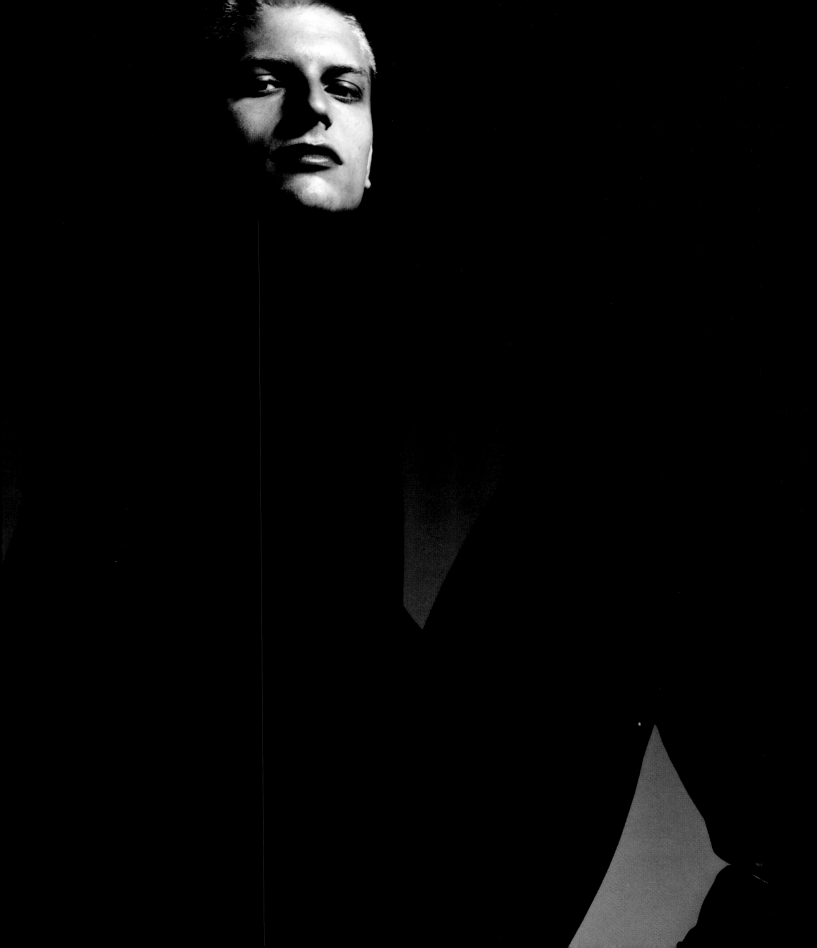

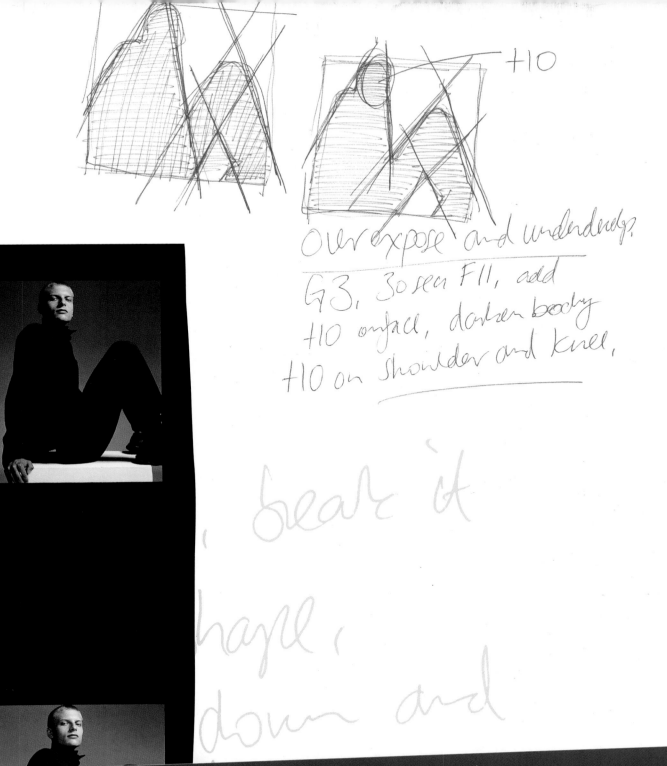

+10

Over expose and underdevelop?
G3, 30 sec F11, add
+10 on face, darken body
+10 on shoulder and knee,

break it

shape,

down and

photographer > Paul Smith | **title >** Untitled | **paper >** Ilford Multigrade Warmtone Matt Grade 3 | **expsosure >** detailed below
developer > Ilford PQ 1-5 | **time >** three minutes

process > This was a tight crop from the original as I tried to break it down to shape rather than form. This was not a typical fashion shot in that I burnt in any highlight details to simplify the image and to concentrate on the pose of the model. At f/11, I made 30 seconds exposure with an additional 10 seconds on the face, then at 10-second intervals on the shoulder, knees and ankle to minimise clothing detail.

from original

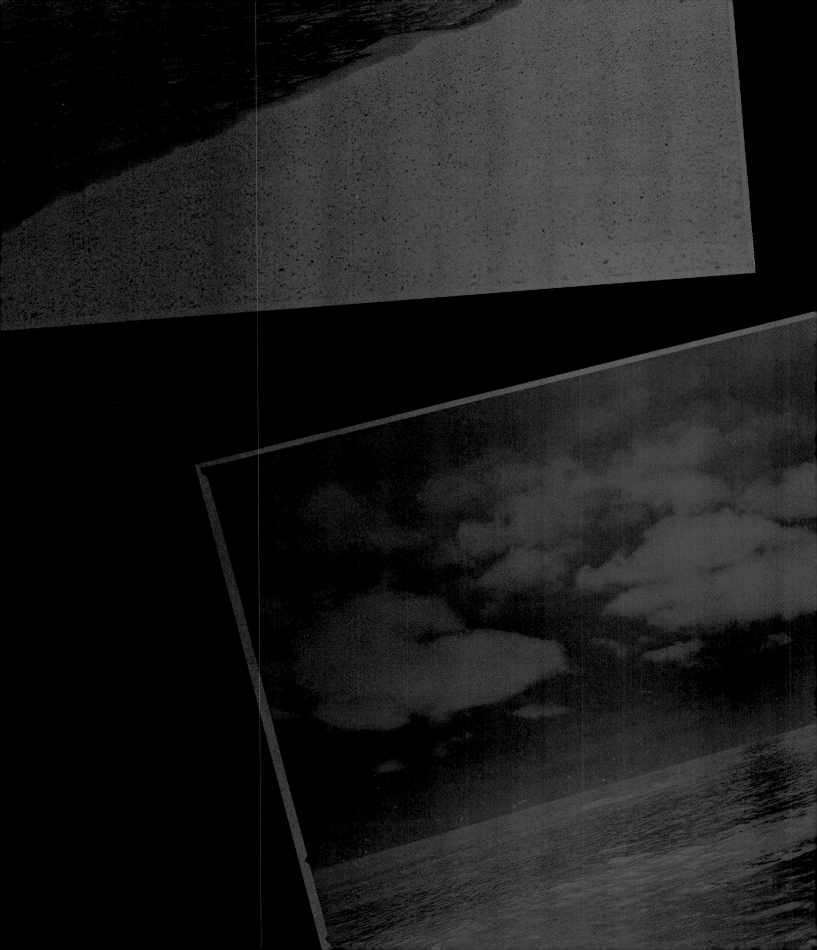

film**processing**

After exposure to light, an electrical charge alters the silver halide, making it sensitive to developer. This, in turn, reduces the grains to metallic silver and creates one negative. Therefore, the more exposure an area has had, the more it is affected by the developer..

Developer components

There are four basic components to any developer:

1 A developing agent, which reduces the silver halide to metallic silver. Common agents are Metol, Phenidone and Hydroquinone.

2 A preservative, which slows the rate of developer oxidisation, most commonly sodium sulfite.

3 An accelerator, in the form of an alkali that energises the developer and can control negative contrast (mild pH value around nine, normally borax or sodium metaborate; medium pH around 11, normally sodium carbonate or potassium carbonate; caustic pH around 12, normally potassium hydroxide or sodium hydroxide).

4 A restrainer, which slows the rate of development, primarily potassium bromide. Potassium bromide can also be added to lith paper developer to 'age' the developer for more control.

Development time

Development time is an important control procedure, and the same basic principles apply for the processing of negatives as of prints. At this stage, we'll discuss how development control can affect our image, and deal with processing methods in depth later. Exposure will control the low-value or shadow detail on our negative, while development will control our high value or highlight densities.

Film contrast can be increased by uprating or pushing the film and using longer development times, producing higher maximum density and slightly higher minimum density (due to base fog). Downrating or pulling the film and using shorter development times produces lower densities everywhere. Alternatively, by using an ultra-fine-grain developer such as HC110, film speed can be reduced without affecting the film's contrast – these methods are commonly known as expansion and contraction techniques.

By expanding or increasing development times, the toe of the film moves to the left, indicating that less exposure would be required to reach the base-fog region. With contracted or reduced development, the toe moves to the right, thus indicating an increase of exposure (see page 40). In practice, if a scene were underexposed then the shadow tones would be compressed together and barely apparent, creating a thin negative. Through development expansion, we can increase the densities of the higher and mid-exposure values, thus increasing local contrast and creating an improved working negative. The same theory can be applied for negatives that are overexposed; by contracting the development time we can compress and therefore decrease the density values of the negative.

I cannot stress the importance of regular testing. Most manufacturers will supply characteristic data regarding film curves and developer behaviour and, with practice, through exposure and processing control, we can learn to translate the visualisation of our image onto the negative film. In an ideal world, it would be effortless to visualise, expose and develop both shadow and highlight detail onto our negatives, yet wouldn't that become boring? As long as we can control our tools, the journey from eye to print should become easier.

Exposure will control the low-value or shadow detail on our negative, while development will control high-value or highlight densities.

film developers

Developers will not affect the size of a film's particular grain, but will affect the grain's appearance. Manufacturers recommend certain developers to match certain films – here are the different brands and some off-the-shelf chemistry:

standard developers These are general-use standard developers that provide good tonal renditions and high acutance. They include HC-110, D-76 and ID-11.

fine-grain developers True fine-grain developers will not alter the grain size but the presence of the preservative sodium sulfite can act as a solvent when it comes into contact with silver halide. This, in turn, will reduce the acutance of the grains, making them appear to decrease in size. This tends to soften the individual clumps of developed grain. Recommended fine-grain developers are Rodinal (depending on dilution), Kodak D-23 and D-25 formulas.

high-energy developers Some developers are manufactured with strong solutions and are reduce silver halides down to metallic silver, particularly useful when a negative has been underexposed. The most common is Kodak D-82.

ilford ID11 A standard developer, which gives normal speed and contrast with fine-grain results. It can be used to push process HP5+ up to ISO1600. Mainly used as stock solution, it can also be diluted 1:1 or 1:3 for single shot use, to give harder and sharper grain.

lford microphen This is a speed-increasing developer, which, with normal use, allows a $1/2$ stop or 50 per cent increase in film rating. This can increase shadow detail while maintaining the film's fine-grain characteristics – ideal for films such as HP5+ up to ISO3200.

ilford perceptol This is an extra-fine-grain developer, which, when diluted, gives excellent tonal rendition. But as there is a slight loss of emulsion speed, film should be overexposed by up to oone stop.

kodak D-76 A standard developer that is great for low-contrast negatives with fine shadow rendition.

kodak t-max Mainly used with T-max generation film, this developer is also useful as a speed-pushing developer for other films such as Tri-X. Working temperature is slightly higher than other developers at 24°C.

kodak HC110 This is the new model of an older generation of fine-grain developer; it provides low fog characteristics and fine grain without losing film speed. It can be used when utilising compensating effects (diluted developer and extended development times to provide shadow separation without increased highlight density).

agfa rodinal The oldest proprietary developer, it was first manufactured in the 1880s. It is a high acutance developer that provides 'edge' effects, increasing grain sharpness while maintaining film-contrast latitude. One-shot process is normally diluted 1:25 or 1:50.

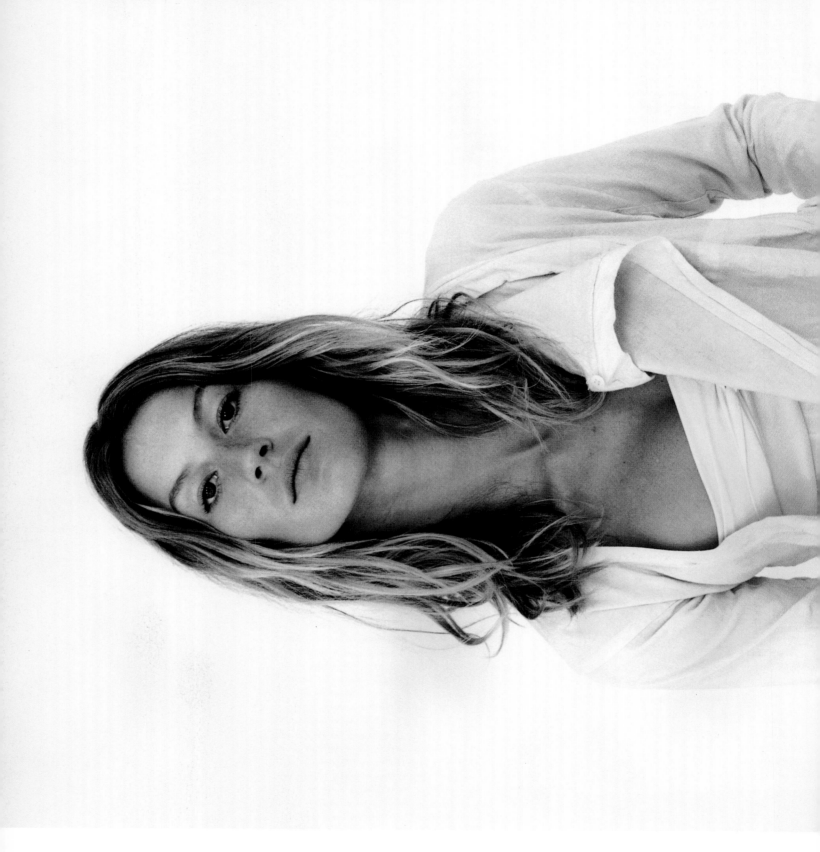

Corinne

photographer > Corinne Day | **title >** Gisele | **paper >** Forte Polywarmtone Semi-matt Grade 2 | **exposure >** detailed below | **developer >** Ilford PQ 1-10
time > two minutes

process > White fashion against a white background is always going to be a challenge. Corinne's images always have that magic ingredient. At first, this looked like a simple image and the important element was not to let the clothes look muddy and flat – yet I also wanted them to slightly recede into the background. Looking closer, the body shape flows from top to bottom and I wanted to print these details, and decided to let the skin tones print in themselves. At f/16, I exposed for 40 seconds holding back the background slightly to keep it clean and, with a dodging tool, I held back the left side torso for 10 seconds to balance the body tones. I also held back the left shoulder for five seconds.

shooti with such

ite

processing procedures

Development time is an important control procedure, and the same basic principles apply for the processing negatives as of prints. Exposure controls the shadow or low-value details on the negative, and development controls the highlight or high-value areas.

Before processing, the film has to be loaded into processing tanks or trays. The most common form of hand processing modern roll films is by means of tanks, constructed of plastic or stainless steel. I personally prefer the daylight variety that allows for processing in normal light once the tank has been loaded and sealed. The film is wound onto a reel or spiral and then stacked in the tank along with other films, this being an economic and methodical means of processing.

To begin with, the task of processing film can seem daunting, and the easiest way to learn is to practise with a pre-exposed roll of film, winding it onto the spiral with your eyes shut over and over until you become competent enough to do it for real. I used to spend many boring underground journeys practising until I felt confidet.

An important point to remember is to give yourself enough time for things to go wrong in the dark. Do not panic if the film will not load – I keep a light-safe box next to me while loading, so that if I have forgotten something or problems arise, I can pop the film in the box, switch on the light and deal with whatever is required.

Darkroom discipline is needed when processing film. Lay everything out in the sequence that you will need it, take your time and practise a dry run. In the dark, remove the film from the spool or cassette, discarding the empty cartridge. With a metal film reel,

hold and slightly curve the film between your forefinger and thumb and insert the end of the film into the clip, pulling the film gently round, rotating the spiral so that the film loads onto the reel in a straight and even manner. The film should feel loose on the spiral if it is loaded correctly. If it does not feel right, don't panic. Simply unwind it and start again. If you are using the Paterson type of reel, locate the film into the ball bearing registration lugs and slowly move the film onto the reel with a slow, twisting motion. The film is now ready for processing.

processing problems

It is vital that the film is not damaged when it is loaded, as this will affect the film during processing. Any defects such as kinks and pinches will show as horseshoe-type marks on the negative. Film surfaces that have touched during processing become unevenly developed and produce blank or white marks, where the chemistry has been unable to work on the negative emulsion.

One of the most common problems that occurs when processing 35mm film is 'bromide drag', which appears as streaks that run

The film is wound onto a reel or spiral and then stacked in the tank along with other films, this being an economic and methodical means of processing.

During development, periodic agitation of films is required to ensure even and balanced processing.

development

During development, periodic agitation of films is required to ensure even and balanced processing. This presents problems of its own and, once again, discipline is the essential requirement.

I suggest pre-soaking film for a few minutes in a water tank that is two degrees warmer than your developer solution. This will reduce streaking and other associated problems by swelling the gelatin layer of emulsion so that it accepts the developer action.

Find a method of agitation that works satisfactorily to produce even development. A common method is to simultaneously invert and twist the tank in one smooth action, taking around five seconds to complete the motion. Most manufacturers recommend agitation times of 10 seconds every 30 seconds, but again, find the method that works for you.

Once you reach the end of the development stage, have your pre-prepared stop bath and fixer chemicals ready. The procedure for processing film and paper is the same, only the dilutions and times change according to the manufacturer's guidelines.

vertically opposite the film sprocket holes. This can be due to several factors including under- or over-agitation while developing, but more likely, it will occur because of the dissipation of soluble potassium bromide into the developer solution during processing, adding to the developer's existing bromide restrainer and thus retarding even development. Pre-soaking film helps reduce this problem, as does mixing chemistry evenly prior to processing, and the use of proper developer replenisher.

Another problem is uneven development and drying marks that appear on the print as light or dark patches that run horizontally across the image area. These are due to inadequate pre-soak and/or uneven agitation or drying that is not performed properly.

Unfortunately, there is little we can do to rectify processing problems. We can disguise or retouch mistakes at the printing stage, though I feel it is best to perfect processing methods from the outset.

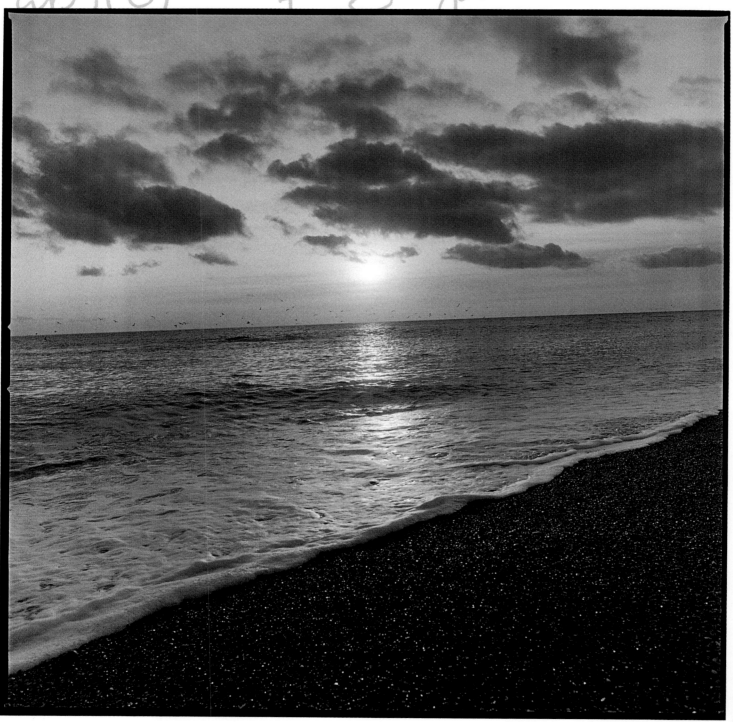

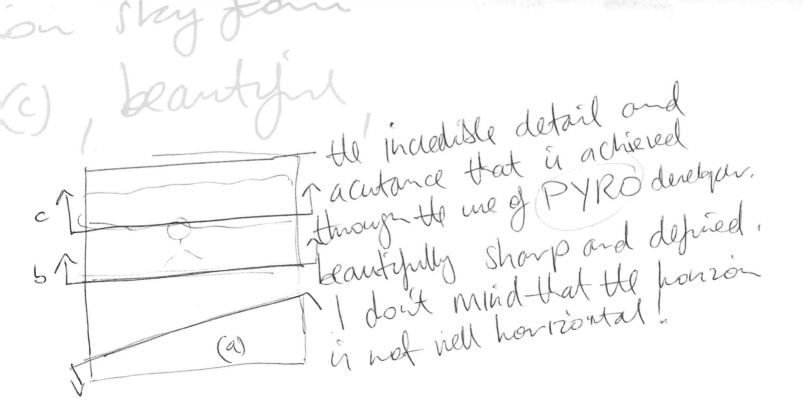

on sky from

(c) , beautiful

the incredible detail and acutance that is achieved through the use of PYRO developer. beautifully sharp and defined. I don't mind that the horizon is not well horizontal!

c

b

(a)

photographer > Fredrik Clement | **title >** Shoreline | **paper >** Ilford Multigrade Warmtone Gloss Grade 3 | **exposure >** detailed below
developer > Agfa Neutol WA 1-10 | **time >** two minutes

process > I've put this in to show the incredible detail and acutance that is achieved through the use of PYRO film developer. It improves grain acutance and the definition between dark and light becomes sharper in appearance. I don't mind that the horizon is not completely straight, it adds to the dream-like quality of the image. At f/11, I exposed for 25 seconds, holding back the clouds slightly. Then I added five seconds on the shingle at A, five seconds to the sky from the horizon up and finally five seconds at C from the clouds on up.

stop bath

Placing the film or print in the stop bath tray halts development. The stop bath is an acid that neutralises the alkali developer, and it also extends the life of the fixer by preventing the developer from neutralising the acidic fixer. There are several schools of thought as to whether stop bath should or should not be used.

Some feel that when the alkali of the developer comes into contact with the acid stop bath, carbon dioxide gas is released which can cause pinhole blisters on paper and, more critically, film emulsion. One way to stop this happening is to use a more dilute and mild stop bath for longer than recommended. Running water can be used instead, but stop bath helps prevent stains and contamination being carried over to the fixing bath, as fixer quickly loses acidity and becomes exhausted. Be very careful when mixing stop bath: always add the chemical to the water, as it is very concentrated and can contaminate easily through splashing.

I would recommend that you follow the manufacturer's guidelines as too strong a fixer solution will actually cause sulphiding of the silver and bleach subtle print highlights.

fixer

The purpose of fixer is to remove undeveloped silver bromide from the film or paper. Any unused silver bromide turns black and contaminates the film or paper emulsion. I recommend that you follow the manufacturer's guidelines as too strong a fixer will actually cause sulphiding of the silver and bleach subtle print highlights.

Up until recently, the most common fixing agent was sodium thiosulfate, or 'hypo'. This has been replaced by ammonium thiosulfate, more commonly referred to as 'rapid fixer', as it is about 30 per cent faster acting than pure hypo. The fixing process is often overlooked but is crucial in the processing procedure. As fixing progresses, fresh fixer reacts with the film or paper emulsion to form sodium argentothio-sulfate compounds, which are then removed by careful washing.

Either transfer the film in the dark to the stop bath tank or discard the developer and introduce the stop bath; whichever method is used, agitate the film evenly in the stop bath for 30 seconds before draining and transferring to the fixer. Agitate in the fixer for 30 seconds and leave the film in the dark for at least a further three minutes, inverting twice every 30 seconds. Once the film has been fixed, transfer to the wash tank. The most efficient wash procedure includes a slow-running water flow around the film at processing chemistry temperature for around 20 minutes. Once the film has been washed, remove to a tank containing wetting agent – the film is then ready to be hung up and dried. Wetting agent minimises the need for wiping and allows water to disperse evenly.

The ideal place to dry film is in a temperature-controlled, dust-free cabinet, and whatever method you use, remember to peg both top and bottom corners away from the image area and to prevent dust from circulating during the drying process. Once dry, the film can be cut and sleeved into archival paper bags ready for contacting.

chapter 5

from film to contact sheet

Film processing for most can be a monotonous and a labour-intensive part of darkroom practice, but it is well worth the effort when it comes to producing prints.

Before any printing commences, it is advisable to make a contact sheet of the processed film. This allows you to get a general view of the negatives, checking for sharpness, density and composition, and helps you choose images that will proceed to the enlarger. The straightforward way to make a contact sheet is to lay a sheet of paper onto the baseboard and expose under the enlarger, having first ensured that the coverage of the light is sufficiently great to cover the paper. It is recommended that the enlarger height and contrast filtration be standardised for every contact, enabling you to judge whether negatives are thin or dense compared to other material. I normally fix the head at a predetermined height and expose at grade 2, with varying exposure times.

A scratch-free piece of glass taped to the baseboard is an inexpensive alternative to a manufactured contact-print frame, and whichever method you apply, the principle is the same. Under safelight conditions, negatives are sandwiched (emulsion side down) between the glass and the photographic paper (emulsion side up) and exposed to enlarger light. A timed test strip provides different densities from to choose the right one to expose the whole sheet. Once the exposures are complete, the paper is removed and processed in the prepared chemistry, the safelight can be switched on after the paper has been in the fixer tray for 30 seconds. Inevitably, negatives on the same sheet may have varying densities, but with practice, we are able to block or 'flag' some negatives off with card and to extend exposure times to more dense frames. This provides us with a balanced contact sheet from which images can be selected for printing. A contact sheet is to visualise composition as much as to determine exposure and sharpness.

After processing, label and store completed contact sheets and negatives together so that they can be easily retrieved for print selection at a later date. It can be frustrating hunting through sheets of negatives to find that one special image that you meant to print months ago, not being able to remember when you took it or where you put it.

B 255726

There are no hard and fast rules, but colder more neutral blacks tend to put a distance between the viewer and the subject, whereas warmer tones engage the viewer and are easier on the eye.

photographic papers

The modern photographic paper industry is forever widening, with new products continually being made available. Here are some of the main manufacturers but this is by no means a definitive list...

agfa One of the market leaders. Its most common paper is the Classic range, which can also be used in lith development. Classic MCC FB and RC are available in gloss and fine-grain matt versions.

forte This Hungarian manufacturer produce great exhibition and art papers. Many of the papers can be used as lith development papers. Unfortunately, short batch production can sometimes hinder consistency of quality. Polywarmtone FB and RC, and VC are multi-contrast papers, available in gloss and semi-matt, that provide rich, warm tones and are affected by different developer and temperature combinations. Polygrade FB and VC are multi-contrast papers, neutral in tone and available in gloss and semi-matt. Bromofort FB, though graded, is a very rich paper, available in glossy and matt. Fortezo 'Museum' is available in graded forms and comes in a triple or 'museum' weight and has a glossy finish.

fotospeed This is a UK company that imports products from Australia, with a reputation for fine exhibition papers. Tapestry is a graded, canvas-textured paper that is warm in tone and very flexible in different developers. Fotolinen is similar to the Maco Structura Lux – it is coated in graded photo-emulsion.

ilford The industry standard; Ilford have a range of RC and FB papers to suit all. Multigrade IV FB and RC are multi-contrast papers with neutral tones available in gloss or matt. The RC version is also available in pearl finish. MGFB/RC Warmtone is a multi-contrast, double-weight, warm-tone paper that is flexible in different developers, available in gloss and matt versions for FB, and gloss and pearl for RC. MGRC Cooltone is a multi-contrast, medium-weight, RC paper that gives cool tones. Ilfobrom Galerie FB is a graded, neutral-toned paper, available in gloss or matt.

kentmere This small UK company has a range of quality art papers, many of which work well in lith development and toning processes. Art Classics is a graded, warm, chloro-bromide paper with a textured ivory paper base. Art Document is a graded, warm, non-supercoated paper, suitable for drawing and painting on, post development. Kentona is a grade 2, warm, double-weighted paper, available in gloss and stipple finishes, which reacts well with different developers. Fineprint VC is a multi-contrast, double-weighted paper, available in gloss and stipple.

kodak Kodak has a range of specialist papers, which has recently seen the demise of the much loved Ektalure. Polymax Fine-Art FB is a multi-contrast, double weight, cold-tone paper with an extremely white paper base. Polymax Fine-Art FB 'C' is a multi-contrast, double-weight paper with a warm cream paper base.

maco Maco is a German-based company manufacturing purely black-and-white materials with a few weird and wonderful products in its range. Expo AG is a RC paper that has a glossy-metallic silver paper base. Expo WA FB is a graded, double-weight paper with a matt, cream base. Expo RF/RN FB is a chloro-bromide, graded paper, slightly warm, available in glossm (RF) and semi-matt (RN) finishes. Structra Lux, like the Fotospeed Fotolinen, is a cold-tone emulsion on a linen support base and also comes in a heavier canvas base.

in focus

As paper is constructed in the same way as film – with silver halide grains suspended in gelatin – the larger the grain, the blacker the image. As paper development progresses, similarly to film, the grains start out as small yellow specks, turning brown through to larger black grains on full development. This is useful to know, as overexposing and under-developing the print can introduce warmth to the image. In effect, the paper grains have not reached full development but the image has been fully exposed.

Moreover, as developer nears its exhaustion point, it cannot reduce the silver halide in the paper and the print can appear browner as it is under-developed. By adding fresh developer in a ratio of 1:1, control can be achieved where the aged developer acts as a restrainer and the fresh developer ensures that even development takes place.

paper types

The emulsion is the light-sensitive part of the paper, of which there are commonly three types: bromide, chloride and chlorobromide. The type used will determine the paper's tone and basic characteristics. The main difference between the different paper types is the proportion of silver chloride and silver bromide in the emulsion. Most combine both elements and those with a higher percentage of chloride are slower in speed, with warmer tones and red- to brown-blacks. They are also more flexible when toners are used to alter the feel of the print. Those papers which contain a higher percentage of bromide are faster, more light-sensitive and provide cooler tones and more neutral- to blue-blacks.

Great skill is required when deciding whether to print a negative warm or cold, and learning to control those attributes can be done through paper choice, exposure and development techniques. There are no hard and fast rules, but colder, more neutral blacks tend to put a distance between the viewer and the subject, whereas warmer tones engage the viewer and are easier on the eye. I think it is important to compare the often subtle values that different paper samples can provide. As with all elements of the printing process, chosing an appropriate paper to print the desired effect is a skill that develops through trial and error. Careful documentation of trials is essential to ensure that once you achieve the desired effect, you can repeat the process.

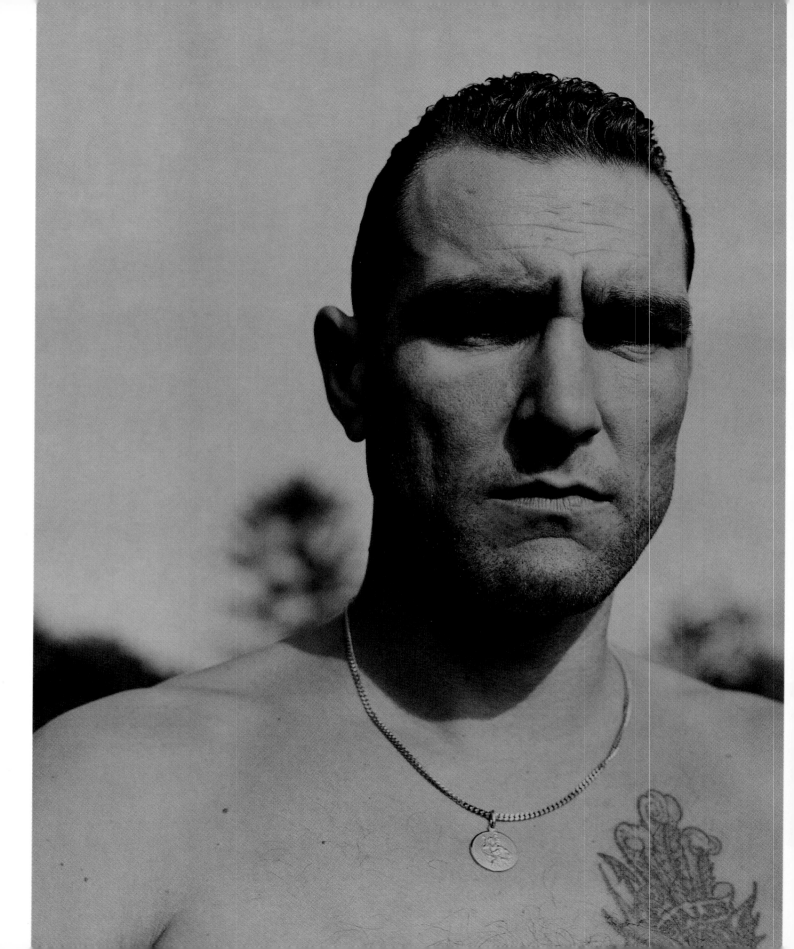

The heavy post flash
Mask the whole image [highlight?]

Description

FAMOUS FOR WORK WITH THE SPICE GIRLS, AND
DAVID BECKHAM THIS WAS A DEPARTURE FOR DEAN,
WHEN WE WORK TOGETHER WE USUALLY TRY AND DEVELOP
A CLASSIC REFINED FEEL TO DEANS IMAGERY.

photographer > Dean Freeman | **title >** Vinnie | **paper >** Oriental Seagull VC Grade 5 | **exposure >** detailed below
developer > Ilford PQ 1-10 | **time >** two minutes

process > Dean and normally work together to try and create a classically refined feel to Deans' images. Here, I went a bit darker and it is interesting for me to see how people's images can be translated in a different way from the norm. The coldness of the print comes from having used a neutral tone developer which adds a blue/grey tone to the image. The heavy post-flash of two seconds added another dimension to this print. At f/11, I exposed for 35 seconds, dodging the eye sockets, adding 10 seconds to the upper body to bring out the tattoo and balance the image. I then post flashed for two seconds at f/11.

Shot on Tr
acutance pr
Over exposu

photographer > Hamish Brown | **title** > Vinnie Jones | **paper** > Forte Polywarmtone Gloss Grade 3 | **exposure** > detailed below
developer > Agfa Neutol WA 1-6 | **time** > 45 seconds

process > Hamish's brief was: 'Dark and seedy with heavy mood and get rid of the shadows'. It was shot on TriX at +1 and processed in PYRO film developer to give greater acutance. Here, I overexposed and underdeveloped to enable me to print for the highlights rather than the shadows. At f/8 grade 3, I exposed for 50 seconds, dodging the face for 15 seconds and the body for 10. Even with overexposure, I had to burn in the background and the hands for a further 20 seconds on each side, being careful not to lose the dust/steam rising above the head.

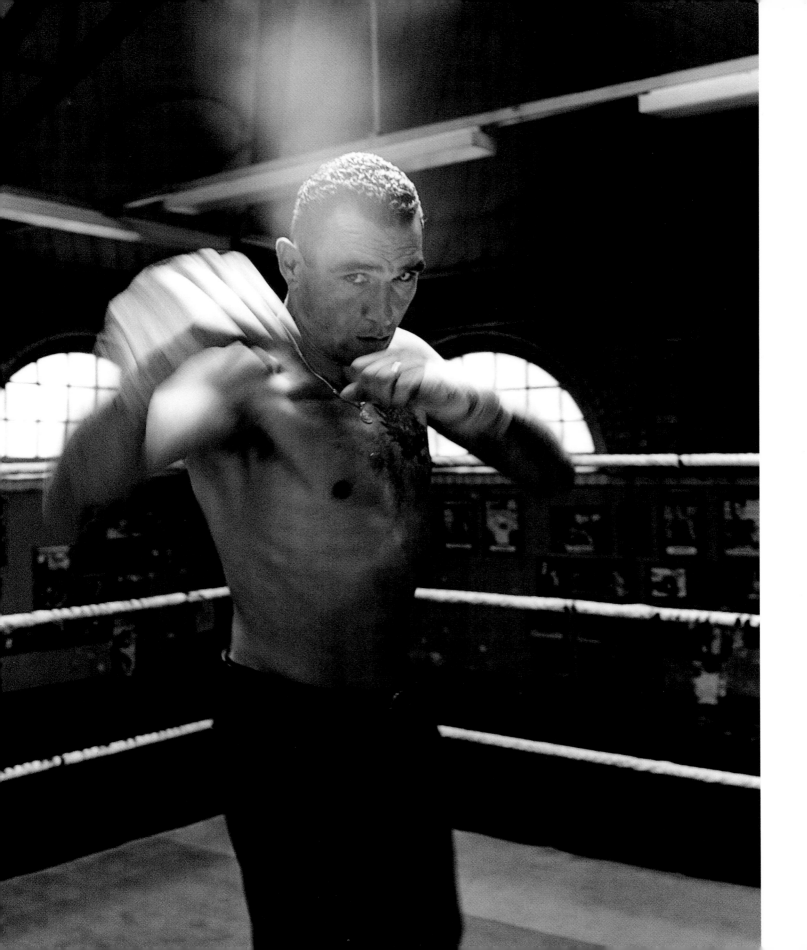

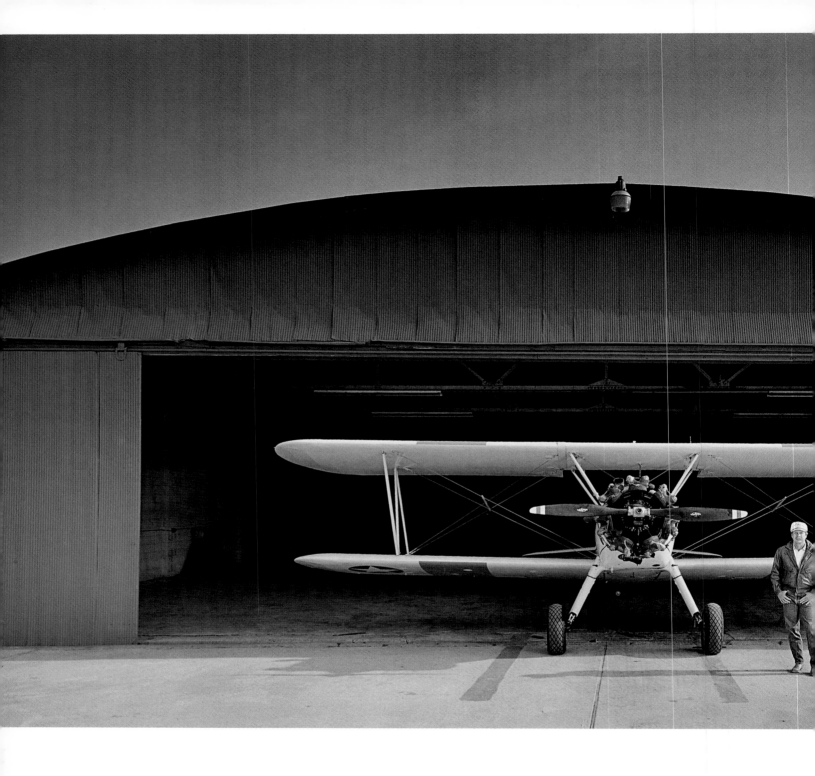

crop to try and
centralise image.

+10

Basic image exposure 35 sec. F16,
add + 10 on base/foreground.
+ 20 on sky to create "Halo".
Slightly vignette +5 around edge.
Wallop.

photographer > Darran Rees | **title** > Biplane | **paper** > Oriental Seagull VC Gloss | **exposure** > detailed below
developer > Ilford PQ1-6, 20°C | **time** > two minutes

process > The basic image exposure was 35 seconds at f/16. I added +10 on the base/foreground and +20 on the sky to create a 'halo' effect. Finally, I slightly vignetted +5 around edge.

The art of printing will be made all the more enjoyable if you work in a controlled and consistent manner – that word planning comes up again.

resin-coated or fibre-based paper?

The range of modern printing papers is ever expanding but, basically, there are two types of emulsion on two types of paper base. Manufacturers extend the range by producing varying finishes and base-paper tones. As every paper has different sensitivities and characteristics, it is important to find a paper that suits your needs.

The main difference between resin-coated (RC) and fibre-base (FB) is that RC paper has an impervious barrier that prevents the photographic emulsion from soaking into the paper base. This decreases chemical carry-over and contamination, and thus decreases washing times. If used properly, it even dries flatter. So why bother with FB papers? They are more expensive, take longer to process, take longer to wash and are more prone to wrinkling. Some argue that there is a superior print feel to FB papers; that it is more akin to art, and that the mastering of FB papers is for serious printers only. I disagree. Do not be confined by photographic snobbery. As far as I'm concerned, there is a wider range to experiment with, more exciting toning techniques to be achieved and it is easier for me to spot any dust marks or scratches on FB paper. But fine prints can be produced on RC papers. If you are starting out, the most economical choice is RC. There are fewer inherent problems and it is an excellent way to cut your teeth without becoming frustrated with cross contamination and staining.

variable-contrast or fixed-grade paper?

Fixed grade (FG) papers are less common now that variable-contrast (VC) papers have improved and become the flagship product for most manufacturers – few are still available in all the grades. Conventionally, FG papers came in grades of 0 to 5, which have an extended tonal range and appear 'softer' at the lower end and, increasing in contrast through the range, 'harder' at the upper end.

Variable-contrast papers have become the norm and this is quite justified as they are more economical to buy. The paper uses multiple active emulsion layers enabling a single sheet of paper to replicate any grade – one box is therefore sufficient to cover every grade. This is achieved as one layer of emulsion has blue light sensitivity and the other blue/green-dye sensitivity. The filtration can therefore be altered, affecting the paper emulsion receptivity. Images can be printed using several contrast settings on one print, but this is not an excuse to become overzealous: ensure that change to the filtration are done for a purpose and not just as a vehicle to test the paper's contrast range.

There are other considerations one should take into account when choosing a paper. The weight of the paper can range from single-weight (SW) through double-weight (DW) to triple-weight (TW). Most papers have an individual surface texture that can add to the print, the paper support base, which can range from super-fine to canvas texture, determines this. This texture will also affect the strength of the D-max blacks: matt papers appear to have less dense blacks. as do textured papers, whereas gloss or semi-gloss papers appear to have darker and richer toned blacks. The paper-base colour can also affect the print – this is achieved by adding a small amount of pigment to the emulsion base layer, and appears white, cream or ivory in tone.

The art of printing will be made all the more enjoyable if you work in a controlled and consistent manner – that word planning comes up again. Always handle paper and film carefully, remembering to keep wet and dry areas separate. Do not rush into anything, think about what you want to achieve, giving yourself enough time to make mistakes and complete the task. When using processing trays and tongs, make sure that they are labelled so that you use the same one for each chemical every time. Make disciplined notes of your procedures at this point – it is easier to make adjustments or compensate a contact or print error if you have carried the development process to completion. Adjusting by guesswork will waste time and paper.

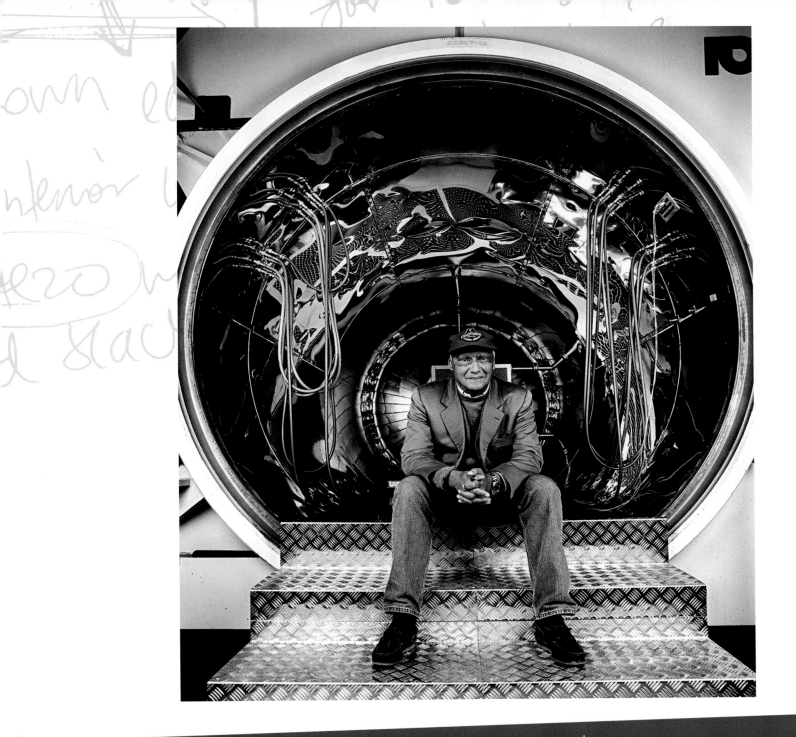

photographer > Jamie Beeden | **title >** Nicky Lauda | **paper >** Forte Fortezo Museum Weight Grade 3 | **exposure >** detailed below
developer > Agfa Neutol WA 1-6 | **time >** three minutes

process > This shot is super-sharp and was one of a series of motosport greats for Car magazine. I cropped the image slightly to balance the composition, but nothing fancy was required here. At f/11, I exposed for 35 seconds, holding back the face for 10, vignetting around the edges and on the steps up to the turbine for 10 seconds and adding 10 seconds to the interior reflections. This, I feel, draws the viewer into the image, onto the subject. The Fortezo works really well here, giving great blacks without losing shadow detail.

paper**processing**

Whether we machine or tray develop our photographic paper, the principles of printing chemistry are the same and should become a familiar routine.

When tray developing, paper is transferred from the contacting frame and immersed face-up in the developer (timing depends on paper/chemistry). Do not prod the paper, as you may damage the emulsion surface; slip the paper under the surface and gently rock the tray. Passing the paper into a tray containing stop bath halts development. The print is then passed into the fixer tray that removes undeveloped silver. Once paper is suitably fixed, the viewing light can be switched on and the print can be judged. After fixing, the print is washed to remove any residual chemistry.

printing chemistry

developer All alkali-paper developers perform the same functions, but vary in speed, contrast and tonal warmth. The important components in a developer that will influence the image tone are agents such as glycin or chlorohydroquinone, bromide restrainer – the more bromide, the warmer the tone – and organic antifoggant such as benzotriazole, that can provide cooler tones. Rather than change my developer choice, I keep to a couple of basic developers, varying dilutions and temperatures to suit my needs. For cold tones, I use Kodak Dektol, and for neutral tones, Ilford PQ, which has a higher concentration of sodium sulfite and therefore oxidises at a slower rate than, say, Agfa WA. Both of these have a higher proportion of antifoggant than the WA, which has more bromide restrainer, providing warmer tones.

Most papers may be developed over a range of time, but generally, the longer the development, the richer the overall tone and graduation. I try to standardise development time to around two minutes but this is not always possible, particularly on tight deadlines and larger print orders. By overexposing and under-developing papers, more interesting effects can be achieved, once you have become familiar with a particular paper/developer combination.

Developers are normally used at 20°C but, by varying the temperature, we can also introduce colour changes in the print. Increasing temperature creates warmer, olive-brown tones; decreasing creates more blue-black tones. Adding sodium hydroxide to a cold-tone developer will warm the tone by a degree.

stop bath and fixer The procedure is the same for paper as for film processing (see page 50), bar that dilutions and times vary.

washing A word of warning – if you fail to wash your prints thoroughly, then problems will invariably arise when it comes to toning, drying, presenting and archiving your images. If you are not confident that your wash is thorough enough, then it may be wise to use what is called a 'hypo' eliminator that eases the removal of residual fixer. Whatever method is used, I cannot stress the importance of print washing enough. After an initial wash in running water, I use an upright Nova print washer that has individual slots for each print – washing for an hour with a steady flow of water passing through the print ensures print stability. When chloro-bromide papers are washed for extended periods, there is a visible warming of the image colour, which is useful for introducing colour without the need for toning.

drying Once prints have been washed, they should be squeegeed on both sides to remove surplus water. There are many methods for drying prints – RC paper can be dried through purpose-built roller driers. FB papers can be air-dried flat between sheets of blotting paper, clipped back to back and suspended to minimise curl, or glazed and heat-dried on a belt/drum drier.

Handle the paper with care to prevent creases and tears while it is wet and at its weakest. Some papers tend to dry flatter than others, due to the actual construction of the paper base. When the print is dry, a sheet of heavy glass placed on a hard surface can be used to flatten the paper down, or, if you have access, use a hot flatbed press, which combines heat with weight to compress the paper.

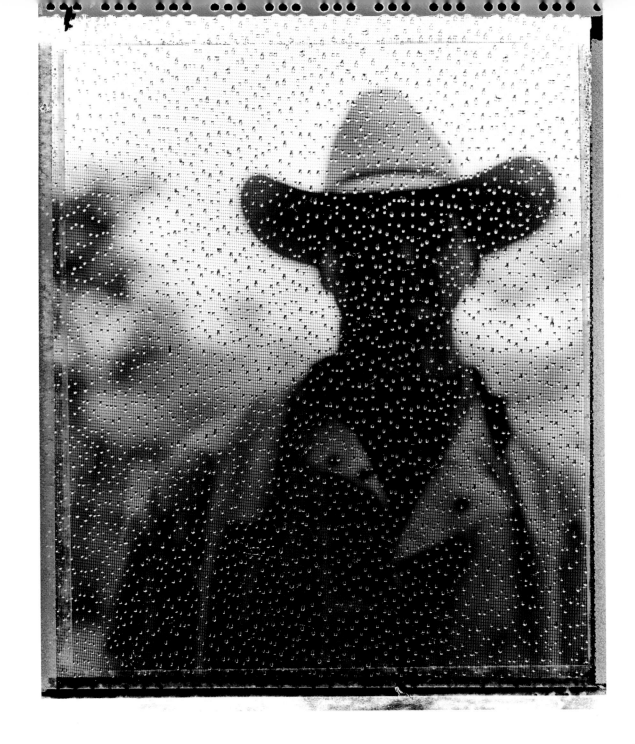

photographer > Jon Nicholson | **title >** Jeff Haley | **paper >** Ilford Multigrade Warmtone Matt Grade 3 | **exposure >** detailed below
developer > Ilford PQ 1-10 | **time >** three minutes

process > This is one of those rare, inspired, simple shots that need nothing more from me than to judge the exposure, turn on the enlarger and go and put the kettle on. Shot on Polaroid type 55 pn film, I exposed for the shadows yet tried to retain the highlight values in the raindrops. At f/16 grade 3, I exposed for 35 seconds and developed.

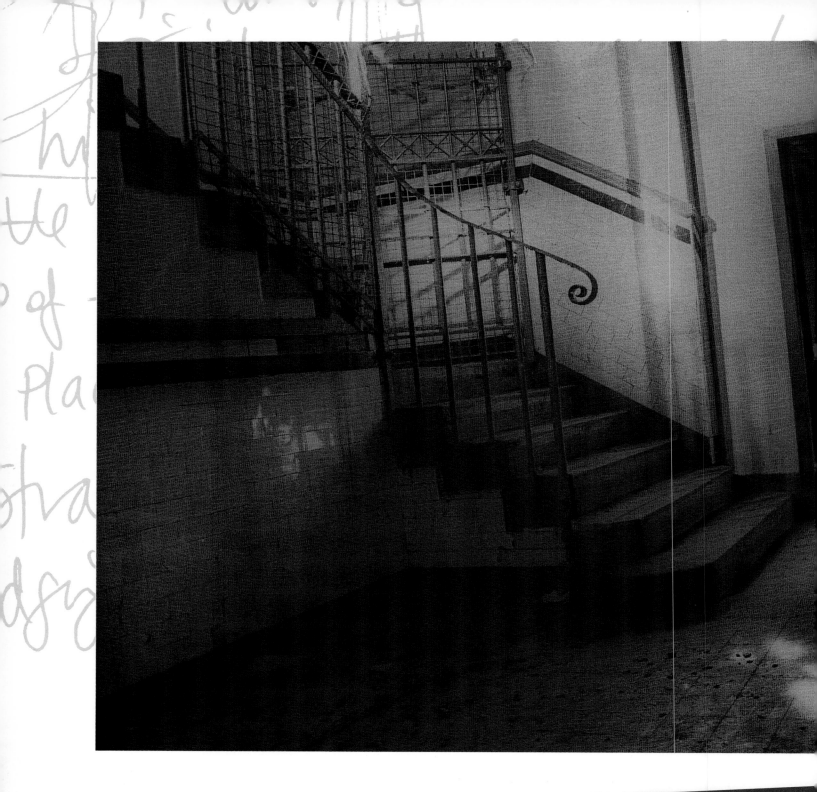

photographer > Steve Macleod | **title >** Old Mission, Aberdeen | **paper >** Kodak Fine Art Matt Grade 2 | **exposure >** detailed right
developer > Kodak Dektol 1-15 | **time >** two minutes

it was placed ontop of the paper during exposure.
— Placed linen ontop of easel.
Straight expose no burning or
dodging initially. 30 sec at G2, F11,
Then darken left side stairwell, + 10 sec,
Though doorway + 10 sec. and bottom ⅓rd.
+ 10 sec.

process > I wanted a ghostly feel making it appear dark and sinister. Every time I visited this derelict shelter, I got spooked – there was a lot of history and it was very creepy. I printed for the whole exposure through a sheet of open linen placed on top of the paper during exposure and this was periodically moved. This creates a soft diffused effect and also elements of texture from the linen material. I dodged at f/11 for 30 seconds, with no initial dodging, then darkened the left side stairwell for 10 seconds and through the doorway for 10. Finally, I added 10 seconds to the bottom third of the image to add weight.

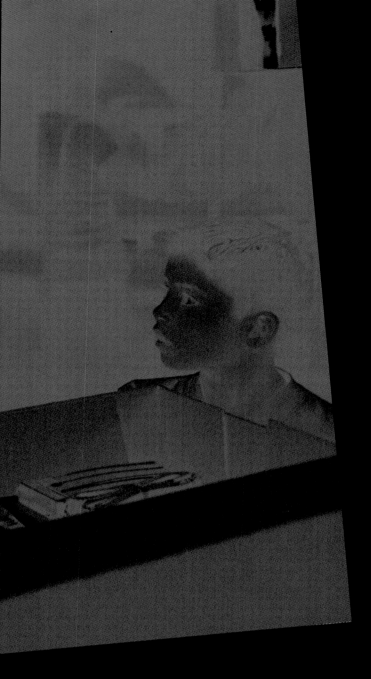

chapter 7

advancing from the
basic print

Moving from contact print to enlargement can be both straightforward and frustrating at the same time. The processing principles remain the same, yet the change in scale and proportion can complicate matters. Therefore, the same attention to detail must apply.

To make a simple enlargement, ensure that both the negative and the carrier are dust-free, as specks will be magnified once enlarged. Carefully wipe the negative with a lens brush or use canned air (from photographic shops). Once clean, the negative is placed in the carrier, emulsion-side down. I prefer to view my images the right way up in the enlarger, so I always place the bottom of the image towards the back of the enlarger for landscape images. For portraits, I prefer to view the top from left to right – this allows me to be both consistent and avoids unnecessary craning of my neck.

When the enlarger is adjusted to the right print size, the image must be grain sharp, yet there is no need to buy the most expensive focus magnifier on the market; more costly models allow greater access to the grain at the edge of the image, but less expensive magnifiers work just as well. Problems may arise from the focus mechanism slipping or from misalignment between the enlarger and baseboard, or a shift in focus when your lens is stopped down. Check and test the enlarger, baseboard and magnifier regularly.

Before we make our enlargement, it makes economical sense to apply a test-strip technique. I often provide lectures and workshops for Royal Photographic Society members and other organisations such as the Monochrome Society, and often come across people who have been taught or have learned the F-stop printing method. More often than not, these are the people who have a great deal of difficulty when it comes to applying and judging test-strip values. They get so bogged down with the principle of this method, that they forget what it is they are actually trying to achieve – which is a good starting point for density and contrast so that decisions can be made to provide a good working print – no more, no less. Therefore, I prefer not to use this type of test-strip method

as it can become a frustrating waste of time and can be detrimental to more creative printing. I believe that the simpler method described below is more time efficient and you are less likely to lose subtle print mid-tones.

From an average negative, I aim for basic exposure times of between five and 25 seconds on a 12 x 10in (30.5 x 25.4cm) or A4 print. Therefore, with my lens stopped down to f/8 or f/11, using a full sheet of paper, with the enlarger set around grade 2, I give exposure strips across the image of five, 10, 15, 20 and 25 seconds.

Once exposed, I develop the sheet for a set amount of time so that I can determine good density and contrast. Do not be tempted to pull the sheet out too soon, as this will not give a true reading. After that, carry on with the procedure as you did for the contact sheet by stopping, fixing, washing and drying, then view to judge the best exposure time. When you become familiar with the fix-up and dry-down patterns of certain papers, testing will become a matter of estimation and you will be able to judge what exposure to use after the print has been fixed. Do not get flustered during any of these stages – just make a note of what has been done and start again; mistakes are future lessons learned.

You can now start to make judgements about image density, contrast and overall feel. The aim

is to be able to judge from a test strip or negative an average density and contrast grade to suit the image. In my working day, I may have to print in several different styles. I have to consider the manner and feel that a particular photographer needs for the image and interpret that onto the printed sheet. The relationship between photographer and printer is the most important mechanism – this drives the bond and common understanding of the image and how it should be portrayed. Ultimately I am a professional printer – I become an extension of the photographer and try to translate his or her ideas onto the printed medium. I therefore feel that my style of printing is as individual as photographers' are different. This, for me, strengthens the argument that there is no single, perfect print – photography is about making a personal decision to capture an image. This is transferred to the baseboard where a totally subjective decision is made as to how that image is presented.

It is easier and more economical to use variable-contrast papers for the obvious reason that you use a single paper type and vary the contrast within the enlarger. For fixed-grade papers, test a sample from each graded box of paper, once you have found a density grade that suits your style of imagery, it becomes cheaper as you only have to purchase that grade of paper.

Be aware that different manufacturers' papers have different sensitivities and that higher grades tend to be about a stop slower than lower grades. So the image is given the determined exposure to grades 0, 1, 2 and 3, and grades 4 and 5 are given a stop extra or double the exposure.

If you follow the procedures, you will soon get into a rhythm and be able to visualise the image before you print it, and you'll experience the joy of being able to estimate quicker how to achieve that visualisation. Give yourself adequate time to work and to rectify any mistakes that may happen. Once you have used the test sheet to determine an exposure and contrast level, repeat the exercise but this time use the full sheet to make the print. For example, an average negative may print at 20 seconds, grade 2 at f/11.

Develop the print for the same time as the test to recreate the chosen density. Also remember that when printing several prints in a session, consider developer exhaustion and, unless a temperature-controlled hot plate or water jacket is used, temperature drop. This can be most easily identified when the development times become longer and you start to lose maximum, or d-max, black in the print. It is commonsense to change the chemistry before the exhaustion point is met. Once the basic print has been processed, you can start to make decisions about localised contrast control, burning and dodging of areas of the print. The aim is to be able to make subjective decisions about the negative and the print as you print it: with experience you will be able to look at a negative and know roughly what grade, exposure and developer combination is required. Experience makes perfect.

Very quickly, you should be able to produce prints that are technically proficient, yet it is being able to add to the print that is

> There are no hard and fast rules as to how an image should be printed and it very much comes down to a matter of taste in terms of tonal range, density and contrast.

more challenging. It is very rare that an image can be printed without the need for extra exposure or localised contrast control to areas of the image. This is what is commonly known as 'burning' and 'dodging'. By dodging, we tend to hold back shadow areas to allow for greater detail to come through, and by burning we add more exposure to a highlight area. The latter is also useful to play down a distraction point and to direct the focus of attention or add mood to an image. Most burning and dodging is achieved using masks. Over the years, I have seen all sorts of elaborate masking and dodging tools. For now, I have one dodging tool – a thin card disc the size of a ten pence piece attached to an eight-inch piece of fuse wire. Oh, and my hands, which are normally very adaptable and never get lost in the dark. I also have a sheet of A4 card with a hole the size of a five-pence coin for more accurate burning in.

Take a look at this Zed Nelson print opposite, for example. The basic print is okay, but there is a lot going on in the scene which distracts from the focus. I can rectify this by underexposing areas, particularly the shadows (i.e. dodging), by overexposing other areas or removing the emphasis by burning in. The idea is to control the point of focus in such a way that some elements become more important than others; for instance here, the rifle itself or the interplay between the small child, the rifle and the other family members.

There are no hard and fast rules as to how an image should be printed, and it very much comes down to a matter of taste in terms of tonal range, density and contrast. What I feel is important, is the capacity to control the light penetrating through the negative onto the print surface, being able to make decisions and having the ability to replicate and produce work that shows consistency and depth. Photography is very much about light and dark and about the elements that are affected by these properties. In terms of printing, don't be afraid to print dark, overexpose and underdevelop, or to underexpose and overdevelop. Our creativity is as much about experimentation and execution – all that is wasted is a sheet of paper.

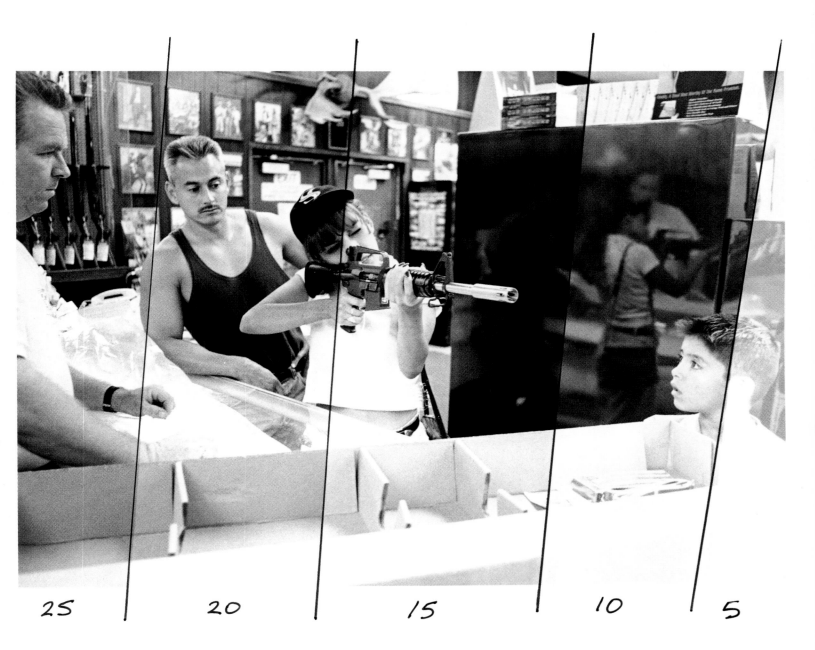

25 20 15 10 5

above: **A basic test-strip print showing various timed exposures of five-second intervals. Aperture f/11, grade 2.**

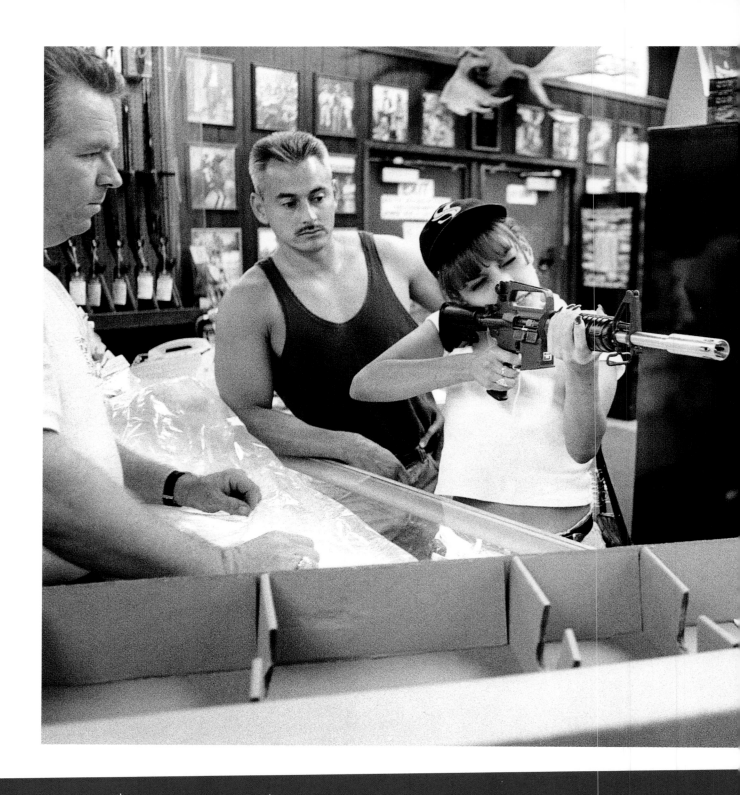

photographer > Zed Nelson | **title** > Rifle Buying Family | **paper** > Agfa Multicontrast Gloss Grade 2/2 ½ | **exposure** > detailed below
developer > Agfa Neutol WA 1-5 | **time** > two minutes

RIFLE BUYING FAMILY

MULTICONTRAST GLOSS

25 SECONDS, DODGING F
ITHEN BURNT IN THE HI
YE AROUND THE IMAGE,
TOL MA 1 - 5 20°C
TES,

process > From the award-winning book and exhibition Gun Nation. This was a magnificent project for me to get my teeth into. We tried to create an everyday feel to many of these disturbing images. I manipulated this print to both balance and draw the eye easily around the image. I burnt in many of the distracting background highlights, vignetted the corners and dodged the faces of the subjects. Compare this to the initial basic print and see how much more effectively it works. At f/8, I exposed for 25 seconds, dodging the faces and the background shadows throughout the exposure. Then I burnt in highlight details 10 seconds each, adding five seconds in each corner and five seconds on the foreeground packaging material.

chapter 8

printedborders and key
lines

Full Frame with a rough keyline

The background was too bright, darken down, +15 seconds,

photographer > Gino Sprio | **title >** Untitled | **paper >** Ilford Warmtone semi-matt Grade 3 | **exposure >** detailed below
developer > Ilford PQ 1-10 | **time >** two minutes

process > Full-frame with a rough keyline. The background was too bright, so I darkened down by 15 seconds. The basic exposure was 30 secs at grade 3, dodging the eyes for five seconds each. I darkened the foreground and the hand by five seconds each to centre focus on the face and eyes.

We all have the capability to master the art of printing, but all too often I find people eager to get into the darkroom, rushing around to create the perfect print only to realise that the image doesn't sit properly on the sheet; the borders are all wrong and there is flare reflecting back off the easel blades. Whether for commercial or personal use, it is amazing how much better a print can look when it is thoughtfully set out and presented.

It is important to find a printing easel that suits your needs. Most easels have lugs or bars that can be moved to set widths permitting various border settings. By setting the bar, we hide that section of paper under the easel edge or blade, and this remains masked. More complex easels have floating and moveable bars and blades that allow for more border variations, but it is important to realise the maximum available recess of the easel that you choose. I prefer the Photon Beard type of easel, as it is very rigid and durable with both moving border bars and blade settings.

Unless otherwise instructed, most commercial labs will print your images full-frame with a minimum white border, or full-bleed edge to edge, but there are multitudes of variations. Find a method of presentation that suits you. This can say a lot about the way you frame imagery, whether full-frame composed within the camera or cropped out, post-processing. As with framed paintings, prints often look better with a bit of space between the image and the edge of the mount, but there are no rules as to how an image should be set onto the photographic paper. Some of the more common methods are to centre the image or to leave a slightly larger border at the base of the image, called "bottom weighting".

Depending on the type of enlarger and negative carrier that you use, there are many creative border techniques. Be careful when printing, that light is not reflected off the edges of the easel onto the paper. This is often more noticeable on lighter tones towards the edges of the image, which appear as a darker band, or in extreme cases, as reflections of the sprocket holes reflected onto the paper. To remedy this, either reset the negative in the carrier so that it sits close to the carrier edge, or dull the edge of the easel with matt-black masking tape to absorb any stray light.

A popular technique when printing full-frame is to use an oversized negative carrier, so that when the image is printed, a black 'keyline' is printed in, which is either a straight or a rough edge of black. The straight-edge keyline is produced by composing the image on the easel full-frame with a minute area of the rebate showing on the exposed printing area. A rough-edge keyline is achieved by filing out the sides of the negative carrier – the rougher the filing the softer and more flared the edges will become. It may be necessary to paint the filed edges with matt-black paint to prevent light reflecting onto the print. Remember to do the filing away from the darkroom so as not to spread unwanted metal filings around the space.

It is not always necessary to print the keyline in, as it can be just as effective to draw it in after the print has dried. This technique is not one for the purist, but I feel that printing is a craft that should not be restricted to the printing medium alone. To do this, use a drawing pen with a width of around 0.5-1mm; hold the pen upright and draw in a smooth action, using a metal ruler with a bevelled edge facing downwards, to prevent any ink from bleeding. If you have difficulty locating the faint edges of a print, a pinprick should be made at the extreme image corners while the paper is in the easel, prior to development.

Other effects include using torn pieces of card or masking tape attached to the easel blades to create soft edges. The key is to experiment with different setups, but remember that creating masks and border effects does not necessarily improve the image. Basic printing makes for a successful print, but the techniques described can add another dimension or draw the eye to certain aspects of your imagery.

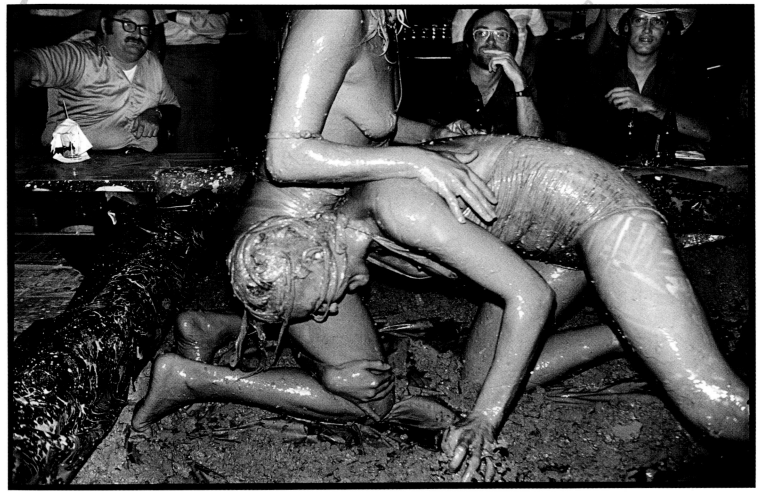

photographer > Robert Goldstein | **title >** Mud Wrestling, Arizona | **paper >** Ilford Multigrade Gloss Grade 2 | **exposure >** detailed below
developer > Ilford PQ 1-9 | **time >** two minutes

process > Rob is an old friend of mine. This image is from a series that Rob is developing on sex and we both felt it was important to bring out the expressions of the punters in the background as much as the muddy girls. Rob is very good at exposing film and there was very little to do here. The image was printed with a keyline and be broken down into rough shapes, the relationship between the girls and the background. At f/16, I exposed for 30 seconds, dodging the background, especially the faces, for 15 seconds, adding five seconds on the lower-left and right sides. Finally, I added 10 seconds to the distracting white paper on the left side.

urn in lower portion of image lightly vignette corners.

photographer > Gino Sprio | **title** > Ben Kingsley | **paper** > Ilford Warmtone semi-matt Grade 3½ | **exposure** > detailed below
developer > Agfa Neutol WA 1-6, | **time** > two and a half minutes

process > Full-frame fine keyline. I could have centred this image to make it more symmetrical in appearance, but I quite like the unnerving quality that this right off-centre image provides. There was very little to do here. The background needed to be taken down a bit, grade 3½ at f/11, 35 seconds overall dodging the face for five seconds, then the lower face for three seconds (all in one movement). I burnt in the lower portion of the image (jacket for five seconds), slightly vignetting the corners.

acret for 5 secs)

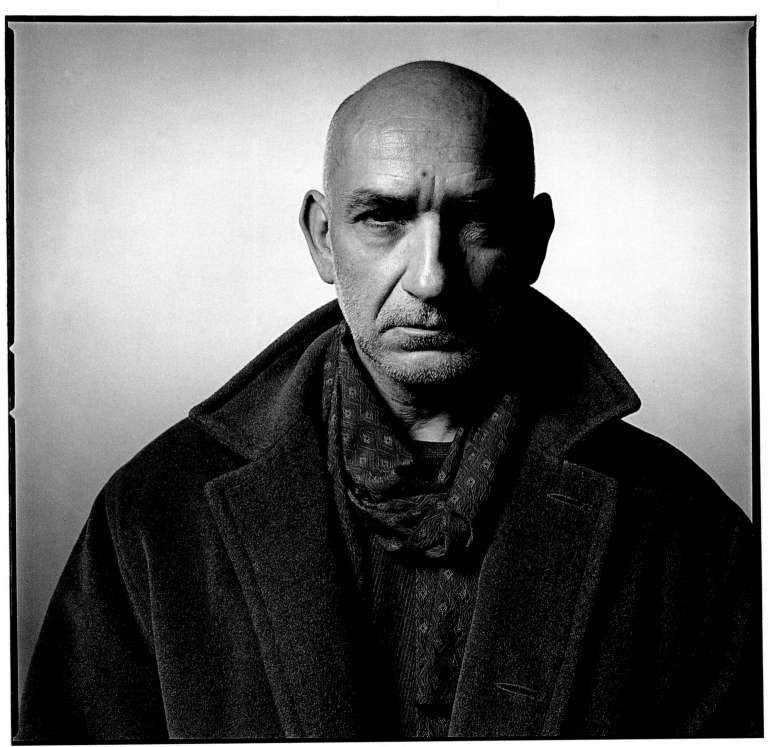

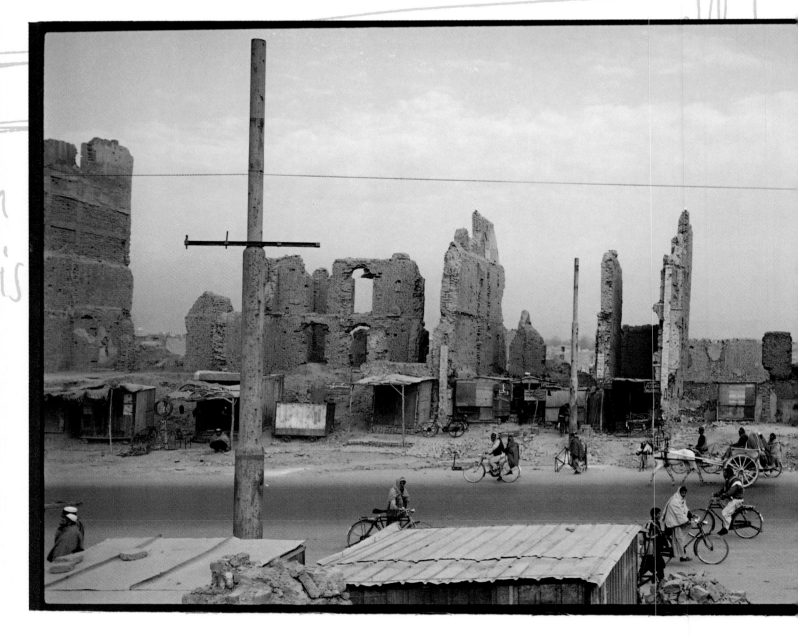

F11 25 seconds, G3,
+ 10 sec. buildings down
+ 10 sec on foreground.
+ 5 sec on skye.

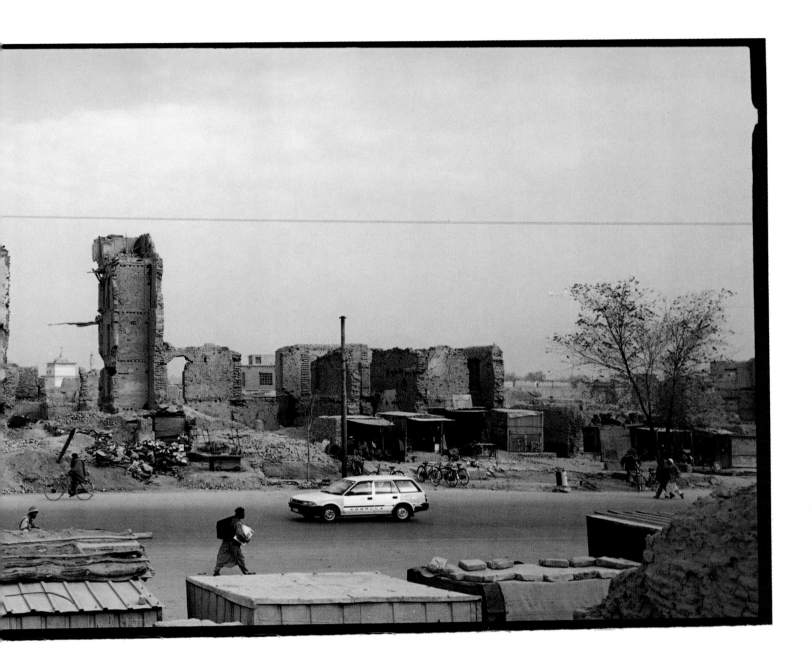

photographer > Gary Knight | **title >** Kabul, Afghanistan | **paper >** Ilford Multigrade Gloss Grade 3 | **exposure >** see details below
developer > Ilford PQ 1-10 | **time >** two minutes

process > This image was part of an exhibition at the Louvre, Paris, France, in the summer of 2002 – a series on the aftermath of 9/11 and the campaign in Afghanistan. Shot on an 35mm Xpan camera, this image is split horizontally during exposure. At f/11, I exposed for 25 seconds, then added 10 seconds from the building, horizon down, and another 10 seconds on the foreground. This helped weight and balance the print. Finally, I added five seconds on the upper sky to stop the eye drifting off the top of the image.

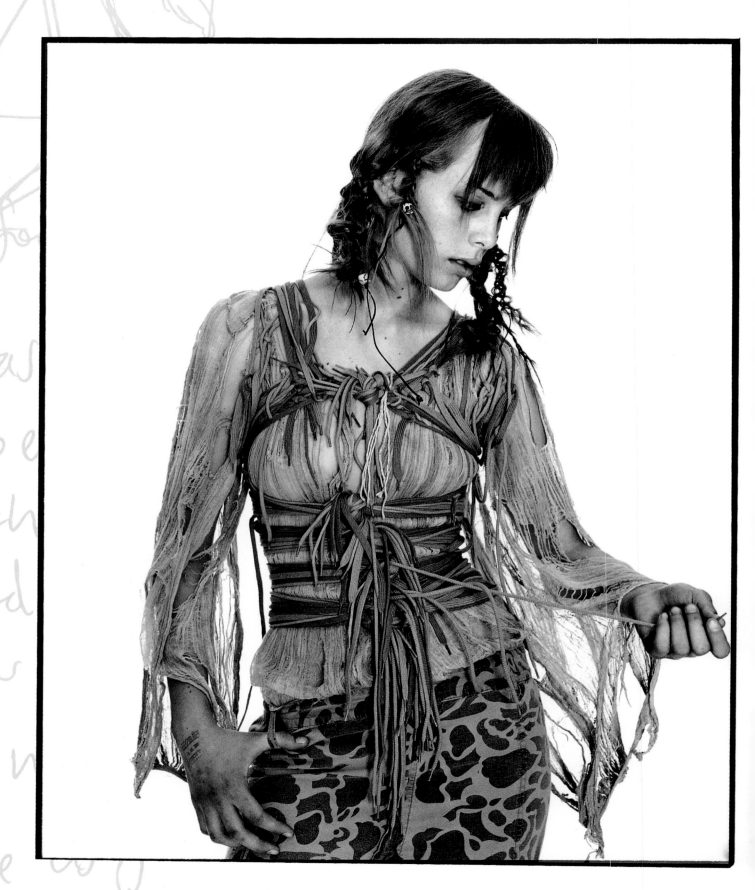

B328991

Toners

Description

REFER TO SKETCHBOOK

Slow paper needed for ease of
exposure control.

fake keylines

Photographers often compose their subject with the intention of printing full-frame. This is a good exercise as it teaches discipline and awareness of composition but it can mean that images that may otherwise have been used are excluded because the composition is inconsistent. The unexpected happens, which means that the full-frame rule can become restrictive and some fantastic images are sacrificed as a result.

There is a way round this. If we want to crop out a certain area of the image but want to retain full-frame with black keylines, simply compose the image in the easel to the full-frame proportions, cropping out the unwanted areas, as in this Corinne Day print. Print the image as normal then, with a piece of opaque card made to exact print size, minus a keyline width and height, place this onto the print in the easel. You have now created a mask that covers the entire image except for a small line running around the edge of the print. Using a small Maglite torch, very carefully burn in the strips of exposed paper, thus creating the keylines to match the print format. Be careful not to move the card about or to allow the Maglite to fog unexpected areas of print.

photographer > Corrine Day **| title >** The Face magazine, fashion feature **| paper >** Forte Fortezo Museum Weight grade 3 **exposure >** detailed below **| developer >** Ilford PQ 1-20 **| time >** two2 minutes

process > This is quite a complex image and I used a slow-working paper that would enable me to do all the work but still at reasonable exposures. Corinne asked me to crop this image so that it became a lot tighter with stronger composition. At f/16, a basic exposure of 40 seconds was done, dodging A for 10 seconds to even out the body; hand B for five seconds to match the other hand; and the hair braids C for five seconds each to show detail. Then, I added 10 seconds to the bottom right D to add weight to image. Finally, I applied a false keyline using the Maglite and card technique.

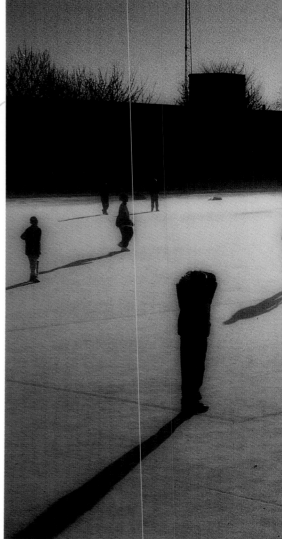

diffusion screens

Diffusion most associated with printing comes in the form of the soft-focus screens typical of wedding, baby and flower portraits. Diffusion can also be used to soften skin tones or add elements of flare to the image. There are several ways of creating diffusion, such as smearing petroleum jelly on the lens so that the light passing through it is diffused as it is printed. This can look overdone and there is a danger of knocking the lens out of focus.

An easier method is to use a sheet of 10 x 8in (25.4 x 20.3cm) anti-newton glass. To diffuse the image, the exposure is made with the glass held below the enlarger lens and above the printing paper. The closer the glass is to the lens, together with movement, the more diffused the image will become, as the highlight and shadow areas 'bleed' into one another. The advantage of using this method is that not only can the image be partially diffused, by splitting the exposure time both with and without the glass, but also that by moving the glass around the image, selective parts of the print can also be diffused, for instance a background or a distracting part of the image. When printing in this manner it is best to increase the contrast of the image by one grade to compensate for the softening effect of the diffuser. Be aware of flare from the easel edges intruding onto the print surface as the light is deflected from the glass.

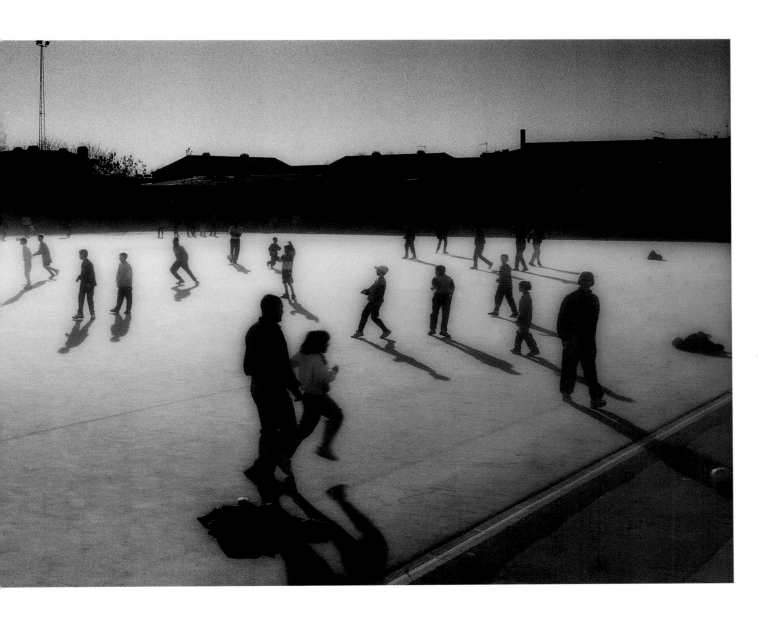

photographer > Fredrik Clement | **title >** Caledonian Road Football Pitch | **paper >** Ilford Warmtone Gloss Grade 4
exposure > detailed below | **developer >** Ilford PQ 1-10 | **time >** three minutes

process > We cropped this image to a panorama to exaggerate the shadows cast by the sun. The use of a diffusion screen for 50 per cent of the exposure adds to the dream-like quality of the image. I printed at high contrast to compensate for the diffusion and also to enable good blacks. At f/16, I exposed for 25 seconds and added 15 on the lower portion of the image to add weight. Then I added 20 seconds to the sky and five seconds on each corner to emphasise the sun's effect. Remember to use an anti-newton glass during initial exposure.

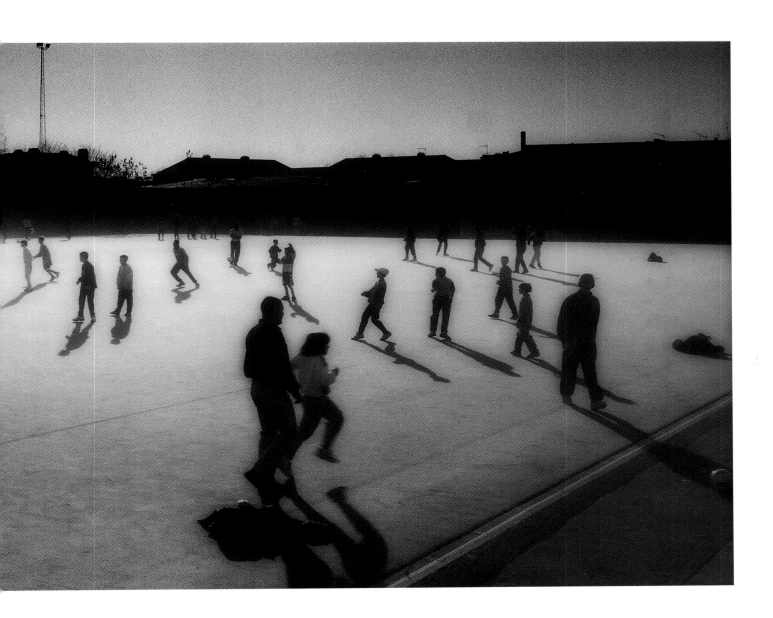

photographer > Fredrik Clement | **title >** Caledonian Road Football Pitch | **paper >** Ilford Warmtone Gloss Grade 4
exposure > detailed below | **developer >** Ilford PQ 1-10 | **time >** three minutes

process > We cropped this image to a panorama to exaggerate the shadows cast by the sun. The use of a diffusion screen for 50 per cent of the exposure adds to the dream-like quality of the image. I printed at high contrast to compensate for the diffusion and also to enable good blacks. At f/16, I exposed for 25 seconds and added 15 on the lower portion of the image to add weight. Then I added 20 seconds to the sky and five seconds on each corner to emphasise the sun's effect. Remember to use an anti-newton glass during initial exposure.

chapter 9

split-grade and
flashing techniques

This has become a rather outdated way of printing, which only allowed for the expansion or contraction of negative values to fit the manufacturer's paper characteristics. Traditionally, when using fixed-grade papers, there was a limited amount that could be done to alter the tonal range and contrasts of an image: flashing the paper or using two-bath development methods could only stretch the latitude of the tonal range. As the printing market evolved, there have become fewer fixed-grade papers available with full sets of contrast grades. Fixed-grade papers are now restricted to the 'Art' paper ranges including Forte, Fotospeed and Kentmere papers.

If you are determined to use fixed-grade papers, then it is necessary to test the image with different grades to match the feel of that image. With the exception of the hardest grades, all other grades should have the same sensitivity and exposure latitude; the highest grades, 4 to 5, are normally about an f-stop slower than the grades 0 to 3, and therefore exposure times should be doubled. The difficulty is that image manipulation can become difficult, except where the photographer's style suits a particular feel and contrast.

multigrade papers

Multigrade (MG) or variable-contrast (VC) papers are economical and flexible. MG papers, more than ever, allow freedom of interpretation for printers and photographers – images are no longer being governed by manufacturers' conventions. The downside is that more choice also means more mistakes, with a tendency to throw everything into the image with a 'because I can' attitude. But there is a feeling that with MG papers, printers have never had it so easy.

One of the most commonly used practices is to split-grade print images on a single sheet of photographic paper. However, it is fundamental that a change of filtration be used to add to an image – not just to test the paper's contrast range.

So how do MG and VC papers work? Well, as stated, the emulsion is constructed with multiple-active emulsion layers on the paper base. One layer is sensitive to blue light, and the other to blue/green light. Therefore, altering the grade filtration will affect the response of the paper emulsion. Most papers are controlled by either sheet or dial-in filtration units, such as those found on colour head enlargers or Ilford MG head units. Ilford's MG filter set and other such sets are balanced so that grades 0 to 3 have the same sensitivity range, and grades 4 to 5 are slower, requiring double (or 1 stop more) exposure. The only difference comes with twin lamp systems that are balanced from grades 0 through to 5.

photographer > Deirdre O'Callaghan | **title** > Snowboarder | **paper** > Forte Polygrade Semi-matt Split Grade | **exposure** > detailed below
developer > Ilford PQ 1-6 | **time** > two minutes

process > I initially cropped this image from the right to tidy up the composition. I began printing at grade 1 but this was too flat, so I tried grade 3. This was better and provided strong blacks but the subtle highlights were beginning to disappear. Therefore, I decided to split-grade print. The main exposure was done at grade 3 and then I printed in the highlights and the flashing at grade 1. At f/16, the basic exposure was 30 seconds at grade 3, then I added five seconds to the left side of the sky and mountain. Then on grade 1, I added five seconds on the trousers and five seconds on the background snow.

Description

Add 10 sec at G2.

A great image with loads of soft light and movement, yet retains eye detail and contact

Focus on face, burn down hair on left by 10 sec at G2, and hand bottom left by 5 sec G2,

Basic exp. 25 sec at G3, burn in nose +5 sec. (during initial exposure back eyes 5 sec each).

Add 10 sec at G2

photographer > Jamie Kingham | **title >** Kim Cattrall | **paper >** Ilford Multigrade Gloss Split Grade 3 and 2 | **exposure >** detailed below
developer > Agfa Neutol WA 1-10 | **time >** three minutes

process > This shot combines delicate light and movement, yet retains sharpness and clarity. We cropped this slightly just to cut out any background material. At f/11 grade 3, a basic exposure of 25 seconds was made, holding back the eyes slightly. I added five seconds on the nose as this was distracting. Then, on grade 2, I added 10 seconds on the hair on the upper left of the image and five seconds on the hand, lower left. The hand I feel is important as a secondary element in that it draws the eye away from and then back to the face.

photographer > David Clerihew | **title >** Untitled | **paper >** Ilford Multigrade Warmtone Matt Split Grade 2 and 3
exposure > detailed below | **developer >** Agfa Neutol WA 1-10 | **time >** three minutes

process > From a series on the theme of transport, the idea was to exaggerate the feeling of movement. I didn't want the shadow areas to block up or the highlights to dominate too much. At f/11 grade 3, a 40 second exposure was made, dodging the shadowy lines for 10 seconds, then adding 20 seconds on the upper-left of the image to drop the highlight down. This was done on grade 2 to make it easier to burn in. I didn't flash the image as this may have affected the shadow areas. Finally, I added 10 seconds on the lower foreground to add weight.

F11 40 seconds dodging shadowy lines for 10 seconds, add 20 seconds upper left and 10 lower half of print.

Too bright

darken

Image size 10×7"

Paper size 11×14"

photographer > Dominic Greensmith | **title >** Skyscraper | **paper >** Ilford Multigrade Gloss Grade 3 | **exposure >** detailed below
developer > Ilford PQ 1-6 | **time >** two minutes

process > As the drummer in Reef, Dom is not only an accomplished musician but he also takes some wicked photographs, and has amassed a collection of images both on and off the road. We produced a portfolio together and an exhibition that was shown during their Albert Hall gig in 1999. I chose this image because I like the tunnel effect that the window creates. This is done full-frame f/11, grade 3, 20 second exposure plus an additional five seconds on the dark window surround to take it to black. I then added 15 seconds at f/8 on the highlights of the buildings below and a further 10 seconds on the brightest highlight area again on f/8.

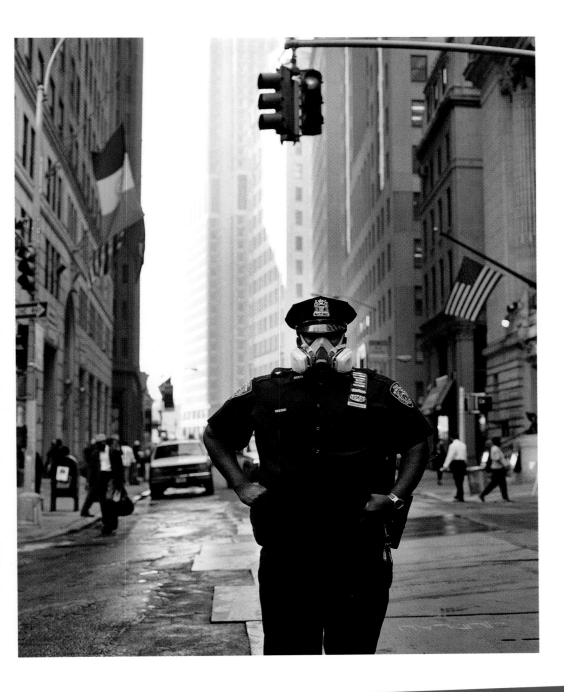

photographer > Zed Nelson | **title >** After 9,11 2001 | **paper >** Agfa Multicontrast Gloss Grade 2/2 ½ | **exposure >** detailed below
developer > Agfa Neutol WA 1-8 | **time >** two minutes

process > Taken during the aftermath of 9/11 and, as usual with Zed, good negs made for easy prints. The only thing to concentrate on was to dodge the face for detail without losing density and to print in the bright backlit sky. I printed on grade 2½ for the main exposure and then burnt in the sky and post-flashed on grade 2. At f/16, I made an initial exposure of 25 seconds, dodging the face and the mid-ground shadow areas for 10 seconds total. I then burnt in the corner five seconds each and the bottom left and right foreground five seconds each. At grade 2, the sky was burnt in for 15 seconds and then whole image post-flashed for 0.4 seconds at f/8.

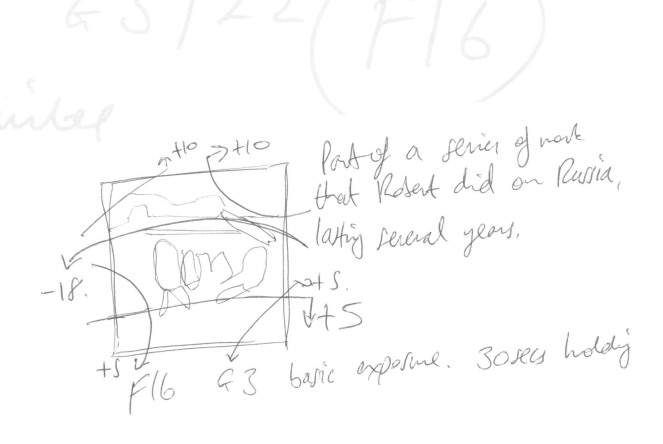

G 3 / 2½ (F16)

→+10 →+10

Part of a series of work that Robert did on Russia, lasting several years.

−18.

→+S.
↓+S

+S
F16 G 3 basic exposure. 30 secs holding

photographer > Robert Wallis │ **title >** Untitled │ **paper >** Ilford Multigrade Gloss Split Grade 3/2½ │ **exposure >** detailed below
developer > Ilford PQ 1-10 │ **time >** two minutes

process > Taken from Rob's project on Russian life, this image shows a group of village elders catching up on the day's gossip. I first tried to print this image by having a low basic exposure and then burning in individual areas, but I found this rather tricky and my control unrefined. Instead, it was easier for me to start with long exposure and to mask larger portions of the image as required. Also, the initial print was a bit weak and needed more contrast. At f/16 grade 3, I made an initial exposure of 30 seconds holding back everything but the sky for 18 seconds. I then dodged the faces and deep shadow areas for the remainder of the exposure. On grade 2½. I added five seconds to the foreground and five seconds each to the bottom right and left corners. I felt that the sky could do with more density, so I added 10 seconds on each upper corner diagonally. The final effect was to vignette the secondary information so that the eye can concentrate on the people central to the image.

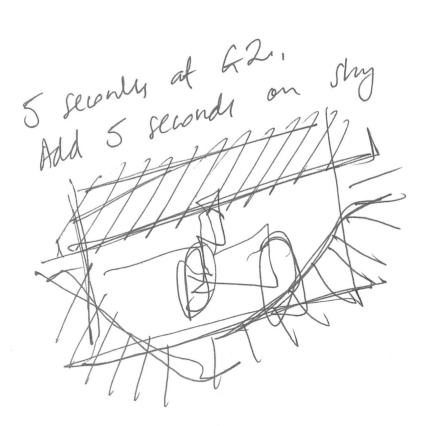

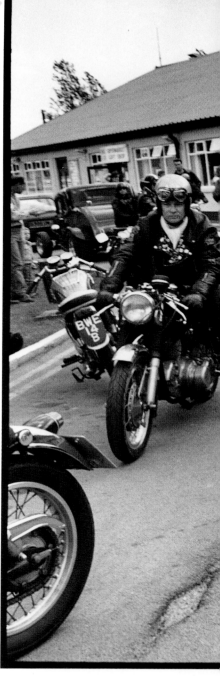

...up and 'celebrate everyday' ...
... a group of vintage bikers ...
wanted to create a simple ...
...ment.

5 seconds at f2.
Add 5 seconds on sky

photographer > Robert Wallis | **title** > Rockers Reunion | **paper** > Agfa Multicontrast Gloss Grades 3 and 2 | **exposure** > detailed right
developer > Agfa Neutol WA 1-15 | **time** > 1 ½ minutes

process > Taken from a project that Rob did on Rock 'n' Roll reunion meets that take place on the east coast of England every year. I wanted to create a classic feel here without any 'hands of god' burning and dodging. At f/11 grade 3, a 25 second exposure was made, randomly dodging any shadow areas that I thought were too deep and holding back the girl's face for five seconds. I then weighted the image by adding five seconds each bottom left and right. At grade 2, I added five seconds from the roof upwards and then five seconds on the sky area, trying not to make it look too obvious.

photographer > Rankin | **title >** Kylie | **paper >** Ilford Multigrade Gloss Grade 4 | **exposure >** detailed below | **developer >** Ilford PQ 1-9 | **time >** 40 seconds

process > Working with Rankin can be a very demanding experience but, as a printer, it is his attention to detail that keeps me intrigued by his work. The ever-popular Kylie has appeared in countless publications and exhibitions, and this is the one the collectors keep coming back for. The negative was so dense and the nature of the way it was to look meant that it could handle major over-exposure. The background was held back during exposure to prevent it from blocking in and becoming too flat. At f/8 grade 4, an exposure of 50 seconds was made, dodging the face for 10 seconds. I then added 10 seconds on the left shoulder just to balance out the torso. The development time here was very short and the tones seemed to rush up from the paper once development had started — the key was to know when to pull the print out!

photographer > Robert Wallis | title > Russian milkmaid | paper > Ilford Multigrade Gloss, Split Grade 3/2½ | exposure > detailed below
developer > Ilford PQ 1-10 | time > three minutes

process > I felt my initial print (above) was too soft at grade 2/2½. so the final print was done at grade 3/2½. The increase in contrast gave that bit more depth of tone. At f/16 grade 3, I exposed for 25 seconds, dodging the face for five seconds. I then added 15 seconds on the sky being careful to mask the head and horizon. The foreground had an extra five seconds to add weight and tone to the ground. Finally, at grade 2½, I burnt in the sky for 10 seconds.

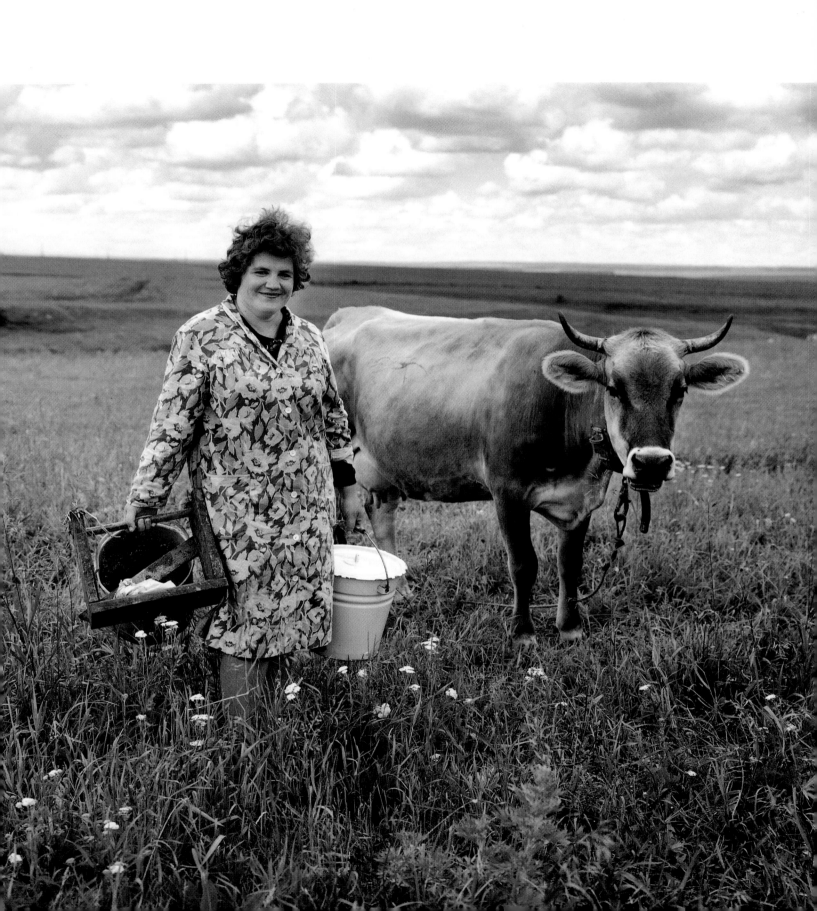

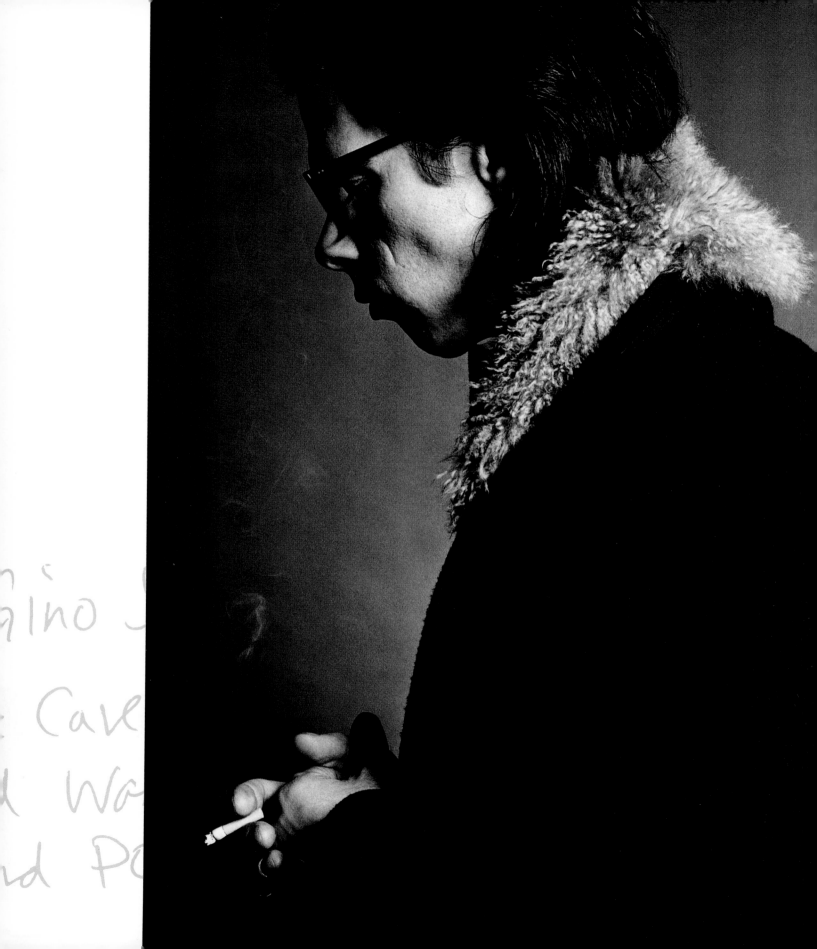

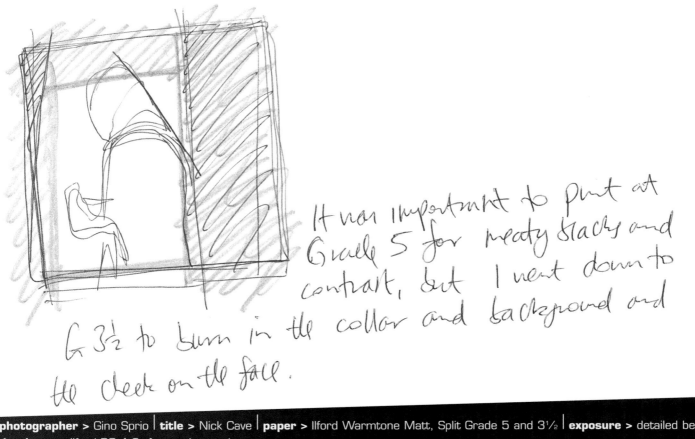

It was important to print at Grade 5 for meaty blacks and contrast, but I went down to G 3½ to burn in the collar and background and the cheek on the face.

photographer > Gino Sprio | **title** > Nick Cave | **paper** > Ilford Warmtone Matt, Split Grade 5 and 3½ | **exposure** > detailed below
developer > Ilford PQ 1-6 **time** > three minutes

process > Taken from an original 2¼ square, we tightened the crop to cut out the distracting background. By coming in closer, we added emphasis to the shape and poise of the subject. It was important to print at grade 5 to get good meaty blacks and strong contrast. Yet, for ease, I burnt in the cheekbone, collar and background at grade 3½. At f/11 grade 5, I made an initial exposure of 25 seconds, holding back the eye socket for five seconds. At grade 3½, I added five seconds to deepen the shadows on the jacket, then 10 seconds top-right-hand side diagonally across the shoulder, and five seconds on the left side, top to bottom. I then added 10 seconds on the face and five seconds on the collar just to dull it down. Finally, I vignetted the corners for five seconds each.

split-grade values

The easiest way to split-grade is to divide the basic exposure into two parts, the whole print being exposed at a different contrast setting for both highlights and shadows – usually grade 0 for highlights and 5 for shadows. This is followed by burning-in, using the same or different grades, but all this gives you, in fact, is an average contrast print around grade 2 or 3.

Another method is to print the basic exposure at one contrast setting and then apply burning-in at a different grade. I prefer this method, as it allows me to find a base contrast for my image at test-strip stage, then I can decrease contrast for subtle highlights and increase contrast to allow for shadow separation. In effect, this gives me more flexibility in printing highlight details that might go amiss during the initial print exposure and contrast setting.

film relationships Film characteristics affect how it translates onto photographic paper. Film curves are not straight, and the toe and shoulder areas are often the most curved (see diagram, page 33). This means that each unit of film exposure does not produce an equivalent increase in density in comparison to the middle of the film density curve. Thus the shadow and highlight details of the film are less well separated, as they fall on the toe and shoulder of the curve.

The toe of the film is normally controlled by exposure; we must give enough exposure to the darkest values of the subject so that they are interpreted by the film. The shoulder, or highlights, are catered for by development, therefore split-grading the print will benefit the toe and shoulder areas of the exposed and developed film. Some films also have higher base-fog levels than others, and this can have a masking effect on delicate shadow details. This is particularly true of faster, underexposed or pushed films, which can also cause denser highlight areas, requiring longer exposures to add tone.

highlight detail As the highlights are the densest area of the print, with the greatest amount of developed silver when they are printed in, a common effect is for them to look blocked up and grainy. To alleviate this, it is best to print softer than the basic contrast grade. This allows for more subtlety and less distraction from film grain. At this point, a useful tip on printing in dense areas without making the burning-in look too obvious, is to open up the lens aperture by one stop – this allows you to burn in the area at half the exposure time compared to the exposure determined by your initial test strip. Put simply, if a sky in a landscape needs 30 seconds exposure at f/11 to add tone to the image, then at f/8, the exposure will be 15 seconds to achieve the same level of exposure. An exception is printing skies at lower contrasts, when a dramatic cloudscape may be improved by burning-in at a higher grade to add greater tonal separation and mood.

shadow detail By using a harder grade setting on shadow details, subtle separation of tones that may not appear at lower contrasts can be lifted out. This is particularly useful when printing low light, push processed or underexposed films.

Knowing when to split-grade is determined, like other printing methods, through test strips. If you are familiar with a certain feel that any given grade may give to the print, then make a basic test at that grade. From this base, look for any possible areas that may benefit from a change of contrast, in particular, highlight and shadow details. Once you have determined these areas, change the contrast to suit. Expose and develop another test at the new contrast grade, importantly keeping the development time the same as the previous one. At this stage, you are comparing the base exposure/contrast test strip with the adjusted contrast shifts. Once you become accustomed to this practice you can make judgements and alterations without doing separate tests.

You can expose the print at a base grade and then either generally or locally burn in highlight details at a higher or lower grade; remembering that you can alter the lens aperture to aid with burning in. The key to split-grade printing is not to overcomplicate the procedure; this is distracting and frustrating, and a waste of time and materials.

photographer > Steve Macleod | **title** > Untitled | **paper** > Forte Polywarmtone Gloss Grade 3 | **exposure** > detailed below
developer > Ilford PQ 1-10 | **time** > three minutes

process > Polaroid type 55 pn film printed dark, very dark. This was shot near the Barbican in London and I wanted to print for the highlight but to retain subtle shadows. The image was cropped slightly side to side to correct the alignment. At f/16, a two minute basic exposure was made, I then added 40 seconds on the lower walkway and a further 10 from the railings down. 10 seconds were also added top-left diagonally to balance the tones.

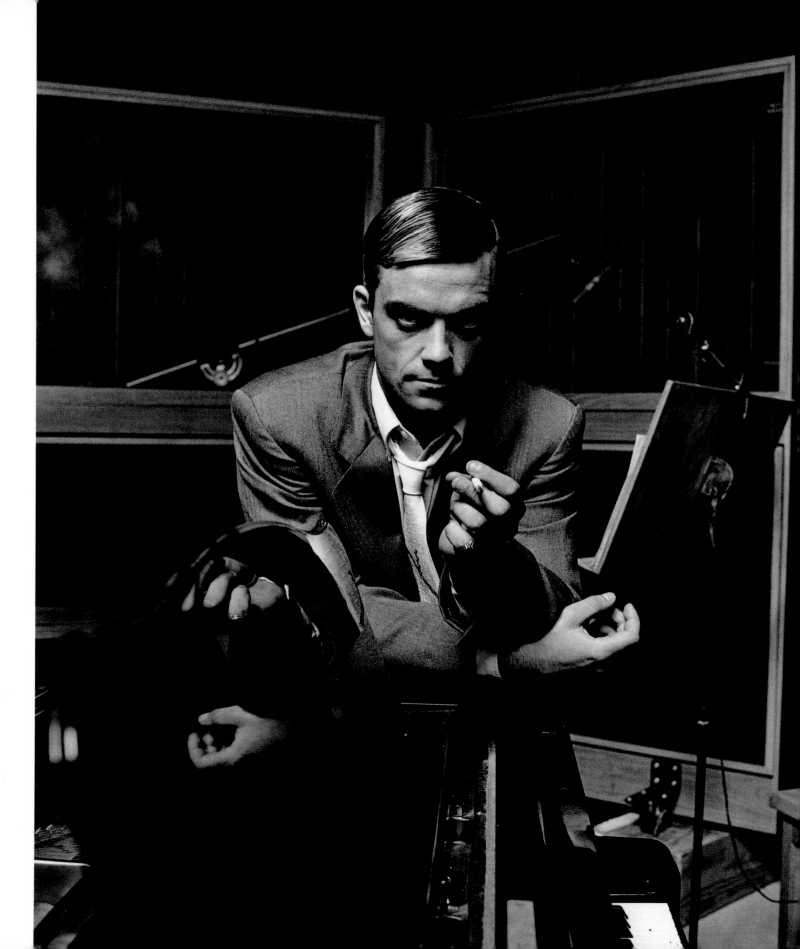

photographer > Hamish Brown **| title >** Robert Williams 'Swing When You're Winning' **| paper >** Forte Polywarmtone Gloss Grade 3
exposure > detailed below **developer >** Agfa Neutol WA 1-10 at 25°C **| time >** one minute

process > Originally, the cover for 'Swing When You're Winning' album, this image was dropped in favour of a colour shot. They were very similar yet it was felt that a colour image would sell more, particularly as it was launched near to Christmas. The brief was to keep it warm and dark so I over-exposed and underdeveloped to obtain deep shadow detail. At f/8, I exposed for 30 seconds, dodging the shadows so that they do not block in; added 10 seconds on the right hand and five seconds on the face. I then vignetted the four corners slightly for five seconds to create a more intimate feeling.

F8 50 seconds dodging

the face for 10 seconds, plus

20 seconds on the beams/top

half of print,

Add 20 seconds diagonally

to print @

Slight vignette all corners to stop down image

photographer > Hamish Brown | **title** > 'Robbie' | **paper** > Kodak Ektalure Grade 3 | **exposure** > detailed below | **developer** > Agfa Neutol WA 1-8
time > three minutes

process > Ektalure was one of my favourite printing papers, now sadly discontinued, but I could not do this book without including an example of it. Hamish and I noticed this image after doing the usual edit and 'in focus' stuff. I love the feeling of light and movement combined. Though this is not a commercial shot of Robbie, Hamish has used this in his portfolio. At f/8, I exposed for 50 seconds dodging the face for 10 seconds, adding 20 seconds on the beams at the top half of the print. Then I added 20 seconds diagonally across top left to balance the background tone. I then slightly vignetted all corners to stop the eye from drifting off the print.

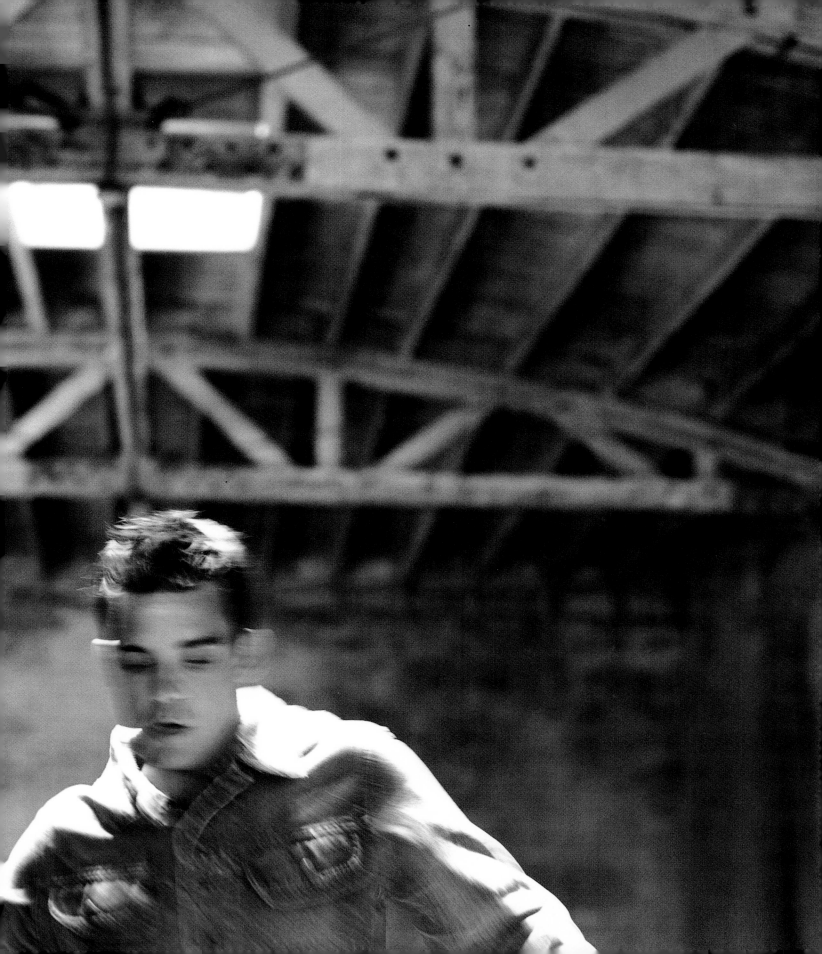

**Flash test strips with 0.5
second increments**

The background has been h[...]
to prevent it from blocking[...]

pre/post flashing

A very useful technique for adding general tone to the image is to use a flashing technique. It makes no difference whether we pre- or post-flash the paper – the result is the same. Some printers prefer to flash the paper prior to printing, sometimes flashing whole boxes at a time – not something I would recommend because the latent stability of some papers is very narrow and may cause fogging later on in use. Nevertheless, flashing is an underated and often misinterpreted printing effect that people refrain from using due to unfounded and lazy claims that it is too complicated and/or time-consuming, and that when the final print is viewed the effects are often negligible – an indication of proficient flashing. There are many ways to carry out this process, including small light attachments that fit to the enlarger for this specific purpose, such as the Flashmaster as manufactured by RH Designs. My preferred method is both fast and, more importantly, simple.

Sometimes, no matter how much we try overexposing print highlights, little tonal change occurs, and when it does, it looks crude, grainy and clumpy. To rectify this, we try and trigger the paper's responsiveness to light, effectively giving it a jump-start. All photographic film and paper has an exposure threshold where the emulsion reaches an inertia point and becomes receptive to light. That is what we try to do with flashing.

Once the print has been worked on and all the exposures made, remove the negative from the carrier and expose the paper, on the easel, to a pre-determined minimum exposure. This will introduce tone into the print, most noticeably in the highlights without the need for burning in, slightly fogging the paper. The amount of light required is likely to be about 0.5 to 1 second depending on the speed of the paper and the size of enlargement. The beauty of this is that, because the paper remains in the easel after initial exposure and flashing, the rebate or border remains masked, creating a clean line between the image and border.

To find a particular paper's fog level (which must not be exceeded when flashing), under safelight conditions, place a piece of paper in the easel without a negative in the carrier. With the lens stopped down to the normal working F-stop, using an opaque sheet of card, expose the paper to increments of 0.5 or 1 second, building up a test strip. Once processed, you should end up with a sheet of greyscale. The 'base-fog point' is the area between the paper base colour and the first hint of tone that appears on the sheet. Therefore, you know that from that point onwards, any more exposure, whether through a negative or white light, will add tone or fogging.

Flashing the paper can result in a slight drop in contrast and this should be compensated for in the initial exposure. By over-flashing, we can also add a creative touch to the printed image, by deliberately fogging the paper to flatten out contrast and introduce definite tones into the print. As all negatives have differing densities, the amount of flashing required will vary accordingly. Moreover, if toning is needed, I usually give more flash exposure to compensate for loss of highlight detail through bleach action. This can be taken further by selectively flashing areas of the image where it will be too obvious to burn in detail. This is done by recreating the shapes of your image with cut-outs and masks, blocking off areas that you do not want to be flashed, and changing contrast grades during printing. This way, areas that are softer appear to recede into the print, higher contrast areas become more prominent.

Remember, however, that nothing beats exposing and developing the film correctly in the first place. There are no hard-and-fast rules that apply to split-grade or flashing, and it can be used generally throughout the printing process or simply locally to soften or lift certain areas. The key is to apply your own system to produce a well-balanced and rounded interpretation of the subject.

There are no hard and fast rules that apply to split-grade or flashing, and it can be used generally throughout the printing process or simply locally to soften or lift certain areas.

photographer > David Clerihew | **title** > Underpass | **paper** > Ilford Multigrade Matt Grades 2 and 3 | **exposure** > detailed below
time > two minutes **toners** > Bleach formula for two minutes; wash for 10 minutes; Thiocarbamide 80ml, sodium hydroxide 20ml; 1 litre of water; tone for two minutes

process > I knew that for this image, the bleach toning action would affect the highlight areas, so I compensated with quite a strong post-flashing to introduce tone in the sky without having to burn it in. At f/11 grade 3, a basic exposure of 25 seconds was made, dodging the shadow areas slightly throughout the exposure, adding five seconds in each corner to draw the eye into the print. I then added 1¼ seconds post-flash at grade 2 to add tone in the sky.

I USED QUITE STRO

INTRODUCE TONE IN

THE HIGHLIGHTS WOU

SHIFT,

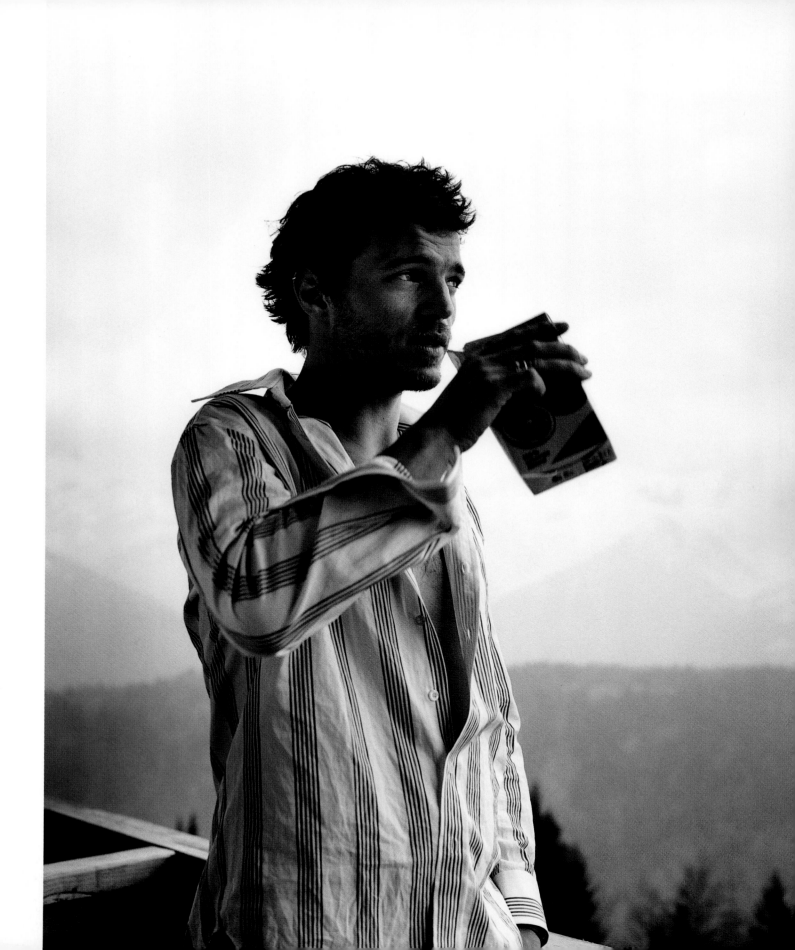

to burn them in ✳

that Deirdre did on
about ~~the~~ wintersports
of people waking up
too worried about the
ted to emphasise the
the image.
Work,
3 seconds G2½ to
lights rather than typ

photographer > Deirdre O'Callaghan | **title >** Untitled | **paper >** Agfa Multicontrast Gloss Grade 2–2½ | **exposure >** detailed below
developer > Agfa Neutol WA 1-10 | **time >** 1½ minutes

process > This image was from a series that Deirdre did on location in Austria. It was about wintersports and we needed to retain a feeling of people waking up in the cold, dappled light. I wasn't too worried about the heavy shadow detail as I wanted to emphasise the softness of the half-light of morning. Therefore, this image became stronger through the use of shape and form rather than a literal interpretation. A f/11 grade 2, a 30 second exposure was made holding back the face slightly for five seconds, just to catch the eyes. Then I added five seconds to the lower body and balcony and five seconds on the right-hand shirt highlight just to flatten it down. Finally, at grade 2½. I post-flashed for 0.3 seconds on f/11 just to bring a little detail to the background and to stop the guy from floating around in space.

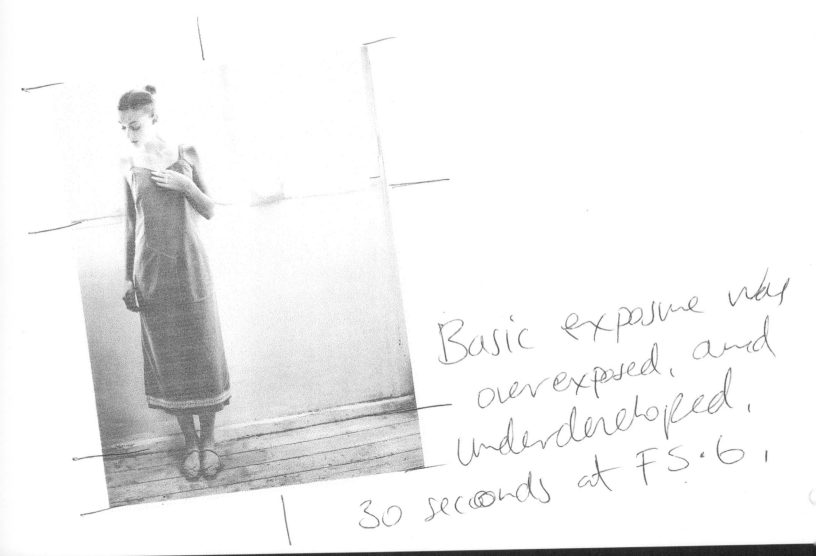

Basic exposure way overexposed, and underdeveloped. 30 seconds at F5·6.

photographer > Jamie Kingham | **title >** Untitled | **paper >** Forte Polywarmtone Gloss Grade 3 | **exposure >** detailed below
developer > Agfa Neutol WA 1-10 | **time >** three minutes | **toners >** Part bleach only for 30 seconds; then wash for 10 minutes; cold Thiocarbamide formula for one minute (consult tables, page 145)

process > This delicate image was post-flashed but we wanted to retain the feeling of bright light burning out any detail in the window. At f/5.6, an overexposure of 30 seconds was made, dodging the face only slightly – I wanted the body to block in as this exaggerated the balance between light and dark. Then I added 10 seconds on the right side window and five seconds on the wooden floorboards. Post-flash was 0.5 seconds at f/11.

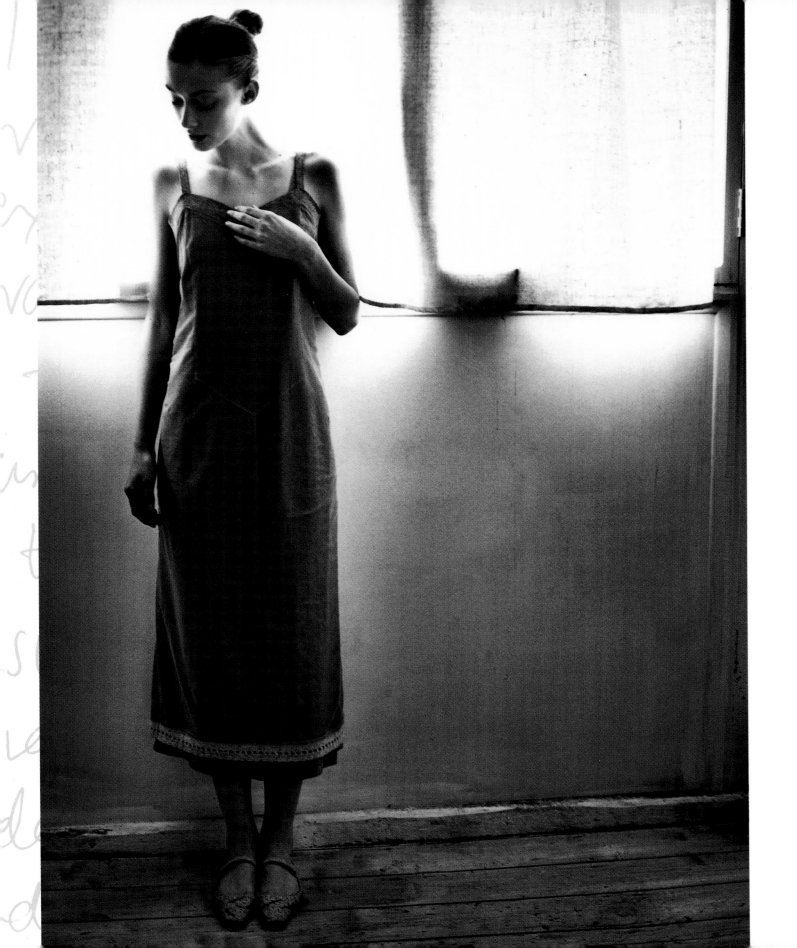

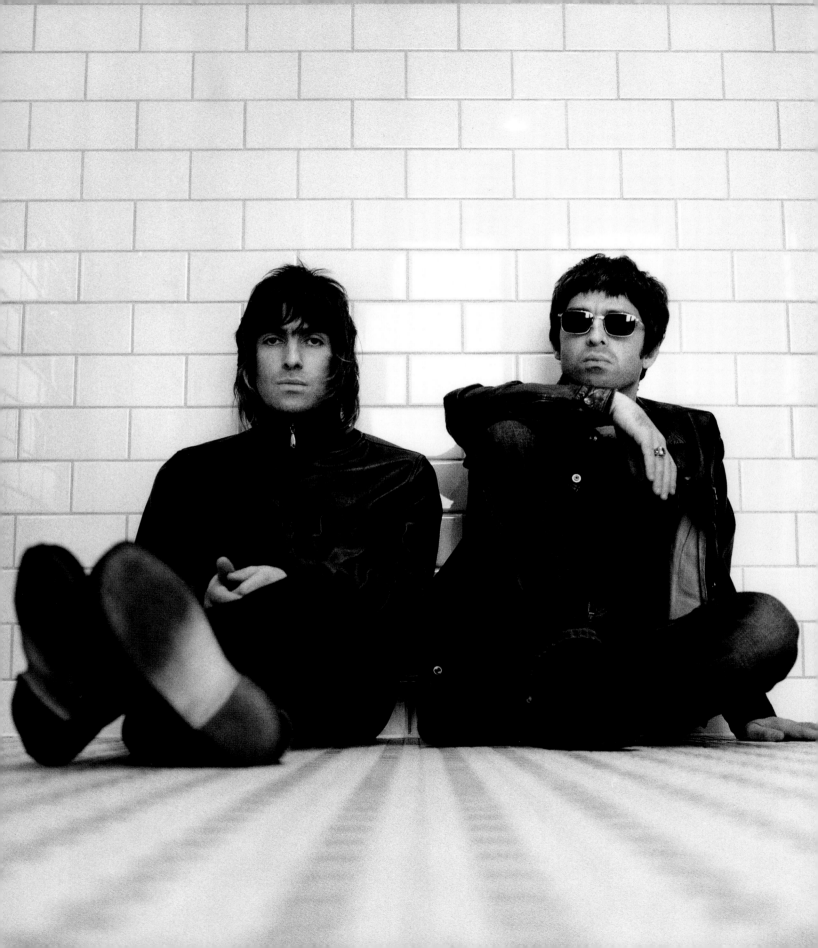

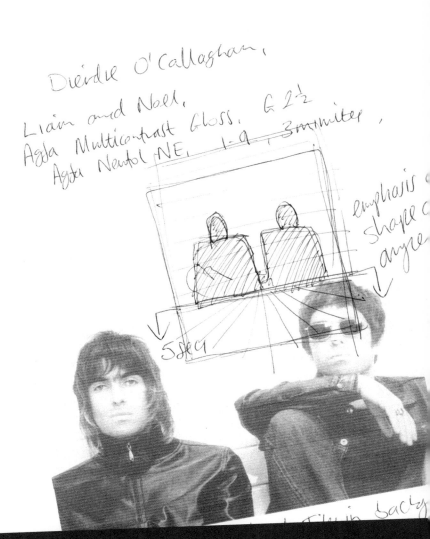

Deirdre O'Callaghan,
Liam and Noel,
Agfa Multicontrast Gloss, G 2½
Agfa Neutol NE, 1-9, 3minutes,

emphasis
shape
anyre

5 sec

photographer > Deirdre O'Callaghan | **title** > Liam and Noel | **paper** > Agfa Multicontrast Gloss Grade 2½ | **exposure** > detailed below
developer > Agfa Neutol NE 1-9 | **time** > three minutes

process > In 1997, I worked on a book and exhibition with Jill Furmanovsky entitled 'Was There Then', all about Oasis at the height of their fame. We all thought then that they would never endure but, thankfully for British music, they are still around. Here, a great image of the brothers by Deirdre is very simple yet effective. It is important that the composition is correct and the use of the tiles emhasises the perspective. At f/11 grade 2½, an exposure of 30 seconds was made, holding the faces for a little bit. I then added five seconds on the floor tiles to add weight and five seconds top left and right to close down the top of the image slightly. I post-flashed at f/16 for 0.4 seconds.

photographer > Steve Macleod | **title >** Old Steps Bath | **paper >** Forte Polywarmtone Gloss Grade 2 | **exposure >** detailed below
developer > Ilford PQ 1-6 25°C | **time >** two minutes

process > Shot early on a Sunday morning while everyone else was sleeping off the night before. I wanted to print for the shadow detail but the highlight through the arch remained too bright and dominated the image. By flashing the paper, I could play down the brightness without having to over-burn the area. Ultimately, it was irrelevant how I printed this at as long as it was long and dark, It was post-flashed and then pulled early from the developer – in effect, breaking all the rules.

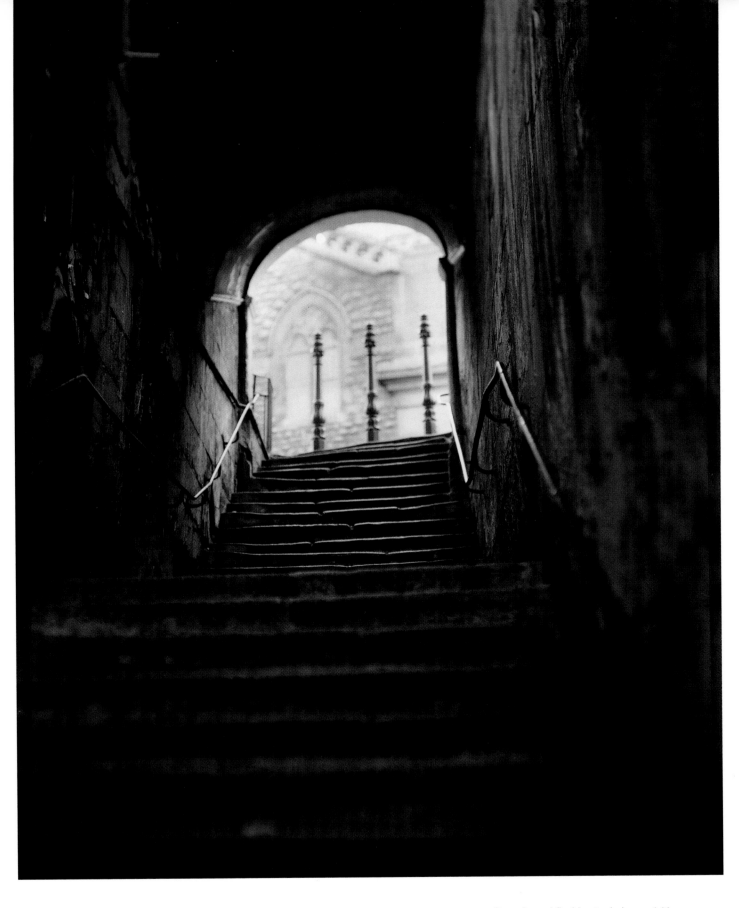

chapter 10

print toning and toners

> **Prints are all black, white or grey: well, they can be, but they don't have to be. There are several methods that we can use to add colour and create a different interpretation to the traditional black-and-white print.**

For many, toning prints infers contamination and otherwise great-looking prints spoiled by heavy-handed toning of the image, resulting in crude final presentation. There are two main reasons why we should tone prints: archival stability and protection of the print, and to provide impactive colour or tonal shift to the image.

toner categories

Toners can be grouped into four categories:

dye toners are classed as either 'mordant' or 'straight'. Mordant, or bleach-dye, toners use the bleach to convert silver to either silver iodide or silver ferricyanide, so that an organic carbon-based dye will then adhere to it. The dye adheres in direct relation to the density of the bleached image. Straight-dye toners affect all areas of the print equally as none of the silver is converted. The most common straight-dye toners are the blue and green types.

direct toners work by bonding an inorganic stable compound directly to the exposed silver, making it archivally stable. The process of toning can be halted by transferring the print to a water clearing bath and can also be continued at a later date. The most common type of direct toners are gold chloride and selenium, which are used in a single bath solution.

conversion toners, or indirect toners, most commonly sepia and brown, use a bleach bath, bleaching the image to a pale colour and then redeveloping to a new colour, depending on the chemistry.

replacement toners take the image silver and replace it with a compound of some other metal, usually ferricyanides; the most common of these are the copper toners.

paper choice

By degree, most papers are receptive to print toners and paper choice is important because there are so many variations. The main distinction is that papers that produce warmer chlorobromide tones by development react more to bleach action. Papers such as Agfa Multicontrast, Ilford Warmtone and some of the Forte range in particular, respond well and rapidly to this action and thus high bleach dilution is recommended to slow the process.

It is exciting to try out new paper, experimenting with different toner combinations, and you should let things happen at this stage. Get to know how differing papers work and find a combination that is sensitive to your style – don't just use a toner to try and improve a bad print.

WARNING! Take care when handling chemistry, especially in confined darkroom space. Whether using manufactured toner kits or working from raw chemistry, there is no such thing as a safe chemical. Many are caustic and toxic. Read the instructions even if you do not intend to following them. Always wear protection and work in a well-ventilated area. As toners do not have to be used in the dark, work in a different room or outdoors.

Ensure that any prints that you intend to tone have been processed properly and washed to remove any processing chemistry – if I am to tone any print, I ensure a minimum wash of one hour. Also handle the print surface with as little finger contact as possible, as this will prevent stains and blotches. I may seem over-cautious, but it can be disheartening to produce a beautiful print only to find that as soon as you proceed to the toning stage, irremovable stains appear, destroying all the hard work.

indirect thiocarbamide toner

Known as 'variable sepia', thiocarbamide toners are of the indirect or conversion type, in that there is a two-bath sequence to the procedure: a bleach and then a toner solution.

bleach is a combination of potassium ferricyanide and potassium bromide. I usually make up a stock solution by dissolving 100 grams of each in 1 litre of water. I then use diluted measures at working strength, about 1:10 or 1:20, depending on the receptiveness of the paper.

Slowing down the process gives you the opportunity to judge what is happening and how far you want to take the bleach effect. If we partially bleach the image, then only the areas that have been bleached will be receptive to the toner solution, therefore creating a split-tone effect. The less you bleach, the greater the split effect. Remember that although all of the print may be affected, the reaction is most noticeable in the highlights, and that when toned, a print can often lose subtle details due to bleaching, especially when a cooler or yellower tone is achieved. The reverse is also true: when a warmer brown tone is used for the shadow details, they can appear muddy and lose density. Therefore, when you come to print an image that is going to be toned, you have to compensate in the printing for these apparent losses. To achieve this, I often split-grade and overprint, or even overflash, so that the highlights appear more defined or blocked in, and the shadows hold more detail. Again, don't be afraid to experiment.

After bleaching, the print should be washed in running water until all of the yellow bleach residue clears; this can take up to five minutes.

toner The toner solution is normally a mixture of sodium hydroxide and thiocarbamide; again make up stock solutions of each containing 100 grams to 1 litre of water. The working solution of 1 litre should be mixed just prior to toning. Once combined, it is the relative strengths of each chemical that provides the colour shift characteristic of sepia toners. Below is a table showing possible combinations and the resulting colour shift. (Sol A: 100 grams sodium hydroxide in 1 litre water; Sol B: 100 grams thiocarbamide in 1 litre water)

sol A	sol B	colour
80ml	20ml	purple brown
70ml	30ml	cold brown
30ml	70ml	warm brown
20ml	80ml	yellow

Once cleared of bleach, the print is placed in the toner solution. The print should lift and come back to the chosen tone; more sodium in the mix makes the print appear quicker, whereas more 'thio' retards the process. After toning, the print should be washed thoroughly and if scum marks or white residue appear, the print should be placed in a five per cent solution of acetic acid, then rewashed.

There are two formulae that are used to bleach local areas of a print, commonly respectively known as 'ferri' or 'farmers'. The main difference between them is that the effects of farmers are irreversible as the hypo content removes the bleached silver from the print, and therefore is not available for redevelopment.

The formula for farmer's reducer is mixed prior to use as it exhausts within a few minutes of mixing: store in separate opaque bottles and mix 5 parts A (10 grams sodium thiosulphate (hypo) added to 100ml water) with 1 part B (10 grams potassium ferricyanide added to 100ml of water), then double the volume with water to make a working strength. Farmers can be used to brighten subtle highlights or to clean up the print border.

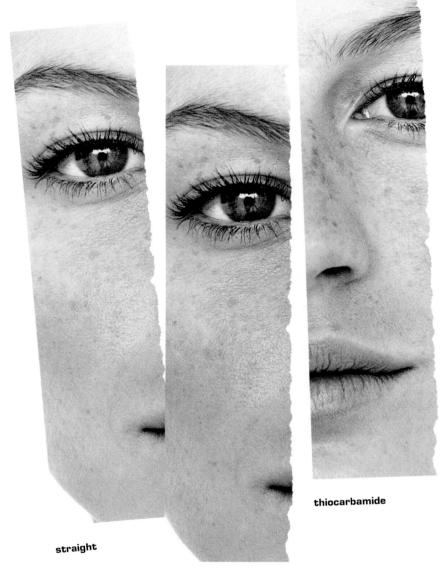

straight

bleach

thiocarbamide

photographer > Corinne Day | **title** > Gisele for UK Vogue | **paper** > Agfa Multicontrast Gloss Grade 3 | **exposure** > detailed below
developer > Agfa Neutol WA 1-9 | **time** > 1½ minutes | **toners** > Bleach formula for one minute; wash for 10 minutes; Thiocarbamide
formula; wash for 10 minutes; Selenium toner 1-10 for two minutes (refer to sample diagrams, page 145, for changes in colour and tone)

process > At the end of the printing session we wanted to try something different for this cover story. The image was cropped tight on the face to align the composition. In printing, it was important to keep the eye detail, and the toning helped raise the detail between the freckles and the skin tones. At f/11, an exposure of 30 seconds was made, holding back each eye socket for five seconds. I then added five seconds to the forehead to balance the flesh tones. This was a very easy image to work from and Corinne adds something quite magnificent to it.

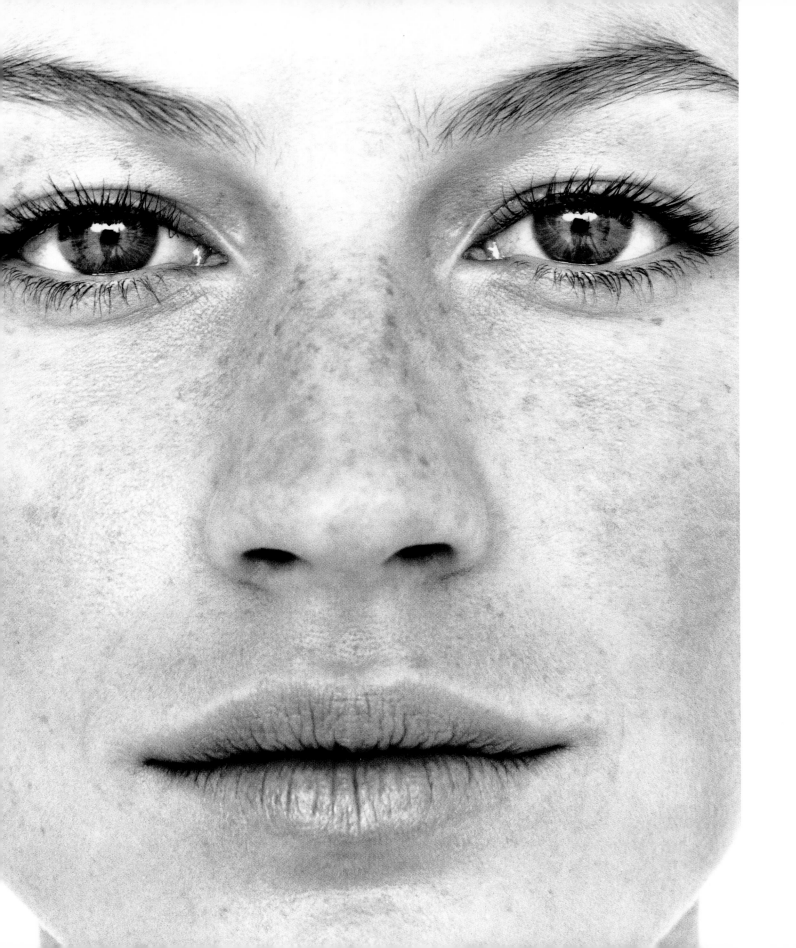

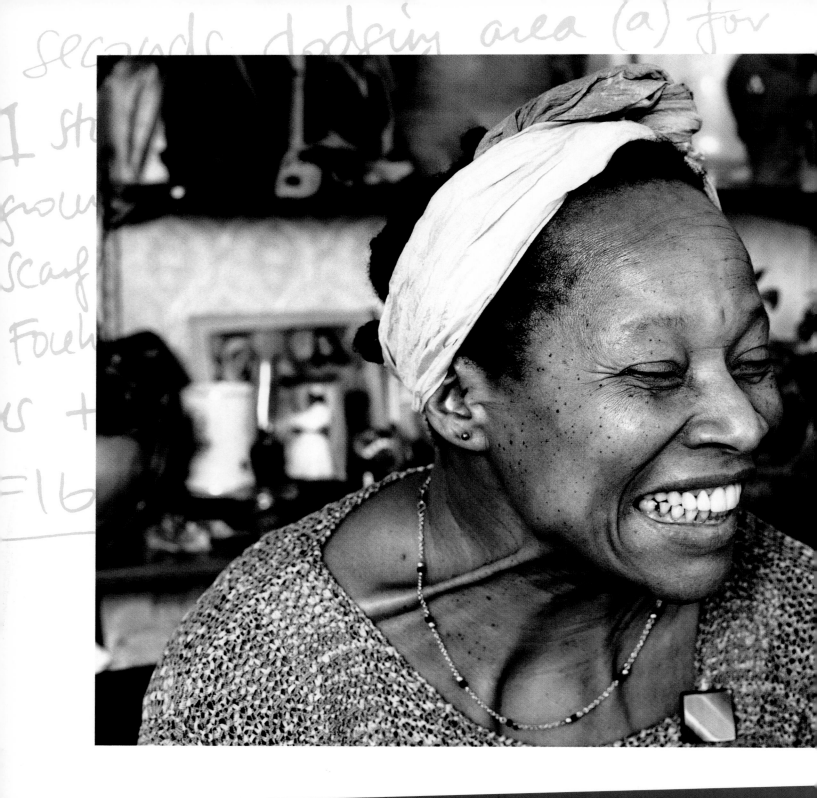

secconds dodging area (a) for
I st
grow
scarf
Foreh
es +
=F16

photographer > Mark Guthrie | **title >** Untitled | **paper >** Ilford Multigrade Warmtone Gloss Grade 1½ | **exposure >** detailed right
developer > Ilford PQ 1-20 35°C | **time >** two minutes | **toners >** Bleach formula for one minute; wash for 10 minutes; warm brown
Thiocarbamide; wash for 10 minutes; Selenium toner 1-8 for one minute

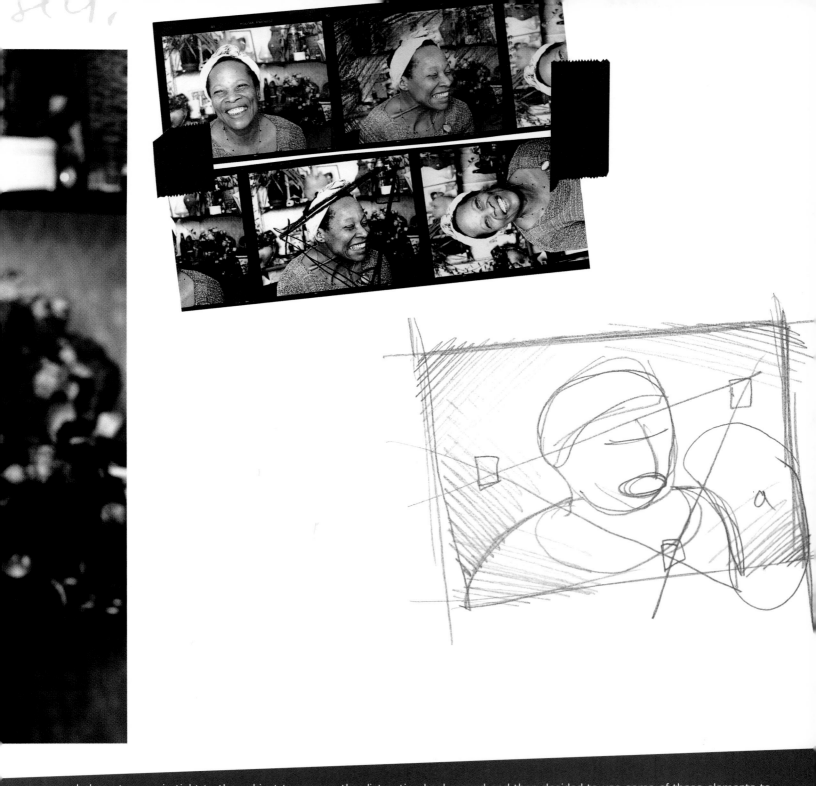

process > I chose to crop in tight to the subject to remove the distracting background and then decided to use some of these elements to direct the viewer around the image. This is quite a heavy crop, as can be seen from the initial contact sheet, but there are three key areas of light that help centralise the subject's face, therefore the eye is drawn around and not into the print. At f/16, I exposed for 40 seconds, dodging the bottom right for 10. Then I opened up the lens one stop to f/11 and burnt in the background for 10 seconds, also the head scarf for 20 seconds and the forehead bright spot for 10. I slightly vignetted the corners and shoulders randomly for a further 10 seconds. Finally, I stopped back down to f/16 and post-flashed at grade 2½ for 0.4 seconds just to take the edge off the highlights.

Post flash & inte into the highlights

Darken

darken background

photographer > Ulrik Bentzen | **title >** Untitled | **paper >** Forte Polywarmtone Gloss Grade 2 | **exposure >** detailed below
developer > Agfa Neutol WA 1-10 | **time >** three minutes | **toners >** Bleach formula for 30 seconds; wash for 10 minutes; cold
Thiocarbamide formula; wash for 10 minutes; Kodak Selenium Toner 1-8 for one minute

process > This image had to be printed quite flat and dark to compensate for the action of the toners. I have also flashed the print to compress the tonal range. I wanted to add to the narrow depth of field used here by creating the effect of the model emerging from the darkness. At f/11 grade 2, a basic exposure of 35 seconds was made, holding back the lower part of the face to balance the skin tones and the eye sockets for five seconds each. I then added 10 seconds to each side of the background around the hair and five seconds on the torso to add weight. This also emphasised the direction of the light falling on the shoulder and collarbone. Prior to development, I flashed the print quite heavily at f/11 for one second to ensure even tones in the highlights through the procress.

photographer > Steve Macleod | **title >** Untitled | **paper >** Agfa Multicontrast Gloss Grade 3 and Grade 2½ | **exposure >** detailed below
developer > Agfa Neutol WA 1-10 | **time >** three minutes | **toners >** Bleach formula for two minutes; wash for 10 minutes: warm
Thiocarbamide formula; Selenium toner 1-8 for three minutes

process > Shot on Polaroid Type 55 pn film, I overexposed by two stops to capture the bright highlight. I wanted to exaggerate the relationship between the
height of the building and the converging angles. A f/11 grade 3, a basic exposure of 40 seconds was made. I held back the border eding for five seconds on
each side so as not to lose this detail that is particular to Polaroid negatives. I then burnt in the sky for an additional 10 seconds and bottom third of the image
for 10 seconds. Then at grade 2½, I burnt in the bright highlight of the building for 20 seconds. Prior to toning, this image looked a bit too heavy and flat but this
was to compensate for the action of the toner.

Shot on Polaroid Type 55 pn. overexpost
not
to exaggerate

burn down
and slap by 10f @f
and slap @f
basic exposure

photographer > Mike McGoran | **title** > Untitled | **paper** > Kodak Ektalure Grade 3 | **exposure** > detailed below
developer > Ilford PQ 1-15 | **time** > 3½ minutes | **toners** > Bleach formula for 30 seconds; wash for 10 minutes;
warm Thiocarbamide formula for two minutes; wash for 10 minutes; Kodak Selenium 1-10 for two minutes.

[handwritten notes, partially legible]

...therefore the emphasis

fairly even.

see at G3 F11.

darken bottom half and corner by 15 sec.
add +10 at top.
* slightly over develop to compensate for action of toners *

+10
+15
+5
+5
121v

process > Mike shot this whilst visiting France where he was renovating a cottage. It was raining and he popped inside a church for shelter and came across this unusual font. This was an end frame and was rather underexposed but, with a bit of tweaking, it still printed up okay. Because it was underexposed, the background tended to block in and I wanted to try and keep the tones even. At f/11 grade 3, I made an exposure of 40 seconds and deliberately held back areas of the background throughout the exposure. I then added 10 seconds to the area above the font, 15 seconds at the bottom left, and a further five seconds to each corner to draw the eye into the print. I was in effect printing back in the shadows that I was holding back, but in a more controlled fashion. I over-developed this print to compensate for the action of the toners.

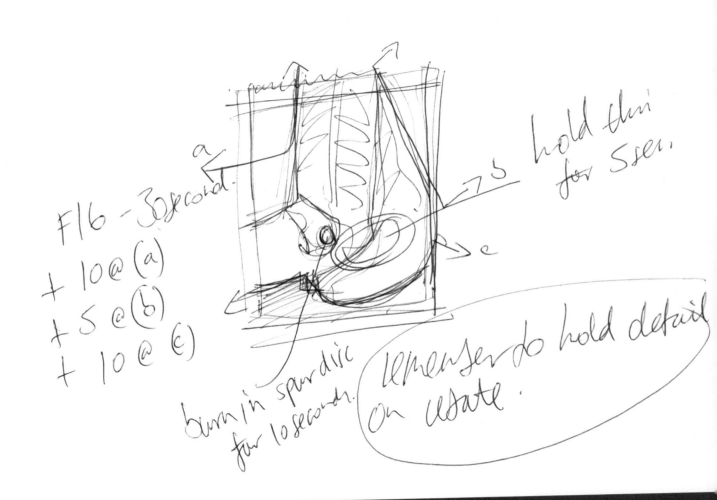

F16 - 30 second.

+ 10 @ (a)

+ 5 @ (b)

+ 10 @ (c)

burn in spur disc for 10 seconds.

remember to hold detail on estate.

hold this for 5 sec.

photographer > Jon Nicholson | **title >** Cowboy Boots | **paper >** Agfa Multicontrast Gloss Grade 3 | **exposure >** detailed below
developer > Agfa Neutol WA 1-6 | **time >** two minutes | **toners >** Kodak Selenium toner 1-10 for three minutes

process > Taken from 'Cowboys, A Vanishing World', this was also a portfolio print, it was shot on Polaroid type 55 pn. Without being clichéd, I wanted to create an old western feel for this, less Johnny Mathis and more Roger Miller. The varying textures and tones are emphasised by the use of selenium. At f/16, I exposed for 30 seconds, holding back the rebate for five seconds on each side so that they didn't block in. Then I added 10 seconds at upper-left side and lower portion of the print and five seconds to the upper-right side from the boot to the edge. I burnt the central spur disc for an extra 10 seconds to show more detail and to prevent distraction.

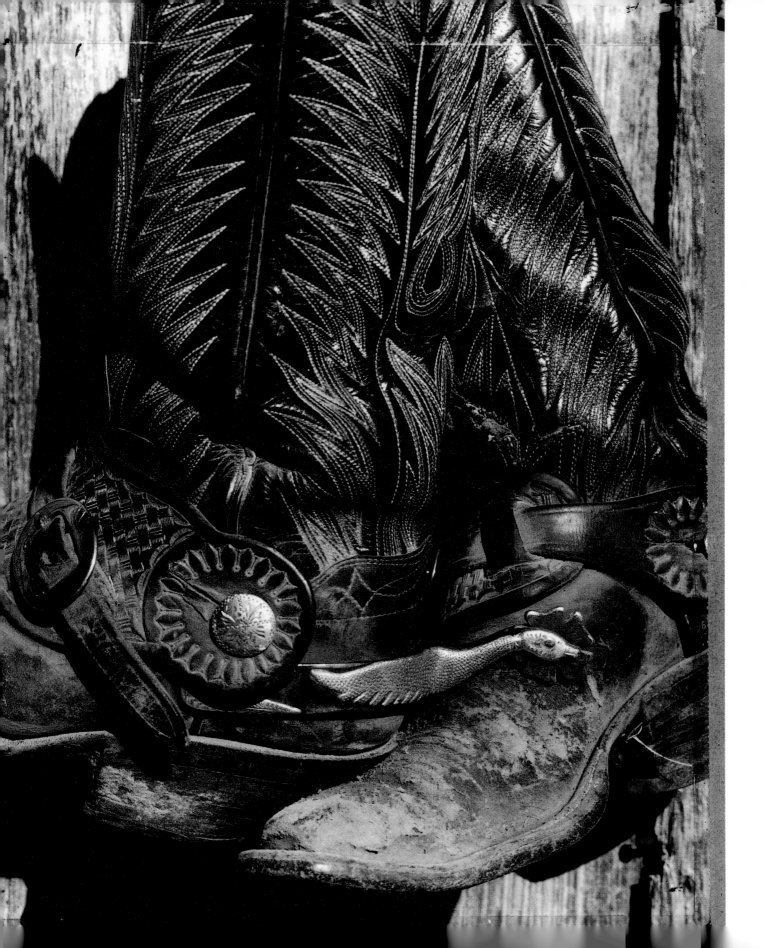

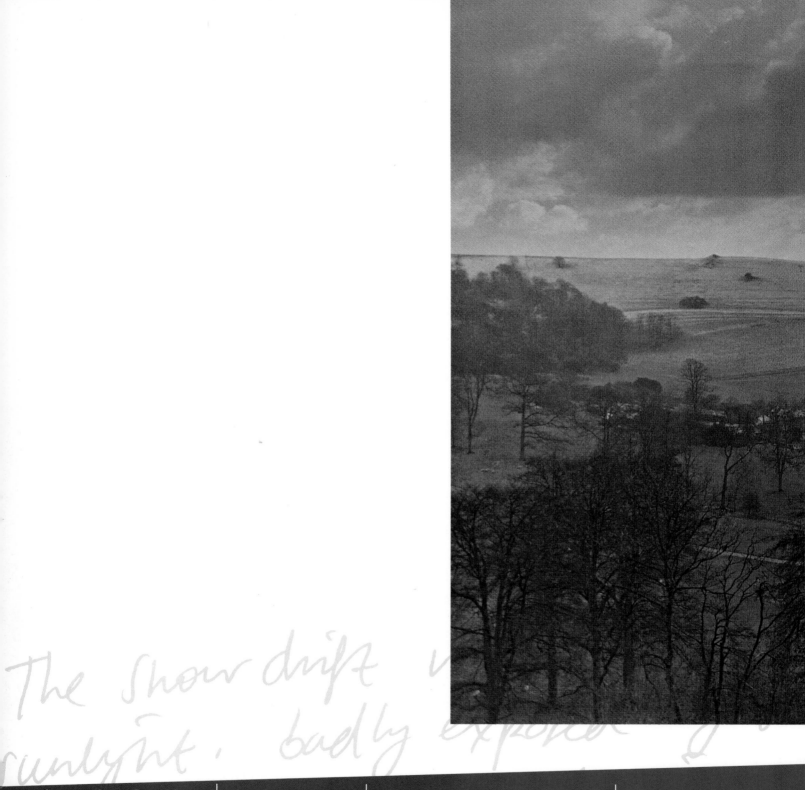

The snow drift in sunlight, badly exposed

photographer > Steve Macleod | **title** > Pewsey Vale Snow | **paper** > Ilford Multigrade Gloss RC Grade 2 | **exposure** > detailed below
developer > Ilford PQ 1-9 | **time** > three minutes | **toners** > Bleach formula for 30 seconds; wash for 10 minutes.; warm Thiocarbamide
formula for two minutes; wash for 10 minutes; Kodak selenium toner 1-10 for two minutes.

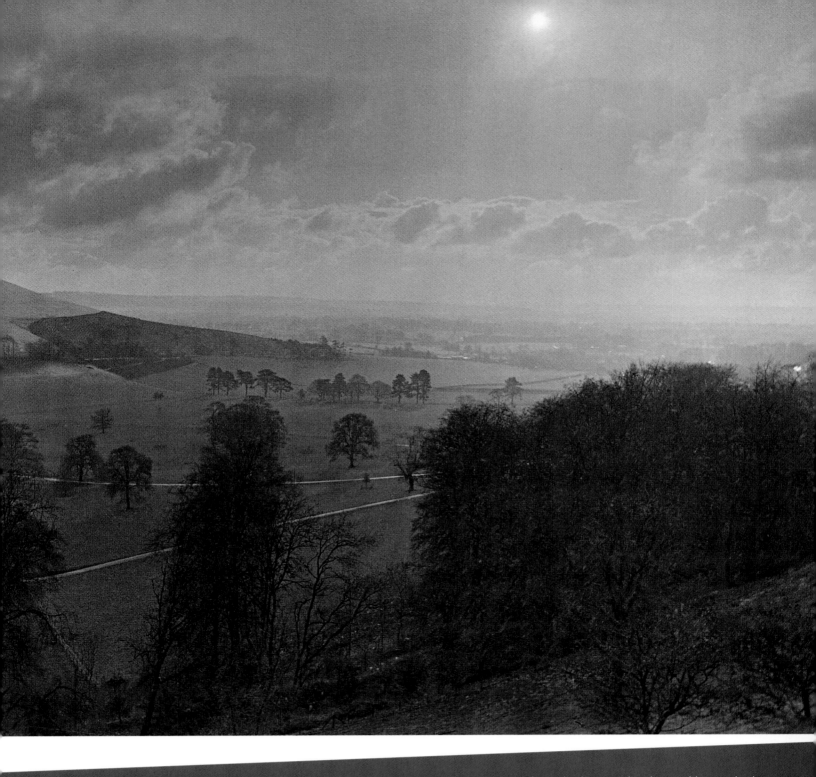

process > This is a cropped panorama from a 35mm negative. Though underexposed with no d-max in the negative, I was able to print in the very subtle values of light. I was answering a call of nature while walking in Wiltshire and noticed the snow drift was coming into the vale through the diffused sunlight. I didn't have much time, therefore shot three bracketed frames in the hope I got one right. At f/11 grade 2, I exposed for 30 seconds dodging the trees in the middle distancce for 10 seconds. I then added 15 seconds in the sky and 10 seconds on the top-left clouds to emphasise them. To balance this, I added 10 seconds in the far-top-right corner. To the bottom of the page, I added 10 seconds to the foreground trees to fake a feeling of distance and perspective. Though this was done on RC paper, it had quite a long developing time and also the effect of the toner is quite different to that of the FB equivalent.

This toner can also be used with a conventional bleach bath and some strange and interesting effects can be achieved by bleaching, toning and bleaching again – not for the faint-hearted!

direct sulphide toners

This collection of toners usually comes as a single solution, that either partially or completely convert the silver into a silver sulphide. Two of the most common kits available are Agfa Viradon and Kodak Brown Toner. Both are alkaline solutions that are made up of polysulphides, which are slow acting and can take up to 30 minutes to reach toning completion when used at room temperature. The process can be speeded up by increasing the temperature up to 40°C, but be aware that these toners give off hydrogen sulphide gas, and Agfa Viradon, in particular, smells really bad! But if you can overcome this, the advantage of these toners is that partially-toned prints can be treated subsequently in other toners.

Dilute Agfa Viradon 1:50 with water and allow to sit for 30 minutes prior to use as it becomes more effective. This toner can also be used with a conventional bleach bath and some strange and interesting effects can be achieved by bleaching, toning and bleaching again – not for the faint hearted!

The Kodak Brown Toner diluted 1:30 is more like the old hypo-alum toner. It has high alkalinity and initially creates an effect similar to a partially-bleached print, then the colour intensifies the longer the print remains in the bath.

photographer > Ulrik Bentzen | **title >** Untitled | **paper >** Agfa Multicontrast Gloss Grade 3 | **exposure >** detailed below | **developer >** Agfa Neutol WA 1-10 | **time >** three minutes **toners >** Agfa Viradon 1-30 one minute; Rayco Blue Toner A+B solutions for 30 seconds

process > This was taken from a magazine feature on winter beauty. I met Ulrik while lecturing in Copenhagen and he is a technically excellent and very creativephotographer, willing to experiment. This image had to be very dark and gothic in nature and, of course, sensual. It is rare that I use blue toner as I feel that it can be quite crude, but here combined with the Viradon, to add another subtle dimension. At f/16, I exposed for 30 seconds, dodging the eye sockets for 10 seconds each, then added five seconds on the bridge of the nose and forehead just to balance the skin tones. I burnt in the background around the head for 10 seconds to focus on the face. The emphasis here is on the catchlights in the eyes – they come out of the gloom and remain clear.

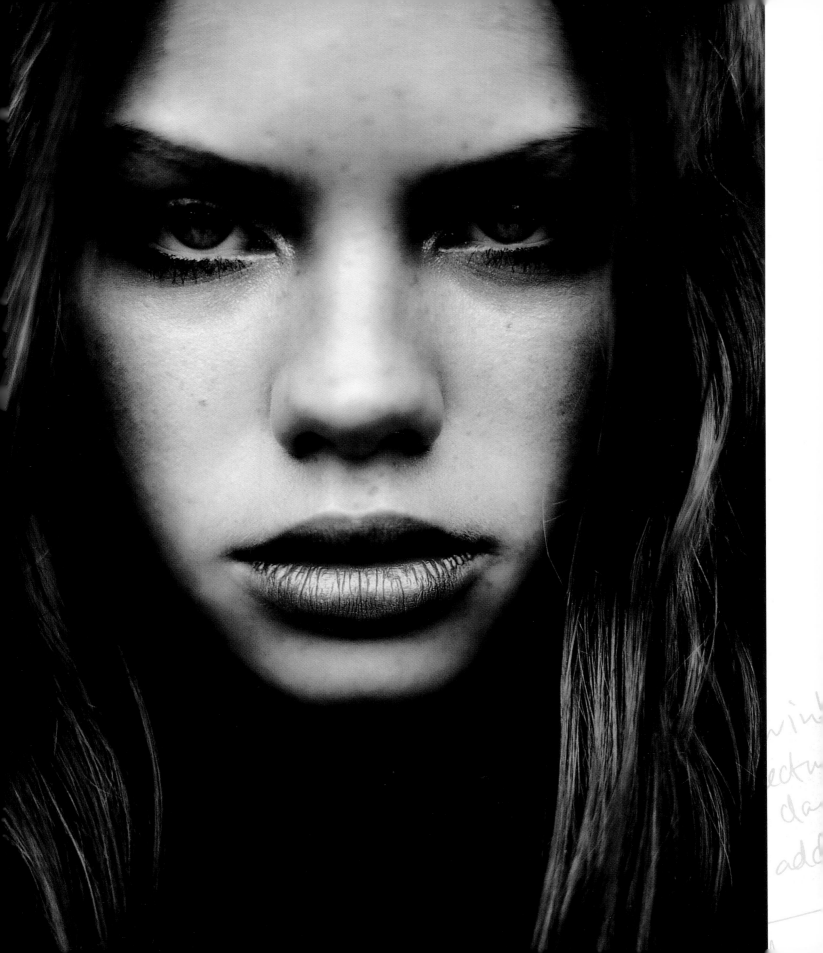

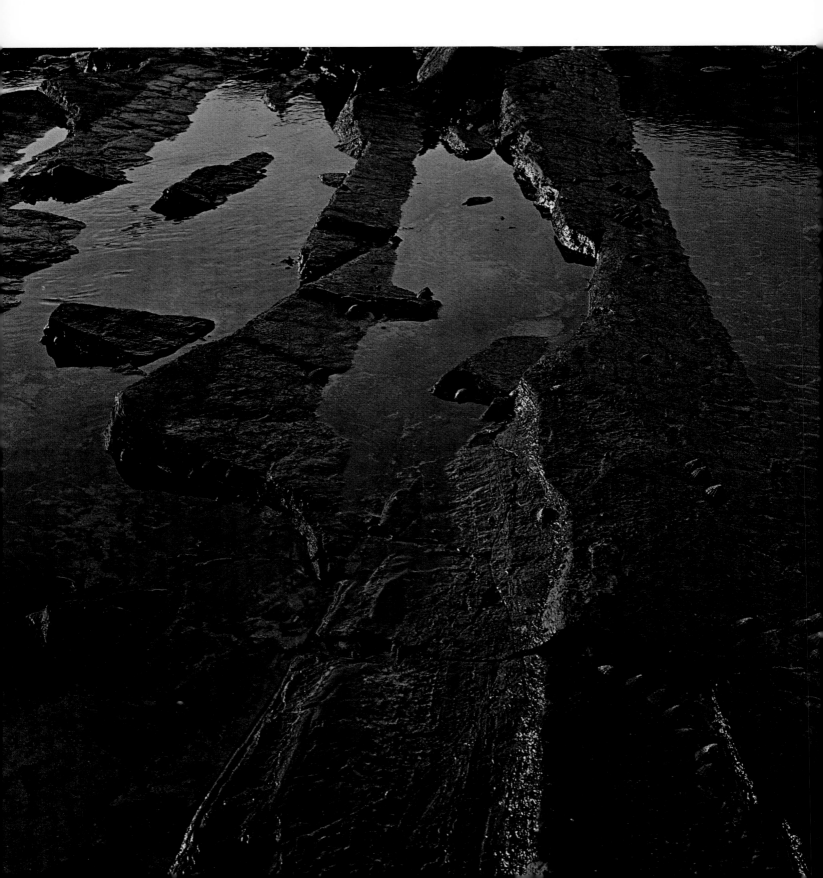

selenium and gold toners

Supplied as single-solution liquids, selenium and gold toners bond an inorganic compound directly onto the exposed silver, converting it to either a silver selenide or gold chloride. Renowned for their archival qualities, these toners act in direct relationship to the amount of silver in the print. Where there is no metallic silver in areas such as clear highlights, then there will be no action from the toner. Like many of the toners, different papers react in very different ways to the same toner solutions, so experimentation is necessary.

Gold toner usually comes as a liquid and is used undiluted. If not exhausted, it is restored after use. Gold toner gives a deep blue, more subtle than the vibrant blue-dye toning. Its effects are more noticeable on slow chlorobromide papers such as Agfa Multicontrast and Forte Polywarmtone, and can take up to five minutes to show colour shift. The toner action is halted by immersion in running water.

Selenium toners come in liquid form also, and can be diluted to give a variety of effects. It is best to experiment, as different paper types will provide varying degrees of colour shift. A general rule is that more diluted toner, say 1-20, provides cooler, more red effects; more concentrated dilutions, 1-5, provide warmer, more purple tones. The temperature, dilution and amount of time in the toning bath control the degree of tone. I normally dilute stock selenium at 1-8 or 1-20 depending on the use, and I store this in an airtight opaque bottle. When I use the diluted stock, I often warm it to 30°C using a hot plate.

WARNING! At this point, be aware that selenium is potentially very toxic and some say carcinogenic in character – so do not take any chances, especially at higher temperatures. Wear protection!

I never discard my selenium stock; I add 10 per cent raw selenium to the working volume of toner, then return it to the bottle; this matures the toner. Do not worry if black debris appears, as this will not affect the print.

Renowned for their archival qualities, these toners act in direct relationship to the amount of silver in the print.

photographer > Steve Macleod | **title >** Rockpool | **paper >** Oriental Seagull Grade 3 | **exposure >** detailed below | **developer >** Agfa Neutol WA 1-6 | **time >** three minutes | **toners >** Kodak Selenium 1-15 three minutes

process > This rockpool is on Sandside beach near where my parents live. I shot this on a cold winter day and decided to print it with low values as it appeared to me that day. This was printed on a graded paper which was fine as the negative and paper matched with the way I chose to print. I feel selenium creates a great split between the shadow and mid tone values. At f/16 I exposed for 40 seconds, holding back some of the deepest shadows, then added 15 seconds to the sky/background levels just to drop them out; Finally, 10 seconds each to the lower-left and right corners.

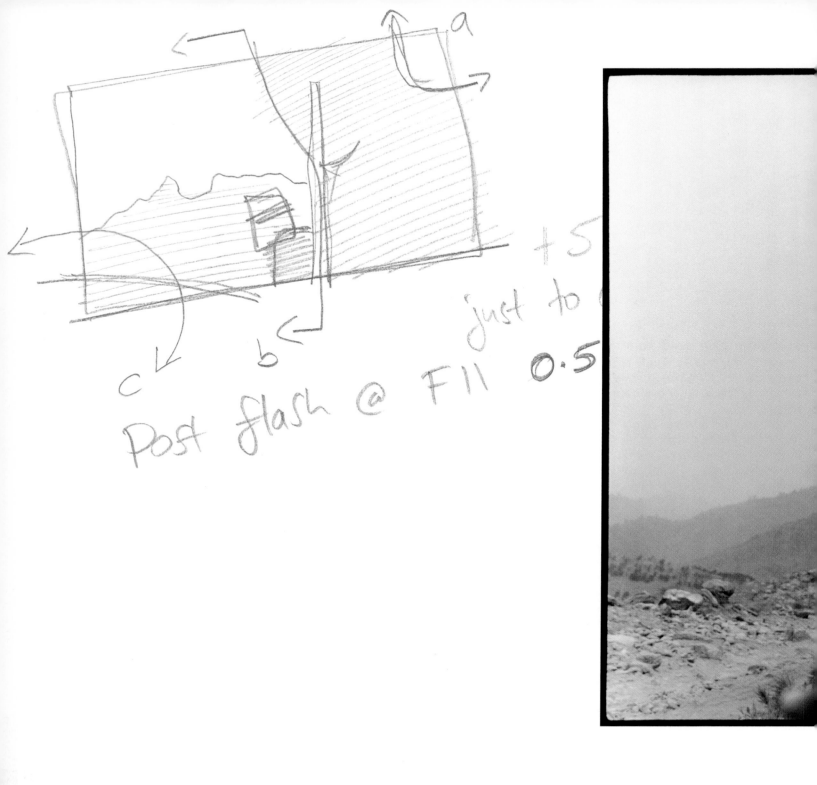

a

+5

just to

Post flash @ F11 0·5

c

b

photographer > Gary Knight │ **title** > Allied Bombing Northern Afghanistan │ **paper** > Agfa Multicontrast Gloss Grade 3
exposure > detailed right │ **developer** > Agfa Neutol WA 1-10 │ **time** > three minutes │ **toners** > Kodak Selenium Toner 1-6 at 35˚C for one minute

dodging facial details slightly.

process > Part of the series taken on assignment in Afghanistan during concentrated Allied bombing of the Taliban front line. At f/8, I exposed for 25 seconds, dodging the face a little. Then I added five seconds at the extreme top-right corner, five seconds from the face to the left of the image and five seconds to the lower-left foreground. I then burnt in the smoke stack for a further five seconds just to emphasise this area. Finally I post-flashed at f/11 for 0.5 seconds.

smooth skin tones
...d by the selenium which
...trast. I wanted

photographer > Hamish Brown │ **title** > Melanie Blatt, All Saints │ **paper** > Forte Polywarmtone Gloss Grade 3 │ **exposure** > detailed below
developer > Afga Neutol WA 1-10, 30°C │ **time** > one minute │ **toners** > Kodak Selenium 1-15 at 10°C, for three minutes

process > A very straightforward print, aiming to concentrate on the powerful stance of the subject. It was important to achieve smooth skin tones and to maintain good blacks (this was aided by the use of the selenium post-processing). I wanted the subject to lift out of the shadows without becoming bleached out. At f/16 grade 3, I exposed for 35 seconds, holding the lower jaw for five seconds and the T-shirt for 10 seconds. The shoulders needed an extra five seconds each side to compensate for the lighting. I then darkened the background by exposing for a further eight seconds. The warm developer helped bring in all the tones together, printing out quickly with a minute development time.

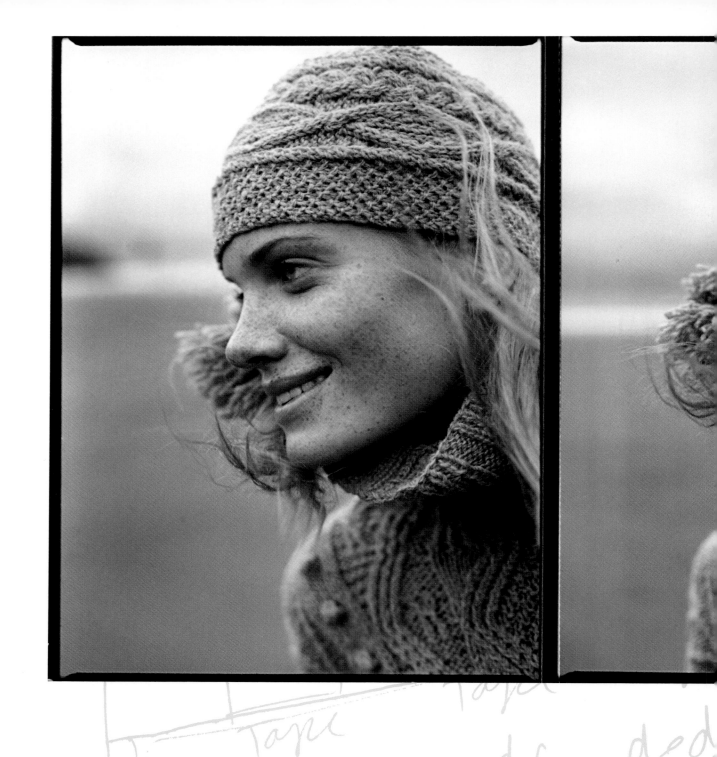

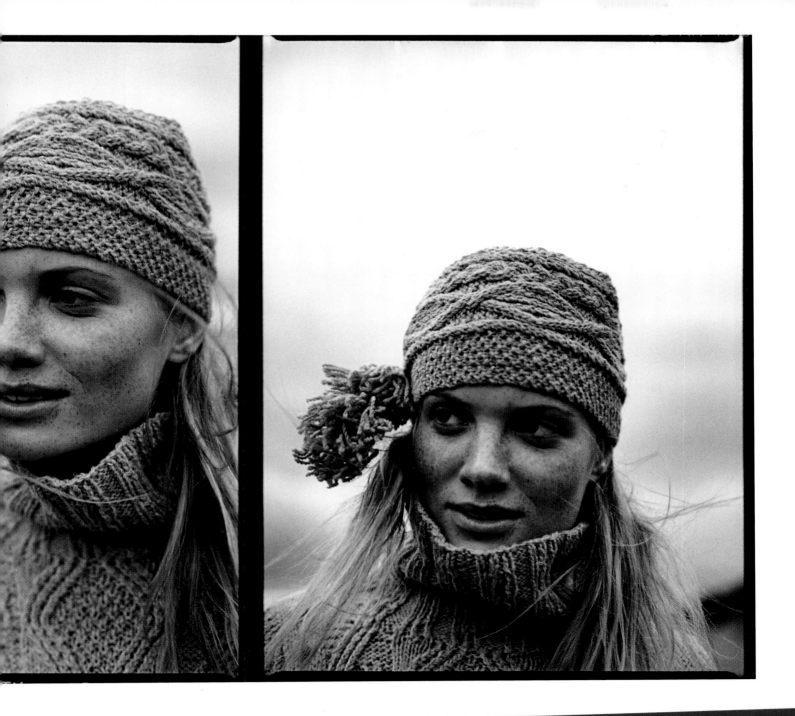

photographer > Jamie Kingham | **title** > Winter Woolies **paper** > Forte Polywarmtone Gloss Grade 2 and 3 | **exposure** > detailed below
developer > Ilford Multigrade Developer 1-20 | **time** > two minutes. | **toners** > Tetanol Gold toner for five minutes

process > As I was looking through Jamie's contact sheets, I noticed these three negatives forming a small story. They didn't run in sequence, so I cut up strips and taped them together onto the enlarger glass carrier. I think it is a credit to Jamie's metering that they all had similar exposure latitude – making them easy to print together. At f/16 grade 3, I exposed for 40 seconds, dodging the faces randomly throughout the exposure. Then, at grade 2, I burn in slightly each background to match for roughly 12 seconds. I then toned the print in Gold toner until the required colour shift was reached.

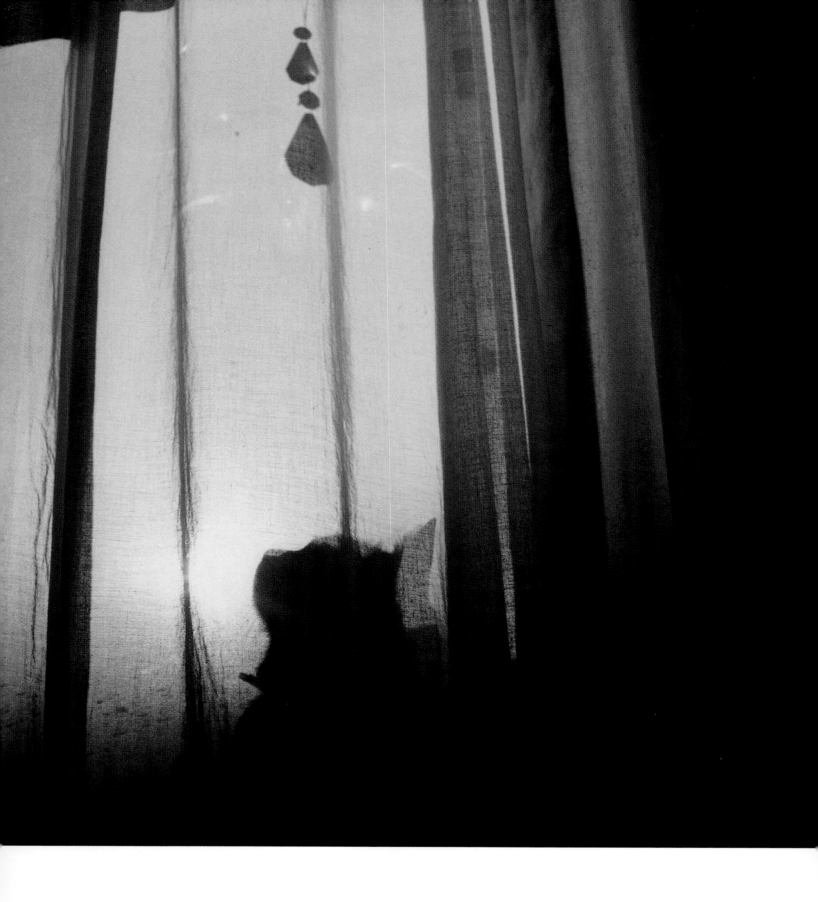

I wanted this to retain a flat diffused light, It needed massive exposure,
F 8 40 seconds overall,
add 15 seconds in each shadow area (cat and curtains).

photographer > Steve Macleod | **title** > Buxton | **paper** > Oriental Portrait VC Grade 4 | **exposure** > detailed below
developer > Agfa Neutol WA 1-6 | **time** > three minutes | **toners** > Tetanol Gold toner for three minutes; Kodak Selenium toner for two minutes

process > This was taken from a C-41 colour negative. As it is a dye-based medium, the black-and-white enlarger can sometimes have difficulty registering tonal values according to the negative. there is also a masking effect done by the negative dye which increases overall exposures and flattens contrast. This wasn't a problem in this case as I wanted to translate a flat diffused light in the print. at f/8 expose for 40 seconds overall and add 15 seconds into each shadow area, i.e. the cat and the curtains on either side. Then flash for 0.4 seconds. The combination of the gold and selenium toners helps increase the contrast and separation of the tonal range.

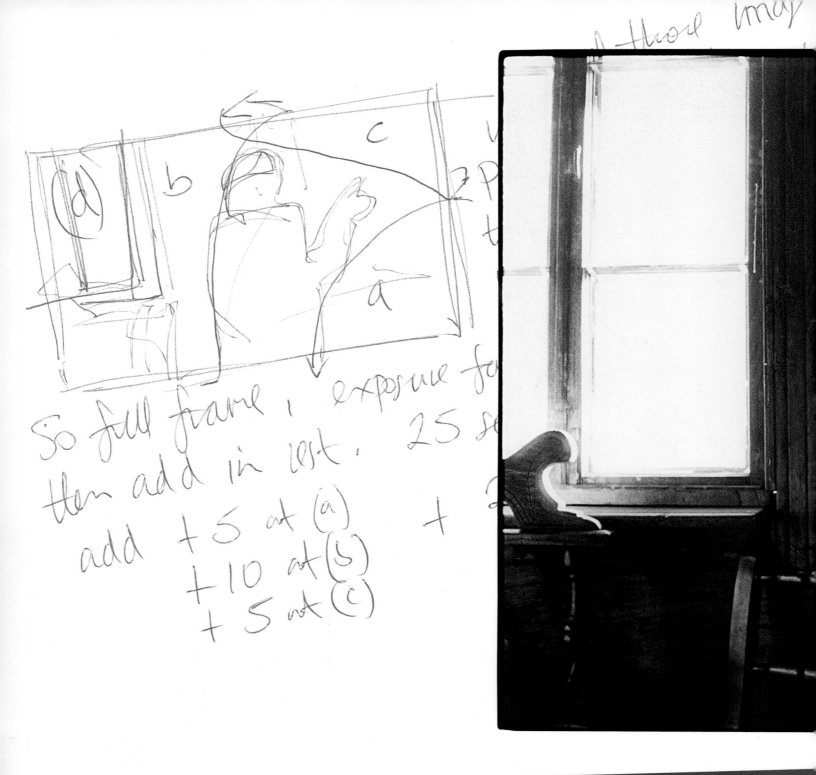

So full frame, exposure for
then add in rest. 25 s
add + 5 at (a)
+ 10 at (b)
+ 5 at (c)

photographer > Steve Macleod | **title >** Old Woman, Georgia | **paper >** Agfa Multicontrast Gloss Grade 3 | **exposure >** detailed below
developer > Kodak Dektol 1-10 | **time >** two minutes | **toners >** Kodak Selenium toner 1-8 for three minutes

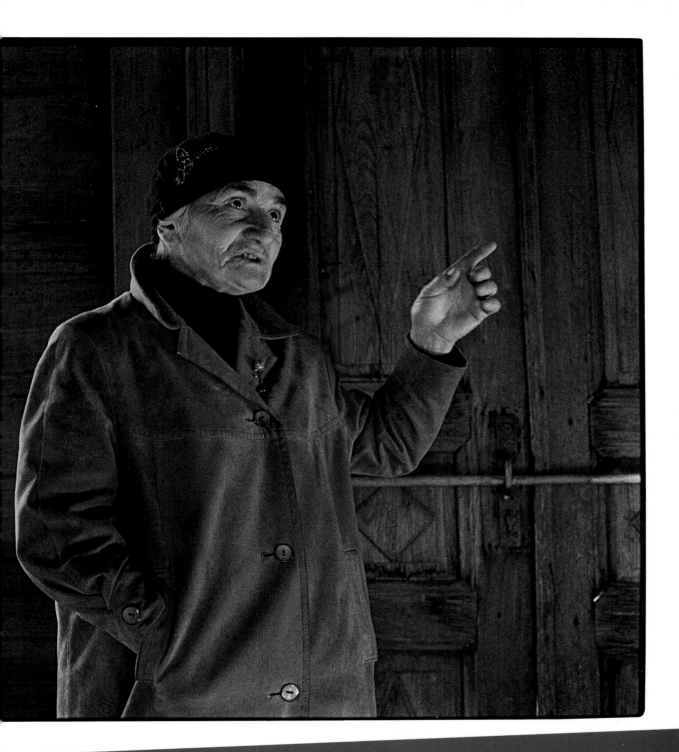

process > This is an image I took near Tbilisi, in the former Soviet state of Georgia. I tried to get a close-up portrait but she wouldn't stop talking and moving so I thought, 'What the hell? Just shoot and crop it later.' Even now, I have difficulty knowing where to crop this, I could do with someone else to look at it and decide, so here it is full-frame. At f/16, I exposed the face and body for 25 seconds, then added five seconds on the right side, dodging the hand; 10 seconds from the body to the left side; finally, 25 seconds on the left-hand window. I thought initially that the white pin pricks on the image were dust marks but they are actually light penetrating through holes in the wall. I feel that the selenium creates a great split in this print.

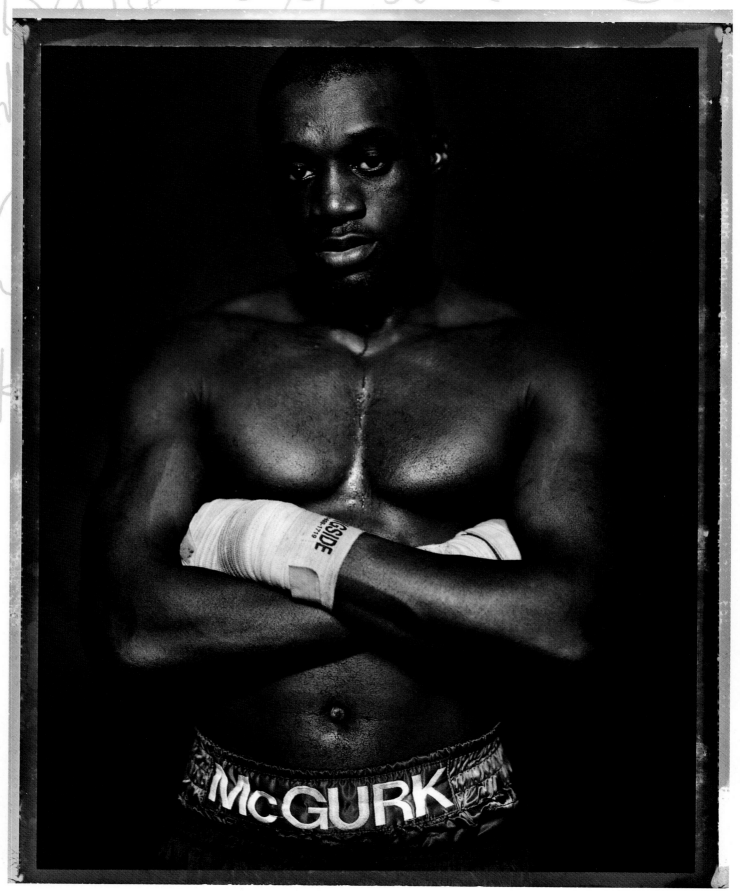

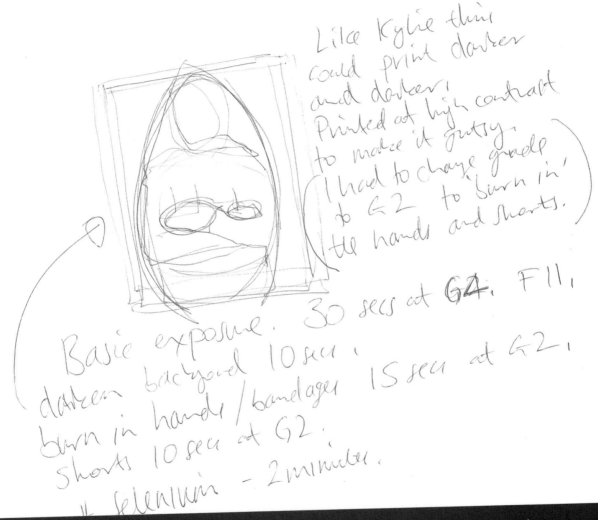

seu at G2,

Like Kylie this
could print darker
and darker.
Printed at high contrast
to make it gutsy.
(I had to change grade
to G2 to 'burn in'
the hands and shorts.)

Basic exposure. 30 secs at G4. F11,
darken background 10 sec.
burn in hands / bandages 15 sec at G2,
shorts 10 sec at G2.
selenium - 2 minutes.

photographer > Fredrik Clement | **title** > McGurk | **paper** > Agfa Multicontrast Gloss Grade 4 and Grade 2 | **exposure** > detailed below
developer > Agfa Neutol WA 1-10 | **time** > two minutes | **toners** > Kodak Selenium 1-10 two minutes

process > I first met Fredrik when he was assisting for Ray Massey in Camden and I was working at Primary. Like the Kylie image (pade 118), this image could print darker and darker. It was also printed at high contrast to make it really gutsy. I changed to grade 2 to make it easier to burn in the hands and shorts. At f/11, I exposed for 30 seconds at grade 4 and then darkened the background by 10 seconds. The dilute selenium increased the d-max of the print, adding to the dark, grubby feel.

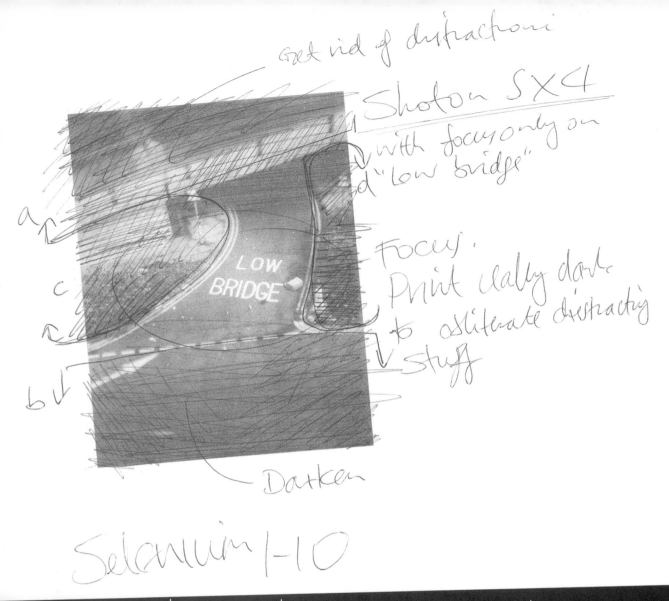

Get rid of distractions

Shot on 5X4 with focus only on "low bridge"

Focus.
Print really dark to obliterate distracting stuff

Darken

Selenium 1-10

LOW BRIDGE

photographer > Samman | **title** > Low Bridge | **paper** > Forte Polywarmtone Gloss Grade 3 | **exposure** > detailed below
developer > Ilford PQ 1-6 | **time**> two minutes | **toners** > Selenium 1-10 for two minutes

process > This was shot on 5 x 4 film and the tilt mechanism allows the photographer to focus on a precise area of the image. The brief was to print dark, concentrating on the letters on the road and obliterating everything else. At f/11, I exposed for 40 seconds then added 20 seconds on the upper bridge/walkway, 10 seconds from the dotted road markings down, and then darkened the verges on the side for a further 10 seconds each. Finally, I added another five seconds on the lower quarter of the print to add extra weight.

Description

b

e

d

a

c

The idea was to make the chairs stand out and to drop the distracting background darken out,

SO.....

photographer > Steve Macleod | **title >** Chang Mai Deckchairs, Thailand | **paper >** Ilford Multigrade Matt | **exposure >** detailed below
developer > Ilford Multigrade 1-6 | **time >** two minutes | **toners >** Bleach formula for five minutes; wash for 10 minutes; cold Thiocarbamide formula for three minutes

process > The idea was to make the chairs stand out from the distracting background; to do this I had to darken the surroundings by burning in any obvious highlights. At f/16 I made an exposure of 30 seconds and held the details in the chairs for around five seconds. I then added five seconds top left from the chairs to the corner, 10 seconds top right from the top of the chairs to the corner. On the right side, from the back of the chair down, I added five seconds and an additional five seconds on the lower half of the image. Finally, I added another five seconds to the white chair in the background, top right. All this has the effect of pulling the chairs out of the viewing area.

There are infinite variations possible, so if you were at any point going to
replicate any of these procedures, then I would advise you to keep
detailed notes to make it easier.

multiple or split-toning

Most toners can provide an array of colour and tonal shifts, but that
is not to say that they can only be used individually. We have to
follow some sequence, as some toners, such as selenium and gold,
convert the silver, therefore preventing the action of bleach and
other indirect toners. Moreover, dye toners such as blue and green
must follow sepia, otherwise the action of the thiocarbamide will
clear the dye from the print surface. Some of the combinations I
use are a mixture of yellow thiocarbamide and gold, which produces
red/pink colours reminiscent of lith colours. Selenium over warm
thiocarbamide can create a subtle split of browns and plummy
reds, and blue over yellow thiocarbamide creates a very defined
split of yellow and green.

If you are going to attempt multiple toning, the
print must be cleared thoroughly between each
toner bath, as there are more opportunities for
contamination between processes. There are
infinite variations possible, so I would advise you
to keep detailed notes to make it easier to repeat
the process. Finally, remember that these
techniques should be utilised to contribute to the
overall feel and mood of the image, and my own
preference is that less is more.

photographer > Steve Macleod | **title** > Sid and Marty's house, Bath, Sunday morning | **paper** > Ilford Warmtone Multigrade Gloss Grade 3
exposure > detailed below | **developer** > Agfa Neutol WA 1-6 | **time** > three minutes | **toners** > bleach formula for one minute; wash for
10 minutes; cold Thiocarbamide solution for two minutes; wash for 10 minutes; Tetanol Gold toner for five minutes

process > I woke up with the hangover from hell and while everyone else was asleep, decided to set up the camera and wait. This image
appeared and I wanted to create something warm and gentle to capture the soft, summer morning light. The only true highlight was the
reflection in the mirror. To get a good working negative, I overexposed the Polaroid type 55 pn by one stop, so that the positive looked thin
and underexposed. At f/11 grade 3, I exposed for 30 seconds, holding back the deep shadow areas so that the detail would still show
after toning. I then added five seconds diagonally across the middle of the image, left to right. Then five seconds middle to top-left corner
and another five seconds in the top-left highlight on the wall. I thought the bottom right-hand table was distracting, so I added a five second
exposure to darken this down and add weight to the print. The combination of thiocarbamide and gold toners provide very effective colour
and tonal shift reminiscent of the scene at the time.

photographer > Darran Rees | title > Houses of Parliament | paper > Ilford Multigrade Warmtone Gloss Grade 3
exposure > detailed below developer > Ilford PQ 1-10 | time > three minutes | toners > bleach formula for two minutes;
wash for 10 minutes; cold Thiocarbamide; wash for 15 minutes; Tetanol Gold toner for five minutes.

process > This image presents itself as layers with a dark foreground and the bridge dropping back into the mist as it crawls up the Thames. As the foreground frames the print, I darkened this more to pull the viewer into the image. The bridge is important as it makes a connection between dense foreground and the more gentle and subtle distance. At f/16, I exposed for 30 seconds, slowly dodging the background details for 15 seconds. Then I added five seconds on each foreground 'block' and five seconds on the sky, and finally five seconds on Big Ben to show more detail.

chapter ||

lithprinting

Mention lith printing to many darkroom practitioners, and most will recall hours spent enduring long exposure and even longer development times, bent over obnoxious-smelling chemistry and throwing copious amounts of paper in the bin. Not an attractive prospect!

Do not despair, as lith printing, once grasped, is a relatively easy method of producing beautifully toned prints with a characteristic all of their own. In its simplest form, lith printing is a technique whereby the photographic paper is heavily overexposed and partially developed in a dilute lith developer. I shall describe the basic lith printing process and then look into how to control and fine-tune development techniques.

photographer > Hamish Brown | **title >** Iggy Pop, Halcyon Hotel, West London, UK | **paper >** Kentmere Kentona Gloss
exposure > detailed below | **developer >** Champion Novalith A+B 100ml of each plus one litre of water at 40°C | **time >** four minutes
toners > Kodak Selenium toner 1-8 at 30°C for two minutes.

process > This was a brutal print and the negative was so sharp that I wanted to push every element of it to the limit. It is very rare that one of these comes along and I decided to use an extreme process for an extreme kind of man (the Ig, not the Brown!). Never did we think that this would go on to win a Royal Photographic Gold Award for Hamish. The selenium adds to the overall drama of the print by splitting the mid tones and heightening the d-max black. At f/8, I exposed for 50 seconds, dodging the eyes for 10 seconds in each socket, then added 20 seconds top-right-hand side and 10 seconds on each arm. The trick during development is to know when to judge the stop point of the print (refer to the section on lith, page 208, for this), but I used six sheets of paper before I got this one right.

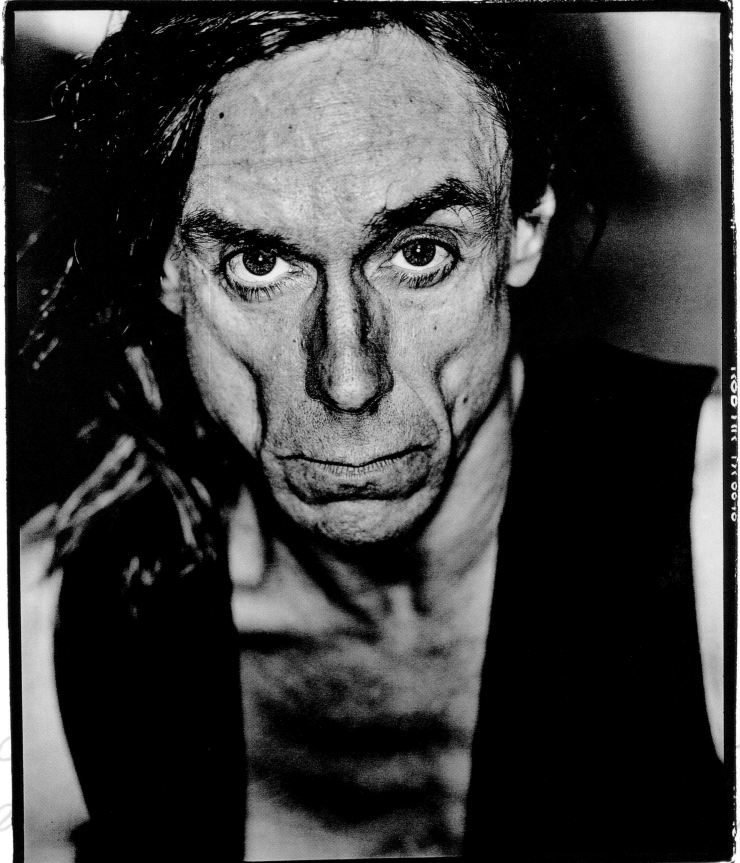

lith papers

There are now many papers widely available that are suitable for lith printing. Containing more silver chloride than silver bromide in their emulsion, they are commonly known as chlorobromide papers. If you are working on a tight budget then papers such as Agfa Classic Multicontrast and Ilford Multigrade Warmtone can be used in the conventional way, and also give good results using the lith technique.

developers

There are several Lith developers on the market including Kodalith liquid developer; Fotospeed LD 20, Macolith and my favourite, Champion Novalith. The developers all come packed as A and B solutions – with the exception of Speedibrews Litho-print – and are mixed prior to use. Most manufacturers provide recommendations, but it is best to find a dilution that suits your needs in terms of developer strength. I have listed two of the dilutions that I commonly use in standard lith printing opposite.

Exposure times become less critical when lith printing, and there are two significant rules to remember when printing: Highlights are controlled by print exposure and shadow detail is controlled by development time. The development time determines the amount of shadow detail, as the 'infectious development'

progresses, the dark areas clump together, forming the shadows. It is therefore important to decide when to snatch the print from the developer, by judging the shadow density and not the highlight detail.

If a print has little detail in the highlight areas, extended development will not increase highlight density as the dark tones will continue to develop, making the print overdeveloped and heavy in tone. Instead increasing the exposure to compensate will enable greater control of the highlight details. If the light tones are too heavy and more contrast is required, then decrease the exposure, and increase development.

Highlights are controlled by print exposure,
shadow detail by development time.

infectious development

When the exposed paper is placed in the developer, it acts as a catalyst, accelerating development, which means that the paper will start to develop slowly with an exponential increase in the rate of development. As the dark tones begin to develop, they increase in density until black dots begin to appear. These will then develop to form the dark areas on the print. The key is to 'snatch' the print before complete development takes place.

It is at this point that most people become frustrated, as, when they snatch the print from the developer, it continues to process and can become overdeveloped by the time it reaches the fixer. You should also be aware of an effect commonly known as 'fix-up', which is when the print, once placed in the fixer, appears to lighten and increase in contrast. This is actually the effect of colour changes that are not visible under safelight conditions (as colours are rendered invisible by safelights of the same colour) and can be very deceptive during the development process. As most papers have different properties, and thus lighten and darken by varying degrees, the best rule to standardise matters is NOT to judge print development by the highlight density. Instead, look at the shadow and mid-tone areas, and use these as the benchmark to indicate when you should snatch your print from the developer. I will describe later methods for taking control of the development rate.

developer dilutions

Here are a couple of solutions that I commonly use:

Champion Novalith developer: 'Old Brown' – one litre at 20°C; liquid A – 100ml; liquid B – 100ml; water – one litre at 40°C. Use with a hot plate or hot water jacket to maintain temperature.

Kodalith liquid concentrate developer: 'Old Brown' – one litre at 20°C; liquid A – 80ml; liquid B – 80ml; water – one litre at 40°C. Again, use with a hot plate or hot water jacket to maintain temperature.

F8 - 3 minutes exposure, printed through muslin laid ontop of the paper during exposure...

'old brown'

Sometimes, fresh developer can give uninteresting colour shifts and tones but, as it is worked and oxidisation occurs, the effects become more pronounced. 'Old brown' is simply old developer added to the fresh developer to 'mature' the chemistry and bring it up to speed.

Unfortunately, the activity and strength of 'old brown' cannot be measured exactly as it is dependant on dilution, age and the number of prints that have been passed through it. The easiest method is to standardise where possible and to be consistent with your dilutions. Be aware that too much 'old brown' can be detrimental to your prints as each paper has a peak colour-fogging level, and too much old brown may fog the paper; I have found this particularly noticeable with Kentmere Kentona, Classic and Ilford Warmtone.

photographer > Steve Macleod | **title** > Towards Breamar | **paper** > Kentmere Art Classic | **exposure** > detailed right
developer > 80 ml each of Champion Novalith A+B, plus 500 ml water at 40°C and one litre 'old brown' | **time** > 10 minutes

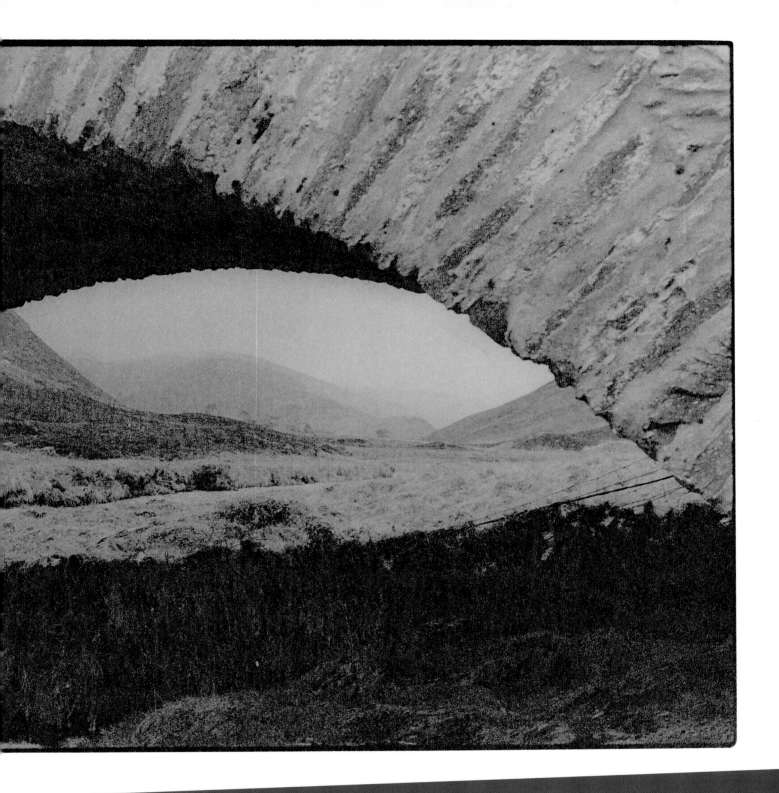

process > This was heavily overprinted through muslin giving it a soft, dream-like quality to the image. Though this is a lith print, there are no definite blacks or whites – the product of long exposures. The result is a very soft, almost charcoal drawing feel to the image. At f/8, I gave a straight three minute exposure through muslin laid on top of the paper and below the enlarger lamp.

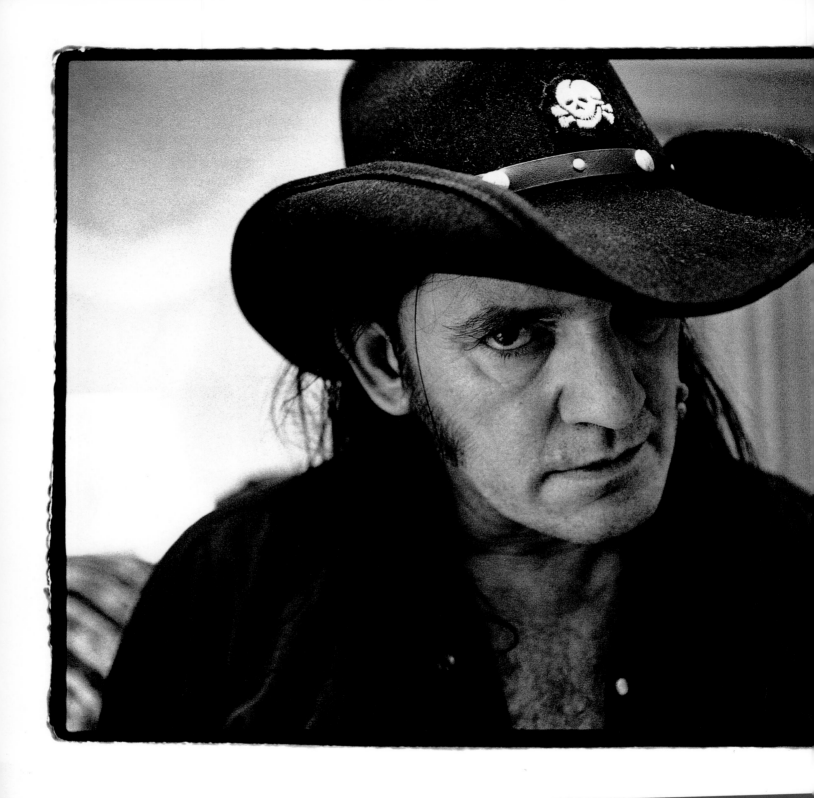

photographer > Dean Belcher | **title** > Lemmy, Motorhead | **paper** > Oriental Portrait | **exposure** > detailed right | **developer** > 50ml each of Champion Novalith A+B, 1 litre of water, 500ml of 'old brown' | **time** > four minutes | **toners** > Kodak Selenium toner 1-10 one minute

process > Another of my favourite bands and a great portrait of one of metal's finest. This was very easy to print as I had done a straight print of this and I knew that the negative was well exposed. I just blasted it with light and let the shadows go, burning down the edges around the body. This is shown full frame but I wonder if it would have been better cropped. At f/8, I exposed for two minutes, dodging the face slightly to make sure the eyes didn't block in. Then, 30 seconds around the edges to concentrate the focus.

add the
ts on
that they don't

This portrait just looked
well normal as a straight
B&W print. So
add a bit of Lith,
the eyes just draw you

photographer > Patrick Ford **| title >** Paul Weller **| paper >** Kentmere Kentona Gloss **| exposure >** detailed below **| developer >** 100ml each of Champion Novalith A+B, 1 litre of water and 500ml of 'old brown' **| time >** four minutes

process > This image looked very plain as a straight print but the lith added more depth, the eyes just draw you in. The 'old brown' contributed to the rich mid-tones and I concentrated on the skin and eyes for this print. At f/5.6, I exposed for 30 seconds at grade 3, dodging the eyes slightly. Then I added 10 seconds on the left shoulder and background and five seconds on the hand, being careful that this didn't block up during development.

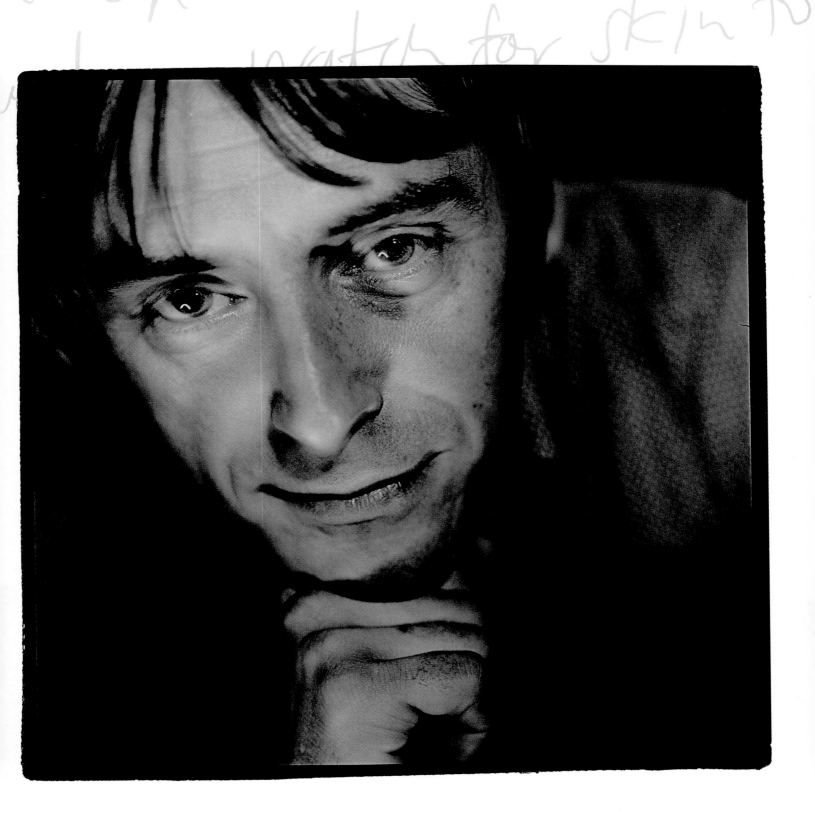

photographer > Samman | **title** > Bikes, Edinburgh | **paper** > Kodak Polyfibre Semi-matt | **exposure** > detailed below **developer** > Kodalith A+B, 200ml of each, 1 litre 'old brown' at 40°C | **time** > 10 minutes developer time

process > The brief was to make this very dark and gloomy so that the only highlight was that portrayed by the wall light. The negative was underexposed so it was relatively easy to achieve this. I had to try and emphasise the diagonals passing through the image. At f/5.6, I exposed for three minutes at grade 0. I burnt in the foreground and upper stairwell for 50 seconds each to 'enclose' the image. The long developer time not only gave the dark feel to it but also added to the overall flatness of the image.

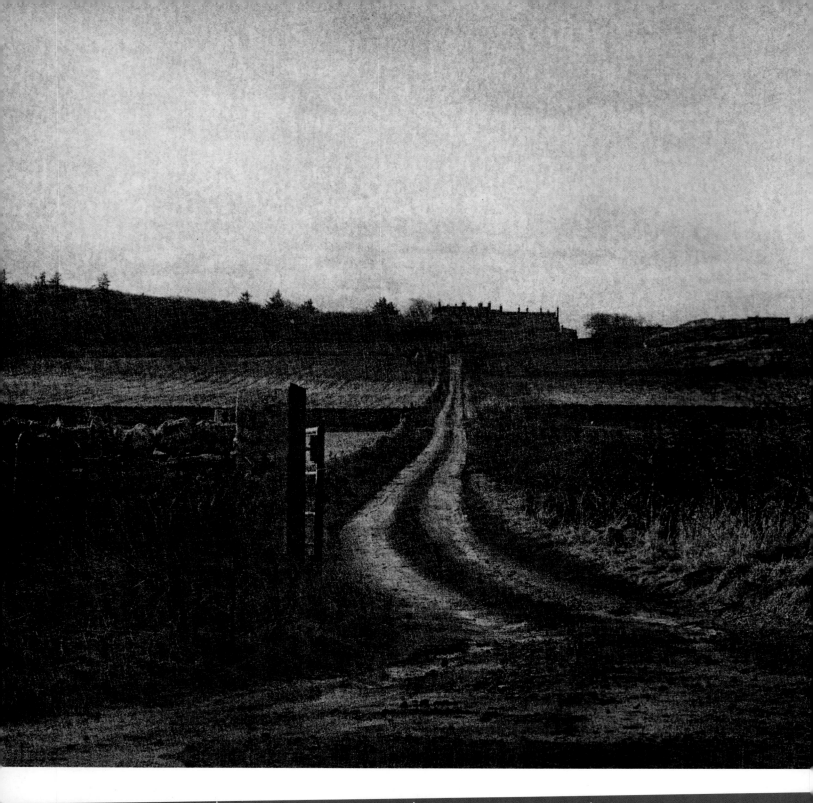

photographer > Steve Macleod | **title >** Sandside House, Caithness | **paper >** Ilford Warmtone matt | **exposure >** detailed right
developer > 20ml each of Champion Novalith A+B, 1 litre of water and 1 litre of 'old brown' at 40ºC | **time >** eight minutes
toners > Kodak Selenium 1-20 for five minutes

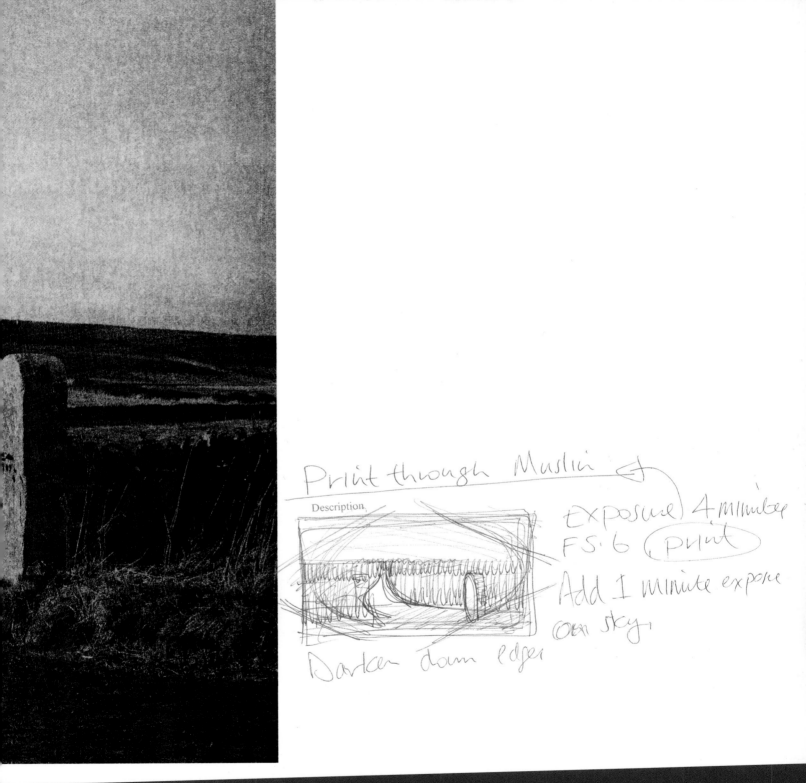

Print through Muslin

Description

EXPOSURE) 4 minube
F5·6 (print)

Add 1 minute expose
on sky,

Darken down edges

process > This, like much of my work from this time, was printed through open muslin. In this case, I kept it moving around during the exposure so that the lines didn't become too distinct. At f/5.6, I exposed for four minutes at grade 0, then added one minute on the sky and 30 seconds in each corner to vignette. During development, I was careful to watch for shadows in case they blocked up and over-developed as this would have made the print look too flat and muddy.

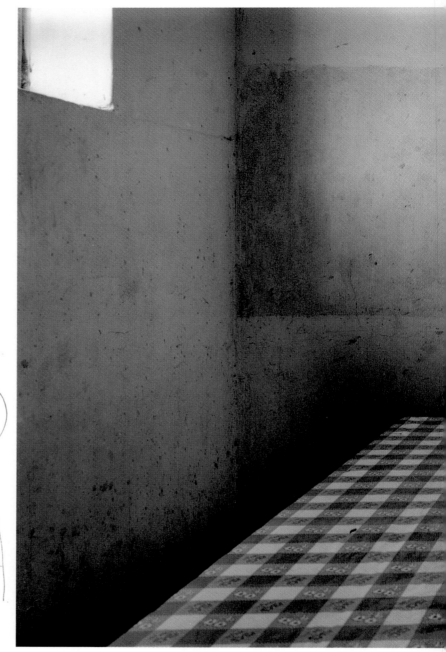

photographer > Darran Rees | **title >** Untitled | **paper >** Forte Polywarmtone Gloss | **exposure >** detailed below
developer > Champion Novalith A+B, 50ml of each, 500ml of water and 500ml of 'old brown' at 30°C | **time >** six minutes

process > The key to this print was for me to produce tone in the walls and highlights, and to make the shadow details dark and muddy. Darran wanted me to emphasise the griminess of the room and to make the checks in the tablecloth stand out. At f/8, I exposed for 40 seconds, holding back the table and glass for 10 seconds each. Then I added 10 seconds on the left side from the table edge to the wall and the right-side pillar. I then added a further 10 seconds to the window, upper left.

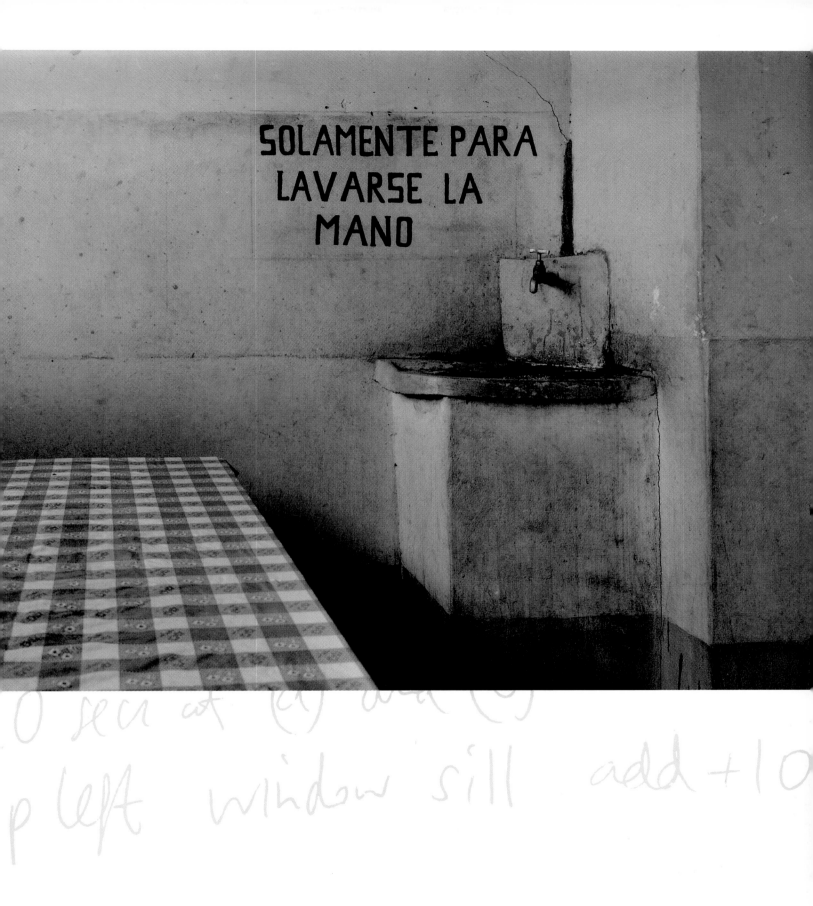

O sea cot (e) ate (s)

p left window sill add +10

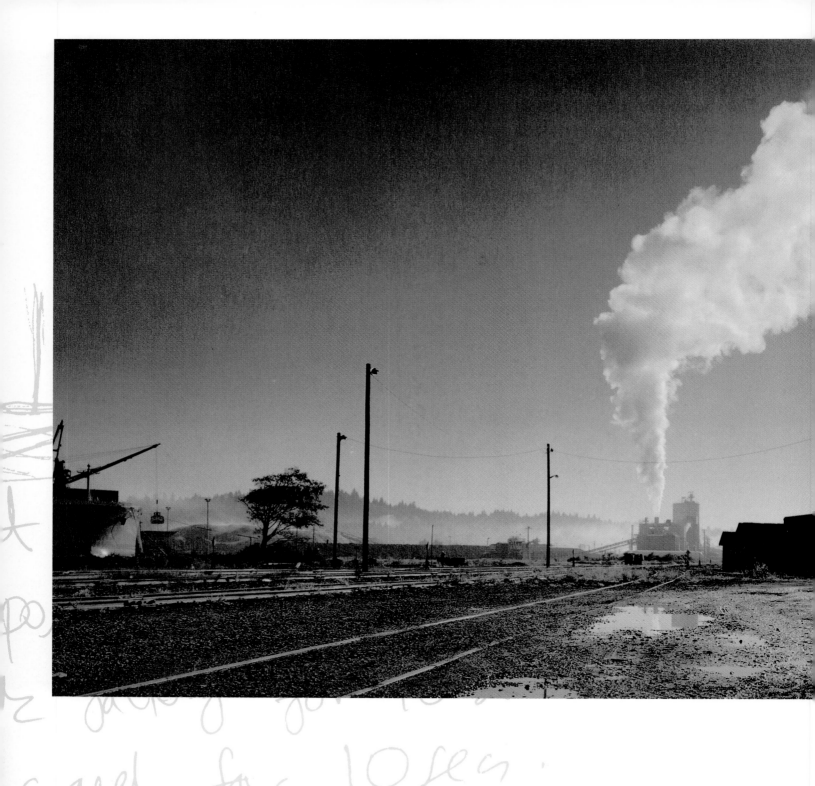

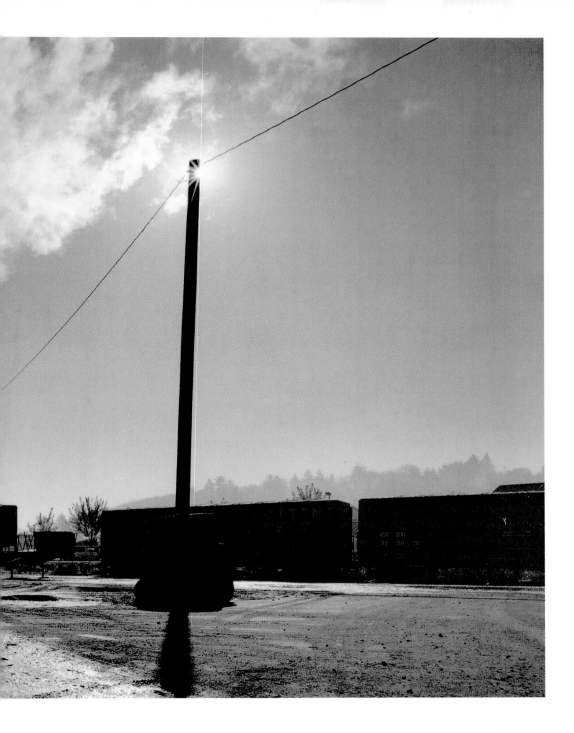

photographer > Darran Rees | **title >** Untitled | **paper >** Forte Polywarmtone Gloss | **exposure >** detailed below | **developer >** Kodalith A+B, 80ml of each, two litres of water and 500ml of 'old brown' at 30ºC | **time >** three minutes

process > This image had relatively short exposure time to increase the contrast and exaggerate the graininess. This was okay for the shadow areas, but I tried to keep the steamstack clear of grain and to stop the distant factory from blocking in. The first exposure was at f/8 for 30 seconds, holding back the 'factory' for 10 seconds. I then burned in the gravel for 10 seconds and the sky for 15 seconds. Finally, I vignetted the top corners for 10 seconds each.

Short exposure
but combination
Short exposure

photographer > Steve Macleod | **title >** Riverbank, Thurso | **paper >** Kentmere Kentona | **exposure >** detailed right | **developer >** Kodak Kodalith A+B, 100ml of each, 1 litre of water and 500ml of 'old brown' at 40°C | **time >** 10 minutes

process > The idea was that the person in the distance would be the only d-max of the print. This was a short exposure of two minutes but the depleted developer at high temperature provided contrast and loads of grain. At f/11, I exposed for two minutes overall, dodging the path for 20 seconds with my hands. Then I added 30 seconds at each side of the path and a further 20 seconds on the sky.

> The visual paper grain size affects the colour and contrast of the image, and is controlled by the development time. The highlights are controlled by exposure, the shadows by development.

determining the print 'snatch point'

As the paper develops, there is an exponential increase in density, and it is at this point that we could split the print in two, because the shadow grains are large, cold and provide contrast to the image, whereas the light areas are smooth, warm and provide mid-tone subtlety. Both of these properties combined give the characteristic look of the lith print. It is down to the individual to decide how much of each is contained within the image, and this determines the snatch point of the print.

As stated previously, there are two significant rules when lith printing that will form the basis of everything you do relating to the process: The visual paper grain size affects the colour and contrast of the image, and is controlled by the development time. The highlights are controlled by exposure, the shadows by development.

In practice, what this means is that if your print has too much contrast and not enough tone, then extended exposure will compensate for this; extended development will only deepen the shadow details due to the infectious development. Moreover, if the highlight details are too deep, then cut the exposure times down to increase contrast, keeping to the same snatch point. As a rule, I print for the shadow detail. I look to the point where the large black emulsion grains become evident in the deepest shadows and decide how far to let them block up in order to determine my snatch point.

photographer > Alessio Pizzacannella | **title >** Richard Ashcroft | **paper >** Agfa Multicontrast Gloss | **exposure >** detailed below
developer > 100 ml each of Champion Novalith A+B, 1 litre of water | **time >** three minutes

process > This was taken from a series of portraits for Sleaze Nation magazine. Much more than a straight print would, the lith process added an edge to this image yet still retained subtle detail in the highlights and eyes. This was a tricky image to develop and I had to be very careful of the snatch point because if I pulled it too early, the blacks would be too weak, and if left too late, they would have blocked in and I would have lost the subtlety, particularly in the hair. Also, I had to be sure that the skin tones had texture without becoming too grainy and crude – there were a few sheets of paper wasted on this job.

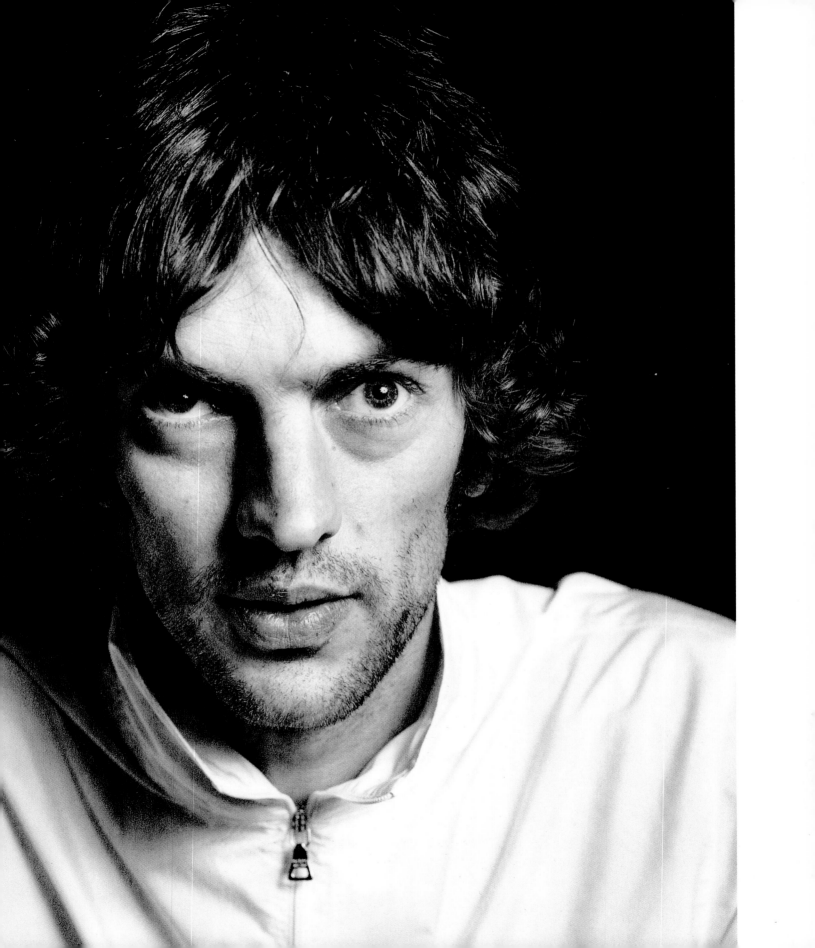

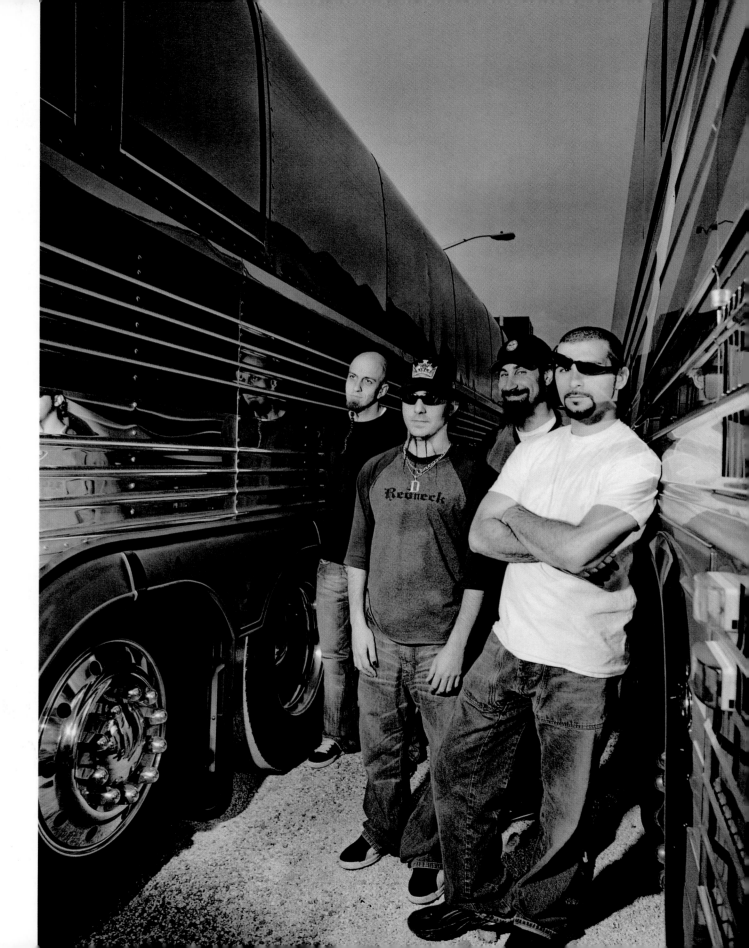

break this
all down to
shape and form.

Play ___ on ___.

photographer > Jamie Beeden | **title >** System of a Down | **paper >** Forte Polywarmtone Gloss | **exposure >** detailed below
developer > detailed below | **toner >** detailed below

process > I was very envious when Jamie told me he was getting the chance to shoot one of my favourite bands of 2002. In the end he only got 10 minutes as they were in the middle of an American tour. We couldn't decide how to print it so tried three different ways and compared the results. #1 – The straight print, grade 3 f/11, 30 seconds exposure, dodging the bus shadow areas randomly throughout the exposure. Then adding 10 seconds on the band bodies, 10 seconds on the sky and 10 on the white T-shirt. Developer Agfa Neutol WA 1-4 for two minutes #2 – Same exposure as the first print but at lower grade 2 with a developer time of 2½ minutes. Then bleach formula for two minutes, wash for 10 minutes and warm thiocarbamide formula for two minutes. #3 – At f/5.6 grade 2, exposure for 30 seconds, adding 10 seconds on the various highlights, 10 seconds on the sky and 10 on the T-shirt. Develop in Kodalith A+B, 20ml of each, and 1 litre of 'old brown'. for five minutes.

photographer > Steve Macleod | **title >** Marty | **paper >** Forte Polywarmtone Gloss | **exposure >** detailed below
developer > Kodalith A+B, 200ml of each, 1 litre of water | **time >** five minutes

process > A very straightforward print from a Polaroid type 55 pn negative. I wanted it to print flat so that all the processing marks and scratches would be obvious. To do this, I made a long exposure so that all the tones would be compressed. At f/8, I made a 50 second exposure at grade 2, that's all.

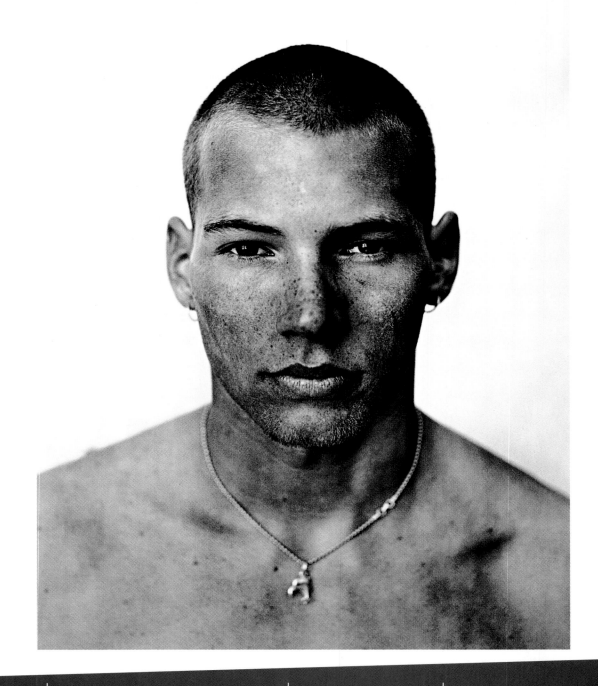

photographer > Deirdre O'Callaghan | **paper >** Agfa Multicontrast Gloss Grade 0 | **exposure >** detailed below | **developer >** Champion Novalith A+B, 20ml of each, 1 litre of water at 40°C | **time >** six minutes | **toners >** Kodak Selenium toner 1-20 for two minutes

process > Not Deirdre's usual style but I wanted to emphasise the model's freckles and skin tones. This was quite a straightforward print to do. I cropped off one side to even up composition and was careful to dodge the eyes during the exposure. At f/8, I exposed for 30 seconds, dodging the eyes and lower chin for 20 seconds, adding 10 seconds to the torso and a further 10 on the left shoulder. During development, I had to carefully time the snatch point to maximise the development of the blacks and to emphasise the freckles. The use of selenium post-development also helped to define these areas.

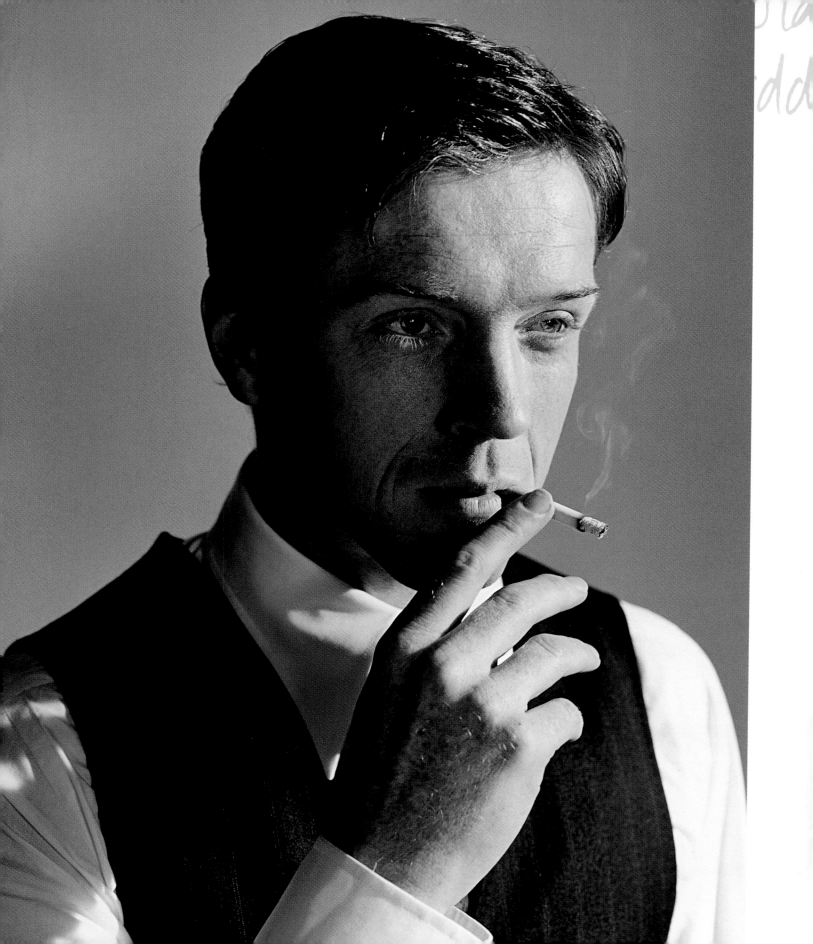

background and top right,
10 seconds lower right shirt,

blacks through the lith action.
F5.6 40 seconds
eyes and body
add 10

hello, Post-flash For 2

photographer > Joakim Blokstrom | **title** > Damian Lewis | **paper** > Ilford Multigrade Warmtone Gloss | **exposure** > detailed below
developer > Champion Novalith A+B, 400 ml of each, 1 litre water and 500ml of 'old brown', develop for eight minutes.

process > This was one of a series of portraits that Joakim was commissioned to do for GQ magazine. Though not one of my favourite lith papers, the Warmtone gave the tonal range that I required. I could still get contrast and definite blacks through the lith process. At f/5.6, I exposed for 40 seconds, dodging the eyes and body for 10 seconds. Then I added 10 seconds on highlight areas on the shirt, hand and face, also darkening the left-hand side background and top-right corner. I opened up one stop to f/4 and added 10 seconds to the lower-right shirt. Finally, I stopped back down to f/8 and post-flashed for two seconds.

During exposure ha

photographer > Edward Webb | **title >** Lake District | **paper >** Forte Polywarmtone Gloss | **exposure >** detailed below
developer > Champion Novalith A+B, 20 ml of each, 2 litres of water at 35°C | **time >** six minutes | **toners >** Tetanol Gold toner, 10 minutes

process > Edward wanted a punchy feel to this image and I wanted the river to stand out. It was important to create a feeling of distance and space without making this look too clichéd. Ultimately, this image appears as two prints, one for the mountain terrain and the other for the sky and cloud cover. At f/11, I exposed for two minutes holding back the river with a small dodging tool to exaggerate the route; adding 30 seconds on the bottom-right foreground and 20 seconds on the extreme-left mountain slope. Then I added 10 seconds on the right-middle distance slope and 10 on the sky above the mountain tip. The reason for this was to try and draw the viewer into the image towards the cloud cover by exaggerating the shapes of the slopes. Finally, I Gold-toned the print for 10 minutes.

(d)

(c) +10

b +20

(a) +30

Like most landscapes it was important to try and create a feeling of distance and space.

sale river pathway – to
exaggerate

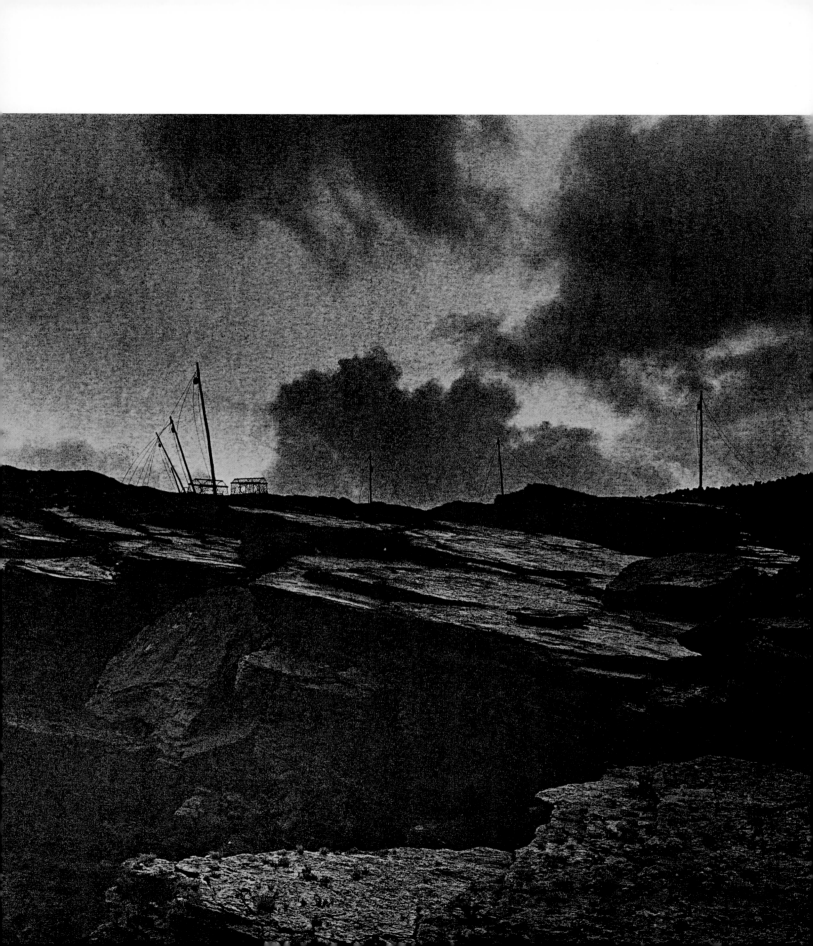

Lith print colours can vary from deep browns through to orange, pink and peach tones, all of which are controlled by the developer and exposure.

two-bath development

At the end of the development time the process speeds up to such an extent that it is sometimes difficult to judge the optimum snatch point. It is a simple matter to slow the development down and thus allow more exacting control of the process. Simply provide a warm-water bath between the developer and stop bath stages of printing. Before the shadow details have reached their peak, transfer the paper to the water bath and agitate slightly. This will slow down but not halt the development process, allowing you to inspect the print at a more reasonable pace. If you feel that the print needs more development, then place it back in the developer for more time and then onto the water bath again, or to the stop bath and fixer stages. You may also find that this slowing down of the process allows some of the more delicate highlights to play 'catch-up' with the shadow details, adding more subtlety to the print.

Once you have become familiar with the lith process, another print-viewing technique may be utilised, which involves the flashing on of the darkroom lights for a very brief time to view the print as it reaches the critical point. You may think this a crazy thing to do for fear of fogging,

but because of the lengthened development times and the fact that the highlights develop at a slower rate than the shadows, the print will not stay in the developer long enough to advance to the fogging stage – it can be swiftly removed to the stop bath and fixer stages.

print colour changes

Lith print colours can vary from deep browns through to orange, pink and peach tones, all of which are controlled by the developer and exposure. Experiment to find a method that is satisfactory to you, making notes of everything you have done – there are so many variables that it can be potentially difficult to replicate an achieved result.

Developer dilution can affect tone: the more dilute the developer, the warmer the print, and the more concentrated the dilution, the colder the print. Equally, the fresher the developer, the more understated the colour of the print. This is why we add a proportion of 'old brown' to the developer bath to artificially mature the developer. Higher temperatures also increase developer activity, which exaggerates grain and colour quality. So, remember that combined with exposure, higher dilutions will extend development times, and higher temperatures decrease them – all of which affect colour contrast and density. It is a matter of combining these elements to create the desired effect.

photographer > Steve Macleod | **title >** Sandside Head | **paper >** Kentmere Art Classic | **exposure >** detailed below | **developer >** Kodalith A+B, 80 ml of each, 1 litre of water at 35˚C, 1 litre of 'old brown' | **time >** six minutes.

process > This was taken on a winter afternoon – a storm was building and the sharp sunlight was dancing off the rocks after a recent snow shower. Unfortunately, the negative was a bit thin so I used the lith process to gain separation of tone with reasonable blacks. the depleted developer enhanced the graininess of the image yet retained good blacks. This is the only image of my own that I have ever printed and been satisfied with. With the aperture wide open at f/4, I exposed for 30 seconds but held back the deepest shadows with a dodging tool for 10 seconds, adding 10 seconds on the sky and ten on the upper-left corner, diagonally from the horizon outwards. Finally, with a piece of card with a hole the size of a 10-pence coin, I randomly burned areas of the shadows for 25 seconds to add density to the shadows.

in the sky and bui...

10 in the skys

From 'Cowboys a var...
This was a monumer...
Jon to understate o...
and for me to print...
All the black + white...
done as lith prints a...

we had to do 20-30...

1
2
3

scale was such that
session!

photographer > Jon Nicholson | **title** > Phil Fox 6666 Ranch, Guthrie Texas | **exposure** > detailed right **developer** > Champion Novalith A+B, 100ml of each, 2 litres of water at 40°C | **time** > three minutes.

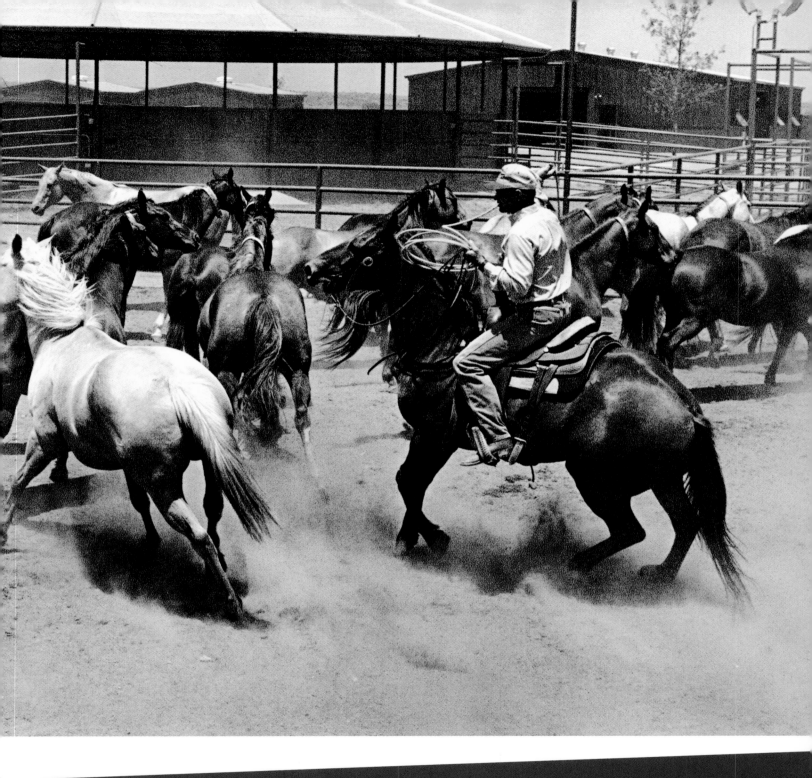

process > Taken from 'Cowboys, A Vanishing World', this was a mammoth undertaking for Jon, worked on over three years. All the black-and-white images were done as lith and the timescale was such that we had to do 20 to 30 prints in each session. We would lock ourselves in the darkroom, I would expose the images and we would process together for hours. This particular image can be split into horizontal layers. The base exposure was f/11 for two minutes at grade 2. I dodged the shadows randomly throughout the exposure. I then burnt in the sky and buildings for 20 seconds and then 10 seconds on the sky only. Finally, I vignetted each bottom corner for five seconds each.

To achieve continuous tones on prints, most developing agents are diluted down beyond the manufacturer's recommendations,

'pepper' fogging

Sometimes, when using dilute developer, a problem known as 'pepper' fogging can occur. Appearing as small black dots throughout the highlight detail of the print, these can be a nuisance particularly on Sterling Premium Lith paper. To achieve continuous tones on prints, most developing agents are diluted down beyond the manufacturer's recommendations, causing the oxidation of a hydroquinine product, and thus an accelerated fogging of some of the emulsion grains.

The cure for this is to add a minute amount of the preservative sodium sulphite to the developer. To do this, make up a 10 per cent solution of sodium sulphite, by dissolving 50g in 300ml of warm water and then top up to 500ml with cold water. This solution should keep for some time in an airtight container but should be checked regularly. Before use, add 50ml of the solution for every 100ml of liquid A, and 100ml of liquid B of the concentrated developer. Be careful, as too much sulphite will result in the loss of contrast and maximum black detail.

lith papers

There paper market is ever expanding. Here are a few of the papers that I commonly use, but I would recommend experimenting to find a paper that suits your needs. Think about whether you want the image to look warm or cold. Are you going to tone the print post-development? Consider also the cost implications: if you are an occasional lith printer, then choose a paper that can be utilised both conventionally and through the lith process. Kentmere are currently testing new formulae for the Kentona and Classic range of papers to align with new European standards, and in future, this will affect the base-colour shift when used in lith developer.

forte polywarmtone: As well as providing top quality conventional prints, this paper responds very well to the lith process, ranging from pink to red through to brown. Dark red safelight.

forte bromofort: Conventionally printed, this paper provides deep, cold black tones, but I use it to give sandy, grey smooth tones. Orange safelight.

ilford multigrade warmtone: A really versatile paper suitable for lith printing. I normally use it in hot developer to speed up the effect, and then tone post-development. Ilford 902 safelight.

kodak kodagraph TP5: A high-contrast projection-speed paper. It provides peachy and pink tones on an RC base. It dries flat, but handle with care as it is prone to finger marks and staining. Red safelight.

kentmere kentona: A double-weight paper, conventionally warm toned. I use this paper to provide deep brown lith prints. Ilford 902 or red safelight.

kentmere classic: Again, a double-weight textured paper, providing lith colours that can range from pink through to rust and violet. Ilford 902 or red safelight.

agfa classic multicontrast: A versatile paper that can be used conventionally or through lith, providing cold or warm yellow tones similar to a cold-tone thio print. Ilford 902 safelight.

Think about whether you want the image to look warm or cold. Are you going to tone the print post-development?

the demise of the
darkroom

GOLD AWARDS
THE SELENIUM TO
FEELING OF THE
TONES.

Several years ago, a very prominent figure within the photographic industry informed me, with some twisted delight, that I should accept the fact that darkroom practices would soon be a thing of the past.

This demise would be due to the rise of digital photography, which would bring a fresh and exciting method of capturing, processing and presenting imagery without film, paper or chemistry. There would be no need for long hours in the dark wasting materials, trying ever so hard to produce that desired print. Instead, we could digitally capture, manipulate and output a digital print at a fraction of the cost and in less time than it takes to develop a lith print.

For some time after this encounter, I began to feel uneasy as a darkroom practitioner. Was it time to retrain? I could perhaps transfer the experiences I had gained in wet processes onto the digital platform. Maybe it was time to give up and become a landscape gardener! I could even hide in the darkroom and pretend it wasn't happening and hope that digital was just a passing phase.

I felt insecure and was reluctant to leave the darkroom behind. I love creating prints. I did not want to lose the feeling of satisfaction having achieved something that I can hold and say 'I made this'. To me, computers drag the soul from the image. I felt that everything was becoming machine-made and dull. But there was no denying that digital cameras, negatives and prints were becoming more commonplace. Technology is expanding at an exponential rate, and images are beamed around the world via ISDN and the Internet.

It was a surprise for me to see prints that I had created being offered on the Internet, clients ordering them by e-mail, either dealing with the photographer directly or through agencies and galleries (as exhibitions are now created specifically for the Net). Agencies such as VII and Network value the syndication and archiving possibilities that digital can provide them with, so many editorials are done digitally. Ron Haviv at VII has just produced one of the first digital monograph war books, 'The Road to Kabul'.

With trepidation, therefore, I decided to change my conception. I was not going to abandon the darkroom for digital technology. In fact, there was no need. There is ample room for everyone in the industry. What I needed to do was to redevelop my opinion. I believe that the digital end of the industry is not going to kill off the conventional darkroom – instead we are going to find a marrying of the techniques and skills that can be obtained from both ends of the industry.

In 1998, I began employment at Metro Imaging, a company that I feel embraces both conventional and new technology in the presentation of the photographic image, whether by applying an ancient chemistry formula or using state of the art digital retouching. In the Metro Art Department, we not only provided fine custom black-and-white and C-type printing – not to mention historical printing processes such as salt, cyanotype, platinum and photogravure – we also offered digital Iris, Pictrostat and Polyelectronica printing services from original artwork or system-manipulated images. I do find that there is a growing demand for prints taken from digitally-manipulated negatives, because buyers still put more of a value on a conventionally-produced print. Therefore, close links are developed between the departments involved to guarantee that quality images can be produced for our clients.

In the Digital Bureau, images can be scanned from artwork, negative or transparency, using one of two methods. The Fuji Linovia is a CCD scanner, similar to a flatbed scanner. It will accept images up to 34 x 44cm, it has a variable scanning resolution but operates at an optimum of 300 dots per inch (dpi). The second method is to use a Crossfield Magnascan high-end drum, that can accept images up to 51 x 63cm. The image is attached to the revolving drum and is 'read' with a resolution of 609dpi. Or you can provide a RGB TIFF file with at least a 70MB file size on CD-Rom, Mac or PC-formatted.

Once the image is scanned, it is transferred via a Mac to the LightJet Film Recorder, which uses red, green and blue lasers to 'write' the image information onto film on any format up to 10 x 8in (25.4 x 20.3cm). The information is plotted at a resolution of 2,032dpi and the system runs on a closed-loop calibration method, where the originals and outputs are compared on a regular basis to ensure continuity throughout the process. Once the digital negative or transparency is output, it is processed in the usual manner, where the rules of pushing and pulling still apply.

Many complain that digital negatives are too contrasty, that they lose definition and shadow detail, and that the curve latitude becomes compressed, making it more difficult to print from this type of negative. In some cases, this can be true, yet it must be

in focus

John Cole in Hastings, UK, took the image of the fisherman shown overleaf. Unfortunately, he was badly flooded and the original negative was partially damaged. As he wanted to make a limited edition print, I suggested scanning and retouching the negative and outputting it digitally. This was done by The Shoemakers Elves in Clerkenwell, London, a digital company specialising in this type of work. I then made the print in the conventional manner and alongside for comparison, is the undamaged original print. Spot the difference.

As in all aspects of photography, it is easy to get carried away by the advances of the digital market. I often see images that are technically of a high standard, where all manner of tricks and effects have been used skillfully, but really they lack any purpose or soul. At the end of the day, whether using traditional photography or digital technology, it is the image that is of prime importance – not how it is achieved. All of these techniques and processes are purely tools that we use to achieve the desired results.

I feel that there will always be a enough rooms for fine handprints, and as the digital industry advances so too does a renewed interest in conventional, more craft-oriented techniques. Each places demands on the other, and this is healthy competition. In the same week, I may be printing salt prints using a formula from the earliest printing era, matching exhibition prints using techniques used in the 1950s and then judging film that has been digitally output from CD-Rom. Long live diversity!

T-max 100 film,

There was a time when I used to print digital negatives that always seemed to have defined grain, high contrast and no shadow detail, allowing for very creative darkroom antics.

said that the output is only as good as your original. If in any doubt, I would recommend discussing your options and objectives with the system operator before you proceed with this method.

There was a time when I used to print digital negatives that always seemed to have defined grain, high contrast and no shadow detail, allowing for very creative darkroom antics. We have come a long way since then, and now digital outputting is actually aiding in creating fantastic prints from negatives that are manipulated in a very subtle manner. Quite often, digital means can make darkroom work a lot easier. For example, I recently did a job for a South African company, that had sent photographers to Europe to capture a variety of different images. Once they had returned to Johannesburg, they began the task of merging some of the images together by computer, thus

saving a lot of time in the darkroom having to mask images together. Once all the merging and tidying up had been done, they forwarded a CD-Rom containing the images to Metro, where they were output onto 5 x 4in (12.7 x 10cm) digital negative, and processed conventionally. I finally provided them with fine multi-toned lith prints done in the darkroom in the usual manner. This whole process took seven days to complete, from the capturing of the images to the presentation of the prints.

photographer > John Cole | **title >** Doug White | **paper >** Ilford Multigrade Gloss | **exposure >** detailed below | **developer >** Ilford PQ 1-8
time > two minutes

process > The original negative was damaged in a flood, so we had it digitally scanned, retouched and then output onto T-max 100 5 x 4in film. This was processed pushed one stop, giving me a working negative to make edition prints. #1 – This is the original negative printed full frame with a keyline f/16 grade 2½. Exposed for 15 seconds, dodging the background for five seconds, then an additional five seconds on the face. Finally selenium-tone 1-15 for two minutes. #2 – This is the retouched negative which was slightly cropped with no keyline. At f/16 grade 3, exposed for 15 seconds, again dodging the background for five seconds, adding five seconds on the face at grade 2 ½. The digital negative appears a bit thinner than the original – this is often the case with digital outputs. To compensate, I printed at ½ grade more contrast.

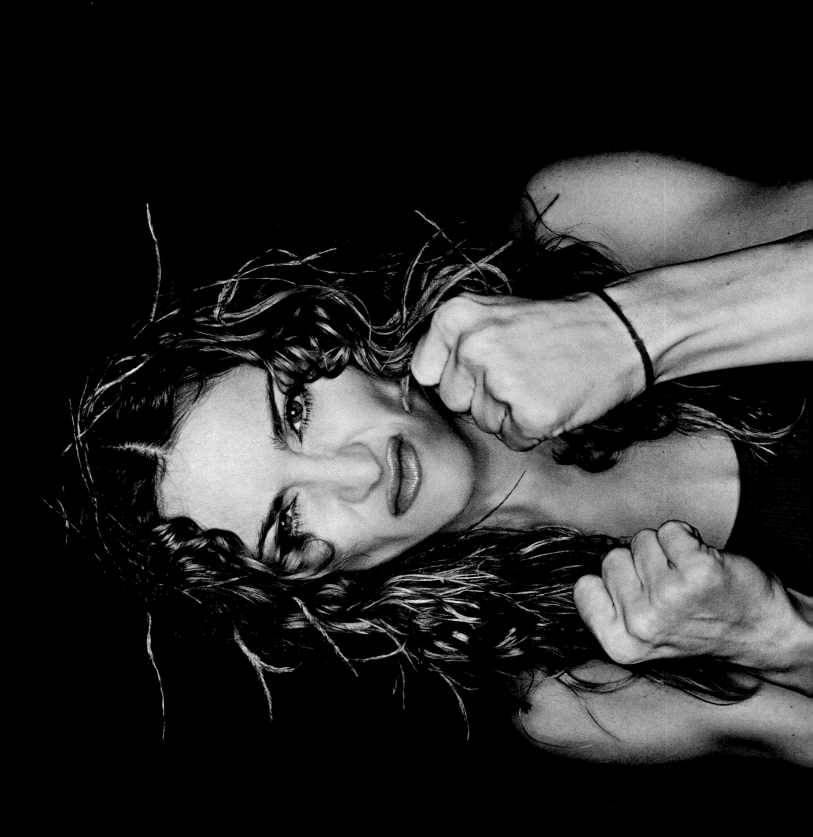

photographer > Rankin | **title >** Madonna | **paper >** Ilford Multigrade Gloss Grade 3 | **exposure >** detailed below | **developer >** Ilford PQ 1-9 | **time >** 1½ minutes

process > The original of this was shot on 120 Kodak Plus-X and then scanned and lightly retouched. To make limited edition silver gelatin prints we had the retouched image output onto Ilford FP4 5 x 4in film using the digital reader/writer. Once it was processed, prints were made in the conventional way. As all the hard work was done during retouch, this was relatively easy to print, it was more important to get the exposure and density right on the digital side of things. At f/22 grade 3, I made a base exposure of 25 seconds, dodging the lower face and the forearms for five seconds each. Then I added five seconds on the lower torso and darkened down the background by 10 seconds.

(handwritten note: dodge the block in and dark)

glossary

acutance > This is the visible edge sharpness or definition between individual grains of metallic silver.

ambient light > Any light not provided by you the photographer. This can be daylight indoors or out, or existing light that was there before you arrived.

aperture > A variable sized circular hole that is used to control the amount of light passing through the lens onto film or paper. Camera and enlarger lenses are marked in f numbers such as f/3.5, f/4 etc. Enlarger lenses can also be marked numerically in 50 per cent reduction steps, i.e. 1, 2, 4 etc.

angle of view > This is the angle between the extremes of the image-forming light entering and measured from the lens. The smaller the focal length, the wider the angle of view, thus the term 'wide-angle'.

artificial light > Any light other than natural daylight. Domestic and flashlight are both artificial.

bleaching > The reduction in density of a processed print by application of dilute bleach such as potassium ferricyanide. Commonly used in sepia or thiocarbamide toning.

burning in > A technique that allows additional exposure to selected parts of an image.

c-41 > Standard colour negative developer that is also used to process black and white chromogenic film such as Kodak T-400.

chlorobromide paper > A paper that provides a warm black when used with the appropriate developer.

chromogenic film > Film such as Ilford XP-2 or Kodak T-400, which uses dyes to create monochromatic images instead of silver-based emulsion.

clearing time > The time it takes for a sheet of black-and-white paper to be fixed in chemical fixer. This is important as it indicates how active the fixer is.

contact print > A print that is made when the negative is placed in direct contact with the printing paper. Doing this with a whole roll of film provides us with reference positives.

contrast > The difference between the lightest and darkest areas of an image, negative or print.

definition > The ability of the camera lens or film to record fine detail in focus.

depth of field > The amount of the image that is in focus and is controlled by the lens aperture in f-stop increments. The smaller the F-stop the greater the depth of field.

diffraction > The 'bending' of a path of light as it passes close to another surface, responsible for drop-off in resolution at smaller apertures.

diffusion > A technique used to 'soften' or 'flare' light as it passes between the lens and the photographic paper. Done with the use of a gel, stocking or anti-newton glass.

dish/tray warmer > A hotplate that is placed under a dish of chemistry to help maintain contsatnt warm temperatures.

dodging > A technique in which a selected area is shielded or masked from exposure.

DX coding > The system where most APS, 35mm and a few medium-format cameras automatically read the film speed by means of a bar code printed on the film cassette or roll film.

emulsion > The light-sensitive coating on all film and papers which forms the image after exposure and development.

exposure latitude > The exposure flexibility of a film or paper. Most films can perform with about three stops overexposure and two stops underexposure.

farmer's reducer > A chemical combination that is used to bleach away the silver from a negative or print. After use the film or paper must be washed and fixed again.

fibre-based paper > A printing paper in which the emulsion is coated onto an unsealed surface. It is available in various weights and surface finishes.

film base > The plastic base of a film onto which light sensitive emulsion is coated.

film speed > The measure of a film's light sensitivity. Usually labelled as an ISO number; the larger the number the greater or 'faster' the light sensitivity.

flashing > The technique of providing printing paper a brief exposure to trigger the paper's response to light. Also used to soften contrast of an image.

fogging > The effect of exposing film or paper to uncontrolled light, caused by light leaking in the darkroom, safelight fogging or strong, multiple X-rays.

f-stop > This describes the size of the lens aperture in relation to the lens' focal length. f/2 in a 50mm lens describes an aperture of 50/2 = 25mm and for a 100mm lens f/2 would be 50mm aperture diameter. Importantly f/2 on any lens will give identical exposures with the same shutter speed, irrespective of physical aperture size.

grade > In black-and-white terms, this refers to the contrast of a paper. Grade 0 has the softest contrast whilst grade 5 the hardest. Fixed grade papers have only one grade while multigrade papers are sensitive to a broader spectrum of coloured light and are therefore more capable of behaving as any grade dependant of the filtration used. Multigrade papers are also known as variable grade or multi-contrast.

grain > The structure of a film's emulsion that becomes apparent at increased enlargement. More prominent with faster films.

high key > The term used to describe an image of predominantly light tones.

hypo eliminator > The solution used to decrease the time that a film or paper needs washing to obtain archival permanence.

ISO rating > The industry standard by which film speeds are measured, commonly between ISO25 and ISO3200. Rating is divided into one-third stop increments i.e. 50, 64, 80 etc.

lith developer > A chemical that is used to process bromide papers to increase contrast or introduce delicate tones without the need for toning.

one-shot developer > A film developer that is used freshly diluted and then discarded after use.

orthochromatic > A film or paper that is not sensitive to the red spectrum, and can, therefore, be handled under safelights.

panchromatic > A film or paper that is sensitive to all spectrum wavelengths of visible light and must be handled in complete darkness.

pulling > A term used to describe the reduction of development time to reduce speed. Can also be used to describe the method of removing a print from the developer before full development takes place.

pushing > A term to describe the increase in stated film speed by extending development time.

reciprocity failure > Some films become slower when extended exposures of one second or more are used, and doubling the exposure to compensate does not work as well as opening up the aperture by one stop.

refraction > The change in speed and direction of light as it enters or leaves a transparent object, The light only changes direction if it is not incident perpendicular to the surface.

resin-coated paper > Printing paper where the emulsion is coated onto a plastic-sealed paper base. Not as prone to staining and contamination as fibre-based paper.

split-grade printing > The method by which different levels of contrast are combined on a single sheet of multigrade paper.

split-toning > The technique whereby a print is given more than one tonal or colour shift by immersion in toners.

spotting > The technique of removing unwanted hair and dust marks from a print by use of dye or ink. Applied using a small sable brush.

stop bath > An acidic solution that halts the developer action during film or paper processing.

test strip > A method of determining optimum exposure by making a series of incremental exposures on the same sheet of paper.

wetting agent > A solution which reduces the surface tension of water on a film or print. A small amount added to the final wash can speed up the drying process.

zone system > A controlled system of exposure, processing and printing where you visualise the final result before taking of the picture, starting at the metering stage where the mid-tone is selected. Calibrated in 9 steps between white and black, the shadow areas are measured and overexposed by two stops. The area around Zone 5 is the 18 per cent grey to which exposure meters are calibrated.

index

acknowledgements

My heartfelt thanks go to all the photographers and people who contributed to this workbook and put up with my pestering for so long. Thanks to Nigel Atherton for getting the ball rolling, and to RotoVision SA for making the dream a reality; especially Clara Théau-Laurent for the support and keeping me to deadlines, Leonie Taylor for the final edit, to Luke Herriott and Simon Balley for the art direction, and to Jo Hill for the design.

Alessio Pizzicannella, Corinne Day, David Clerihew, Dean Freeman, Deirdre O'Callaghan, Fredrik Clement, Gary Knight and all at VII, Hamish Brown, Jamie Beeden, Jamie Kingham, Joakim Blokstrom, John Cole, Jon Nicholson, Mario Testino and all at Art Partners, Mark Guthrie, Paul Smith, Rankin, Robert Goldstein, Robert Wallis, Shepard Sherbell, Tanya Paice at Blunt Management, Tierney Gearon, Ulrik Bentzen, Zed Nelson and all at IPG, Darren Rees, Dean Belcher, Edward Webb, Mike McGoran, Patrick Ford, Paul Smith and Samman.

Hamish for the belief and support above and beyond; to John Cleur for thankfully not taking me seriously, Mick Jones for tea and encouragement; Andy W and Andy S, who should know better.

Chris at Goldenshot for the support and helping make Potosi live. Gary Knight for the words of wisdom and inspiration behind my work.

Everybody at Rankin Photography, especially JR, Sandra, Susanne, Laurie and Matt.

Thanks to Yvonne McSherry for bringing a digital camera into my darkroom.

My family Mum, Dad, Kevin, Alan and Calum, thank you for keeping my feet on the ground yet allowing me to fly every now and again.

Dr Vaughan Williams and Dr Claire Gould for the encouragement support and honesty that has helped me to try and understand.

For Claire more than any other person.